Creating Textures *in* Watercolor

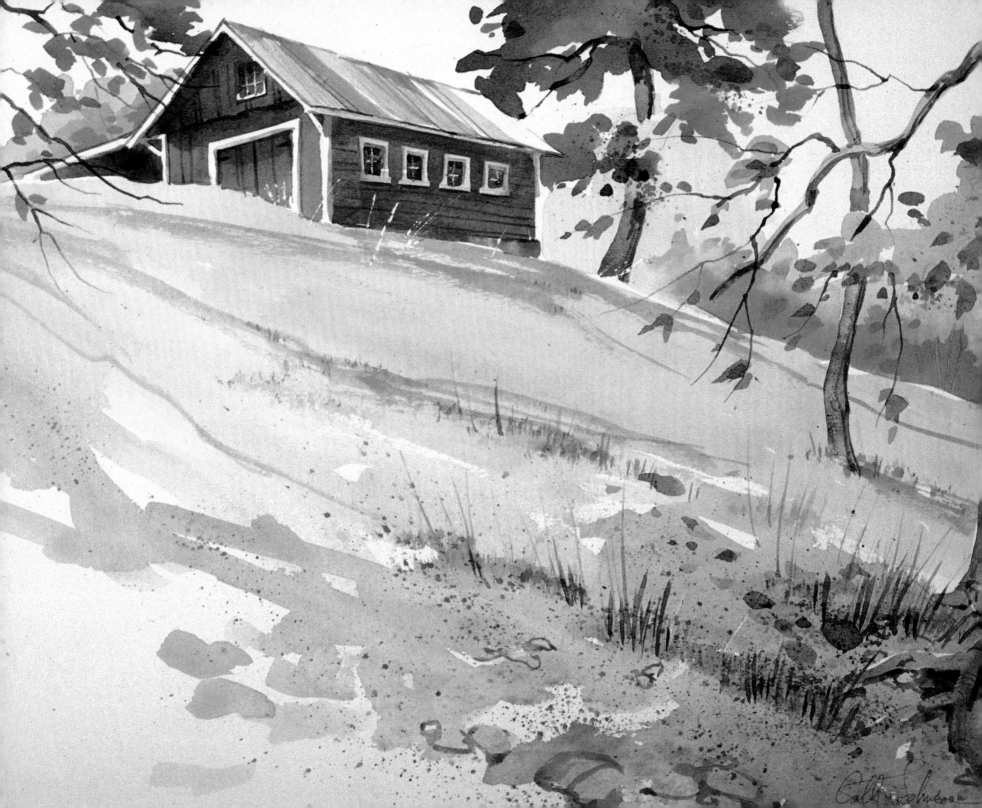

Creating Textures in Watercolor

A guide to painting
83 textures from grass to glass
to tree bark to fur.

CATHY JOHNSON

NORTH LIGHT BOOKS

Cincinnati, Ohio

96 95 94 93 92 5 4 3 2 1

Library of Congress Cataloging in Publication Data

Johnson, Cathy (Cathy A.)
 Creating textures in watercolor : a guide to painting 83 textures from grass to glass to tree bark to fur / Cathy Johnson. — 1st ed.
 p. cm.
 Includes index.
 ISBN 0-89134-417-9 (hrdcvr)
 1. Watercolor painting — Technique. 2. Texture (Art) — Technique.
I. Title.
ND2422.J64 1992
751.42'2 — dc20 91-22587
 CIP

Edited by Greg Albert and Rachel Wolf
Designed by Sandy Conopeotis

DEDICATION

To my students,

whose intelligent questions

have helped to shape this book;

to Greg Albert,

my supportive and meticulous

and understanding editor;

and to Harris,

whose presence makes it all possible.

TABLE OF CONTENTS

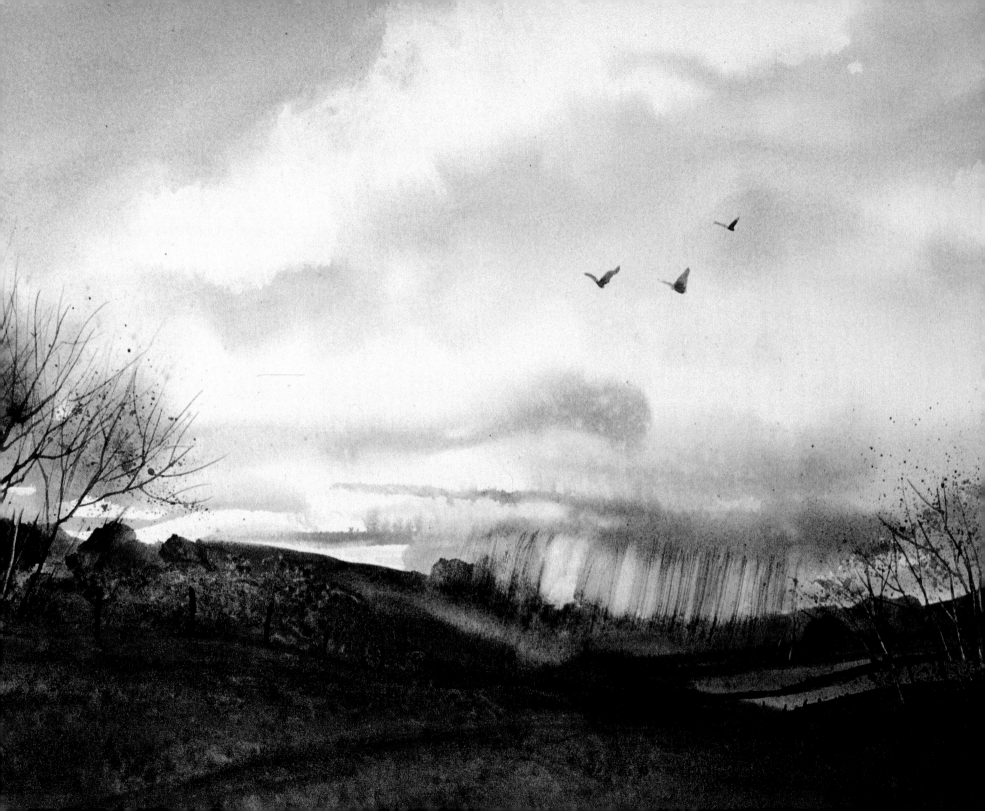

INTRODUCTION

Everything has texture—surface characteristics you can feel or that affect the way a thing looks when the light hits it. Think of tree bark, rough grasses, polished glass, a baby's cheek, the glossy flanks of a thoroughbred horse. All these things share a common feature—they have a unique texture that contributes something essential to their identity.

You can capture these textures in watercolor to enhance the tactile appeal of your work. You can make each subject ring true by believably rendering soft or hard, rough or shiny, smooth or ridged surfaces. It's simply a matter of thinking through and planning ahead to capture the effect you're after.

There are those who say watercolor is tricky—impossible, at times!—and so it can be, if you are only shooting for those exciting, spontaneous effects that produce what we call "happy accidents." It's exciting, all right, but almost as dangerous as hang gliding without proper instruction. It takes practice to learn how to wing it without crashing.

Like learning to hang glide, watercolor takes practice—you don't jump off a cliff without a good grounding in the basics. Capturing textures in watercolor is much the same.

Careful observation is one of the best keys to rendering surface texture, followed by a good dose of (right-brain) thinking. How does the light hit your subject? Is it oblique or straight on? What does that tell you about what you see? Does it enhance or flatten surface characteristics? And what should you paint first to get the effect you're after? What comes second? How far should you go? And what attracted you in the first place?

It isn't necessary to paint every hair on a kitten to capture the *effect* of soft fur, or to capture every light-struck detail of a cut-glass vase; these techniques are a sort of shorthand you can carry as far as you like. (However, if you *are* into photorealism, you can "get there from here.") I prefer the simpler approach, and most of the examples in this book will reflect that simplicity.

This book includes techniques that depend heavily on the paper you choose; rough paper reacts quite differently than hot-press or plate, and if you are ready for that difference you can learn to use it to your advantage. Chapter One will lead you through the basics of paper surfaces.

Other basics depend on brushwork—drybrush, wet-in-wet, wet-onto-dry and vice versa. Watch for examples of these brush-handling techniques throughout to give you hints on which approach to choose with a specific subject.

Still other techniques are flashier—I covered a number of these in my book, *Watercolor Tricks and Techniques*, but for the purposes of this book I've distilled them to the four S's: salt, scraping, sponges and spatter. Some are more useful than others, depending on you and your needs; I seldom use salt anymore but couldn't live without spatter. You'll find your own favorites to achieve the effects you're after.

The body of the book is more basic, a simple step-by-step, show-you-how-you-can-do-it. Not, mind you, a "Here's how it's done" approach, because everybody works differently. If the specific examples I've chosen aren't for you, skip them and try something else. Look beyond the surface. Even though I may be talking about smooth, shiny apples, the same basic technique applies to pears or eggplant—to any shiny organic subject. If you like the texture I've achieved for rust but think it would work for you on moss instead, change the color and go for it.

Most of the examples in this book *are* step-by-step. I'll suggest an underwash—either simple or slightly more complex—then suggest ways you might manipulate the wash to create texture or suggest a secondary wash once the first is dry to layer on the texture. Final details add the spark needed to complete your subject, and you're through. In most cases, you'll let the wash dry thoroughly between steps—and that's what makes this approach so accessible and so much simpler (and more predictable) than many watercolor techniques. It takes patience to let the

wash dry, or a good hair dryer, but the effects are well worth it. Your frustration level is almost guaranteed to drop.

This is not a new technique: there's nothing flashy about it. It's the traditional English style of watercolor, from a century or more ago. It's learning to control a difficult medium so that next time you want to jump on that hang glider and run for the edge, you'll have the knowledge and the skill to do it. Enjoy the ride; the view is great.

This book is intended to be accessible and easy to use, like a workbook. The pages open wide to allow you to see what's going on more easily and to paint along if you like. I've used some of these samples in my workshop classes for years, and my students have enjoyed copying them. Usually they say, "Tell me this is your next book!" Well, it is, and I hope you find it as useful as they have.

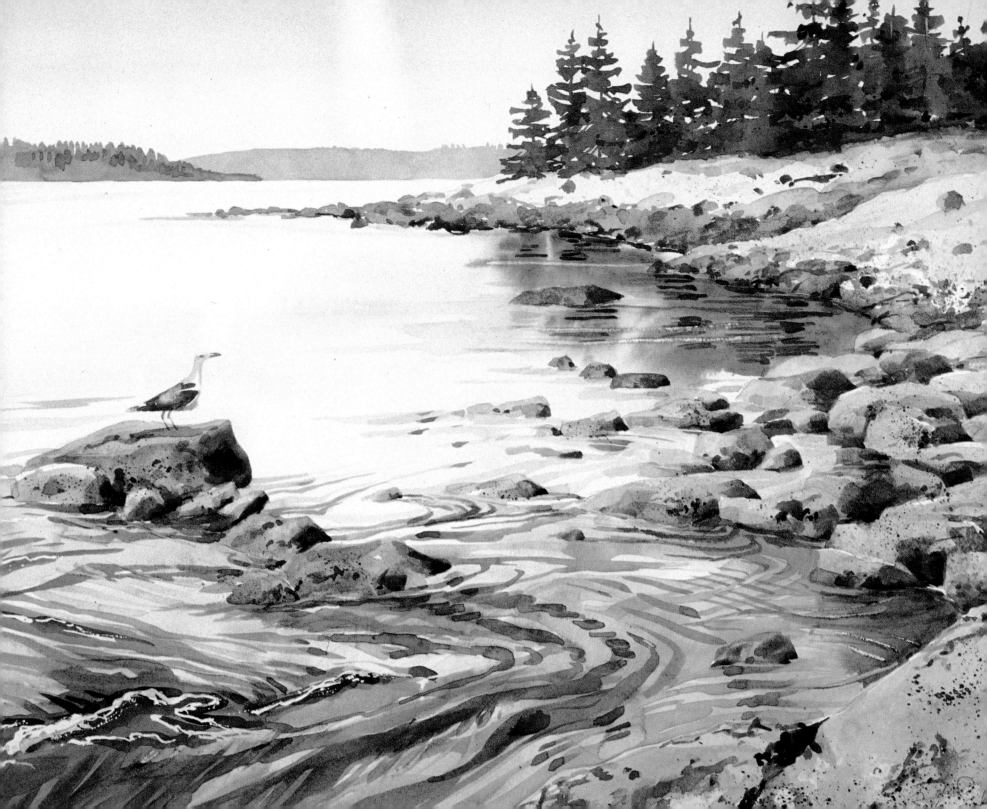

Chapter One

PAPER SURFACES

It's hard to believe that the surface you choose can have such an effect on the texture you're depicting, but it does. Choose your paper carefully to make your task easier. A good-quality rag paper with a neutral pH will not only ensure your work will last but will make your *working* as pleasant as possible. There's nothing like trying to fight a nasty, cheap paper that wants to warp up like the Appalachians at the first touch of a wet brush.

To that end, buy the heaviest paper you can afford. Most watercolor paper comes in 90 lb. (too lightweight to use without stretching it first), 140 lb. (a good compromise that will curl some when wet but will usually flatten back out as it dries), or 300 lb., a heavyweight paper that's almost like painting on watercolor board. Of course, that's a nice idea, too, if you can afford it. Most watercolor board—good-quality paper mounted on a cardboard backing—is extremely hardy; it'll take about any kind of punishment, including scrubbing out, scraping or erasing.

Surface characteristics vary from brand to brand; get to know the papers you like and you'll know what to expect from them. Rough paper from one company may seem smooth to you after using another manufacturer's rough for a few years; another brand of hot-press may seem to have a bit of tooth, more like cold-press compared to others. Shop around; buy a pad of various papers or a set of loose samples from one of the larger suppliers. Get your feet wet along with the paper.

Rough. No matter what brand of rough you choose, it will have certain characteristics, with tiny hills and valleys created by the manufacturing process wherein paper pulp is poured out on a screen to dry. Some papers are almost like a relief map of mountains, others were obviously mechanically created, but it is these tiny bumps that catch and hold pigment.

Oddly enough, it is easier to do a flat wash—an unblemished, featureless expanse—on rough paper than it is on the smoother cold-press or hot-press. The pigment settles more or less evenly in the valleys, almost as if it averages out. But when you drybrush over that smooth wash, the paper surface itself mandates the texture. For that reason, I usually choose cold-press or hot-press; I like to make my *own* textures, thank you.

Incoming Tide, Maine 15″ × 22″

Cold-Press. This paper is weighted down as it dries, smoothing the surface either a little or a lot, depending on the manufacturer and how much pressure is applied. It's very versatile, making a smooth-enough flat wash for most purposes (how often in nature do you find a truly flat, unvarying hue, anyway?) while allowing you to overlay any texture you like with a variety of techniques.

Hot-Press or Plate. You guessed it — this one is made by pressing the paper with a hot metal surface, just like you'd iron your best shirt. It can vary from a rather vellum-like surface to a smoothness you can almost see your face in. Washes are unpredictable on hot-press paper, but very, very exciting. When I find I am tightening up too much, exerting too much control on my paintings, I get out the hot-press for spontaneous effects. Here, you *have* to create your own textures if you want recognizable ones — otherwise you'll just get puddles that depend for their surface on the paper and the characteristics of the particular pigment you've chosen.

Try samples of each to familiarize yourself with these paper types, and buy as many brands as you can afford to find the one you like best. (But don't marry it. My favorite paper is no longer imported, and I had to learn a whole new approach with much gnashing of teeth.) Pick your paper surface according to the subject you've chosen or to your mood; there's a whole world of difference before you ever set brush to paper.

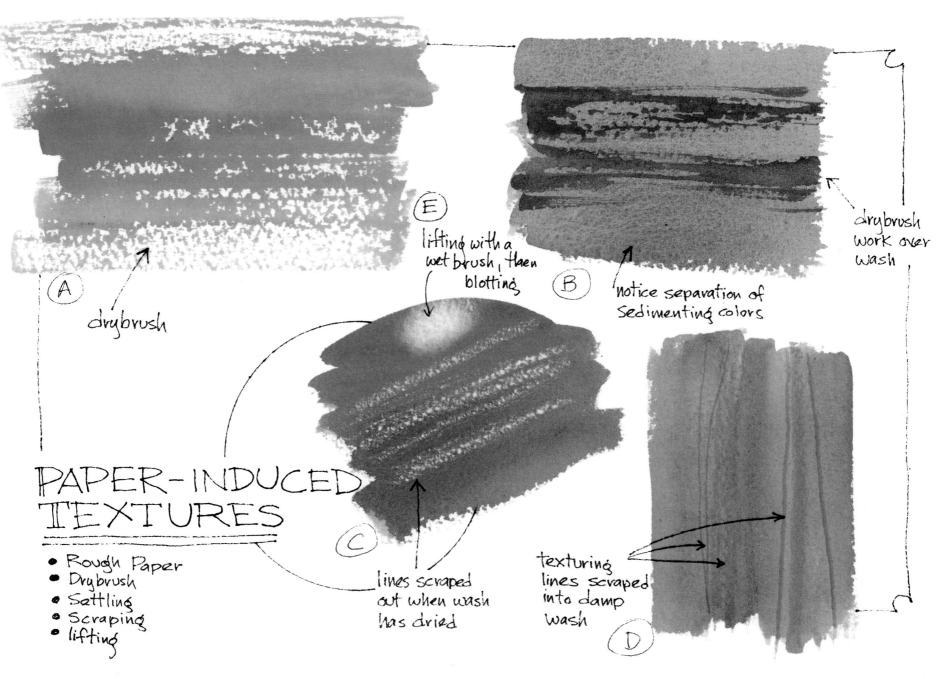

Ⓐ drybrush

Ⓔ lifting with a wet brush, then blotting

Ⓑ notice separation of sedimenting colors

drybrush work over wash

PAPER-INDUCED TEXTURES

- Rough Paper
- Drybrush
- Settling
- Scraping
- lifting

Ⓒ lines scraped out when wash has dried

texturing lines scraped into damp wash

Ⓓ

7

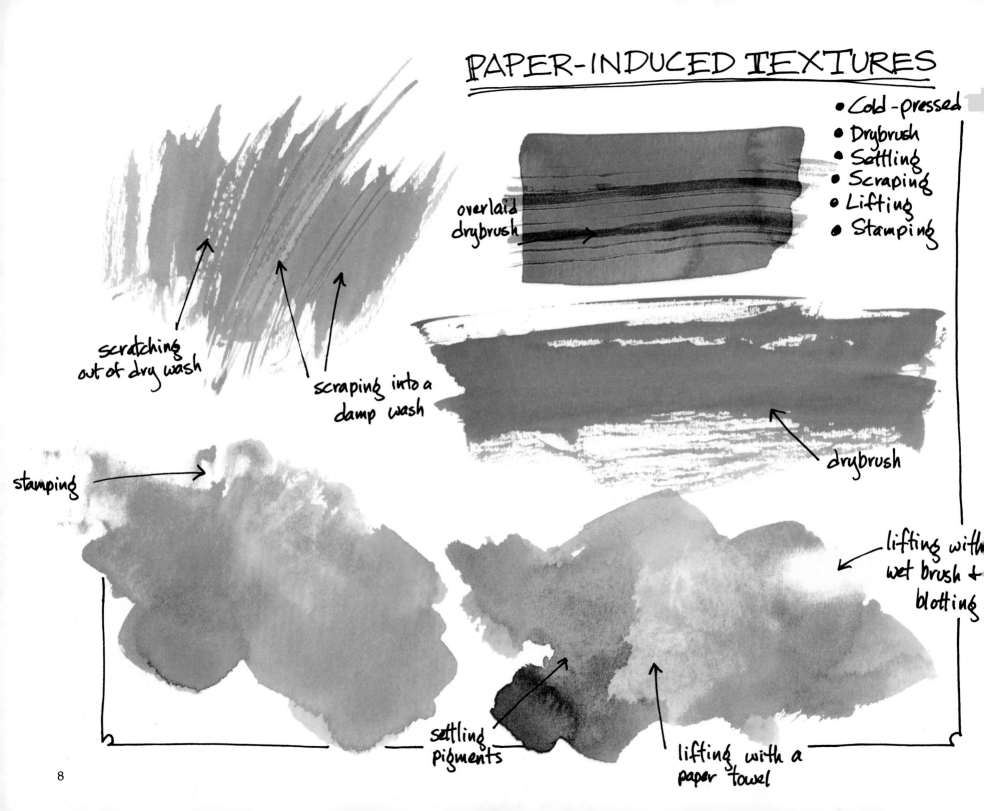

PAPER-INDUCED TEXTURES

- Cold-pressed
- Drybrush
- Settling
- Scraping
- Lifting
- Stamping

overlaid drybrush

scratching out of dry wash

scraping into a damp wash

stamping

drybrush

lifting with wet brush + blotting

settling pigments

lifting with a paper towel

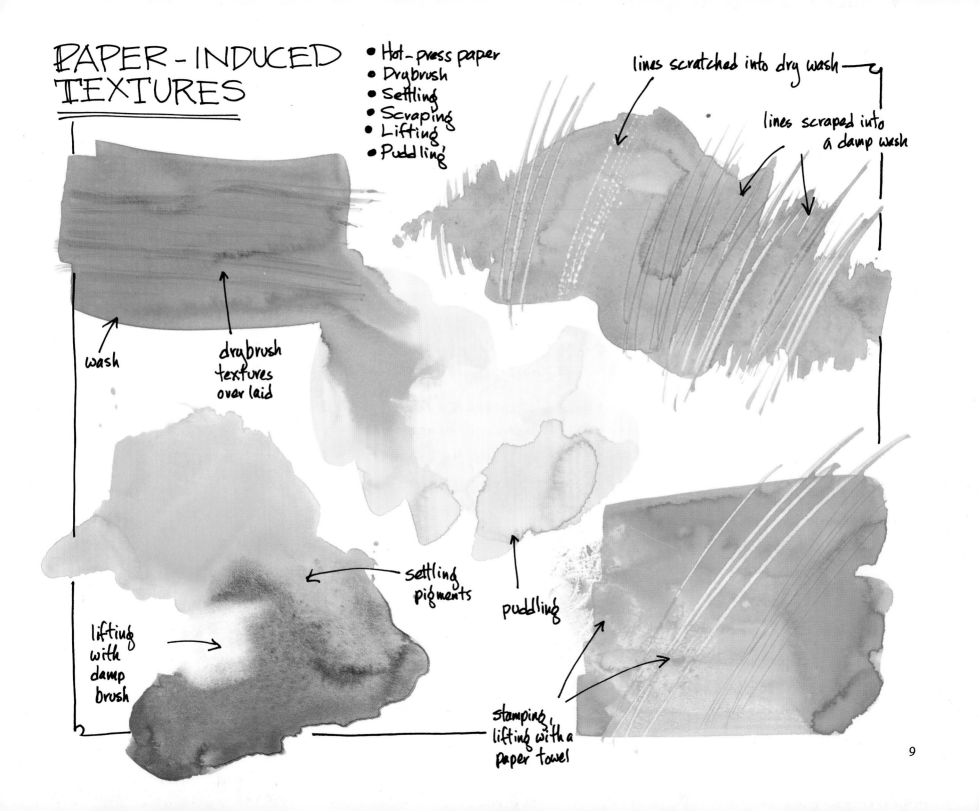

PAPER-INDUCED TEXTURES

- Hot-press paper
- Drybrush
- Settling
- Scraping
- Lifting
- Puddling

lines scratched into dry wash

lines scraped into a damp wash

wash

drybrush textures overlaid

settling pigments

puddling

lifting with damp brush

stamping, lifting with a paper towel

9

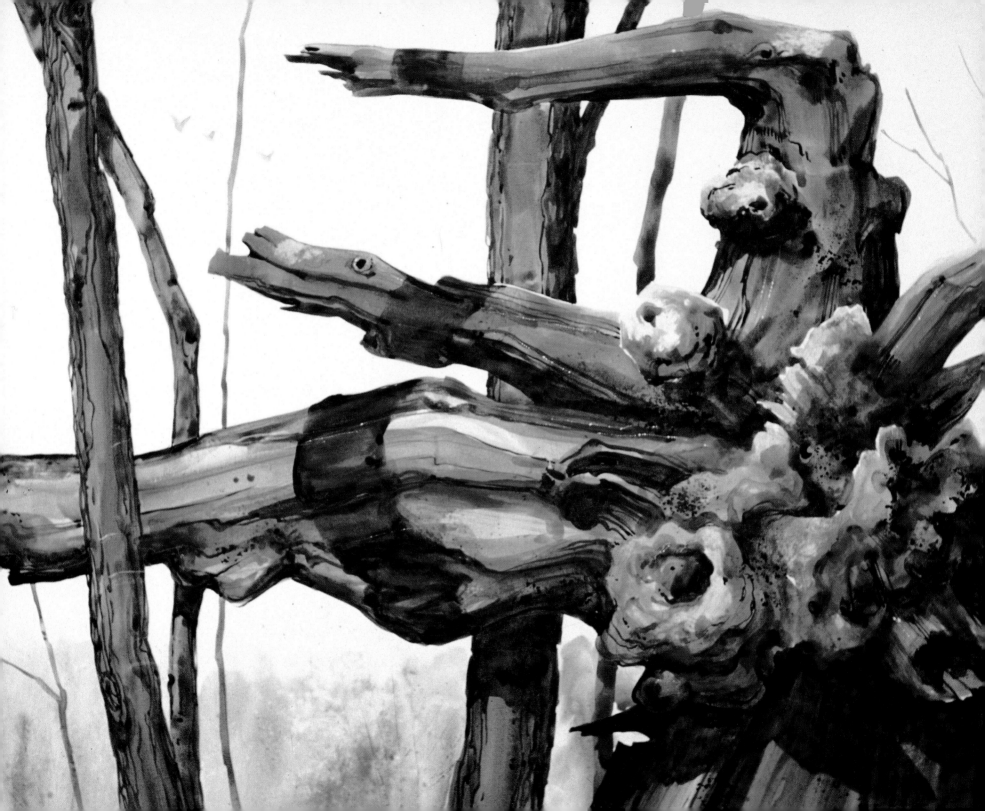

THE FOUR S's

There are any number of ways to manipulate pigments on your paper—plastic wrap or waxed paper impressed into damp pigment, stamping, finger painting, inks, Maskoid and rubbing alcohol, to name just a few. Here, I've narrowed the field to what I call the four *S*'s—four simple ways to achieve big effects.

Salt can be tricky to use. If your wash is too wet, it is uncontrollable, too dry and there's no effect at all. But it can be an effective tool to suggest starry skies, the sparkle of snow, a sandy beach—or just an interesting texture. It has been somewhat overused in the past—try it with caution and restraint.

Scraping can let you achieve textures difficult to master in any other way; it's controllable but spontaneous. Depending on how wet your wash is and how you hold your scraping tool, you can make dark, fine lines in a wet wash or push the pigment from a damp one to reclaim lights. Held almost at a right angle, the scraping tool bruises the wet paper fibers, making them accept more pigment and resulting in dark lines; at a more acute angle, close to the paper, the tool produces lights in a wash that has lost its wet shine. A narrow tool makes narrow lines; the broad edge of a spatula or a trimmed credit card will give you broad areas of lighter value.

Sponges are useful for more than mopping up; you can suggest a number of textures by painting directly with them. Natural sea sponges are most useful for this, but a man-made sponge with a brick-like texture may be helpful as well. And of course, lifting color with a clean, damp sponge is easy.

My favorite texturing trick is *spatter*; I spatter into a wet wash for soft effects, into a dry wash for harder-edged spots. A clear-water spatter can produce a spray of tiny light spots that can stand in for salt, but with a softer effect. A well-aimed spray of fine water droplets at the edge of a wash will break it into a lacy edge. It all depends on what you're after.

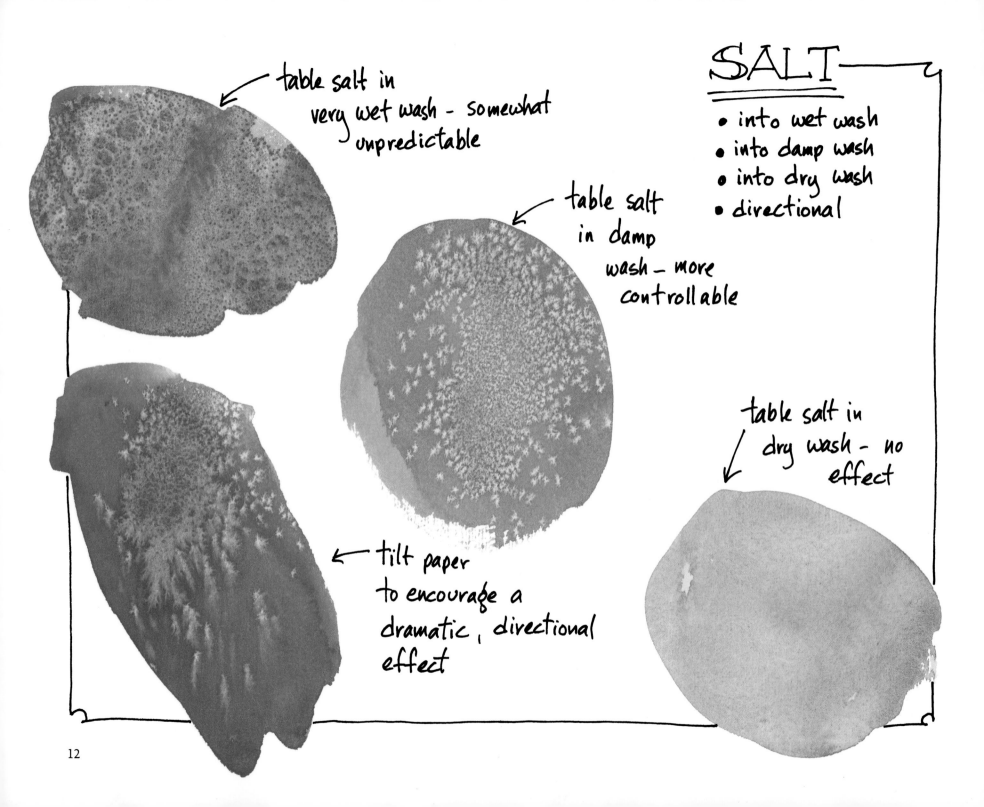

table salt in
very wet wash - somewhat
unpredictable

table salt
in damp
wash - more
controllable

- into wet wash
- into damp wash
- into dry wash
- directional

table salt in
dry wash - no
effect

← tilt paper
to encourage a
dramatic, directional
effect

12

SCRAPING

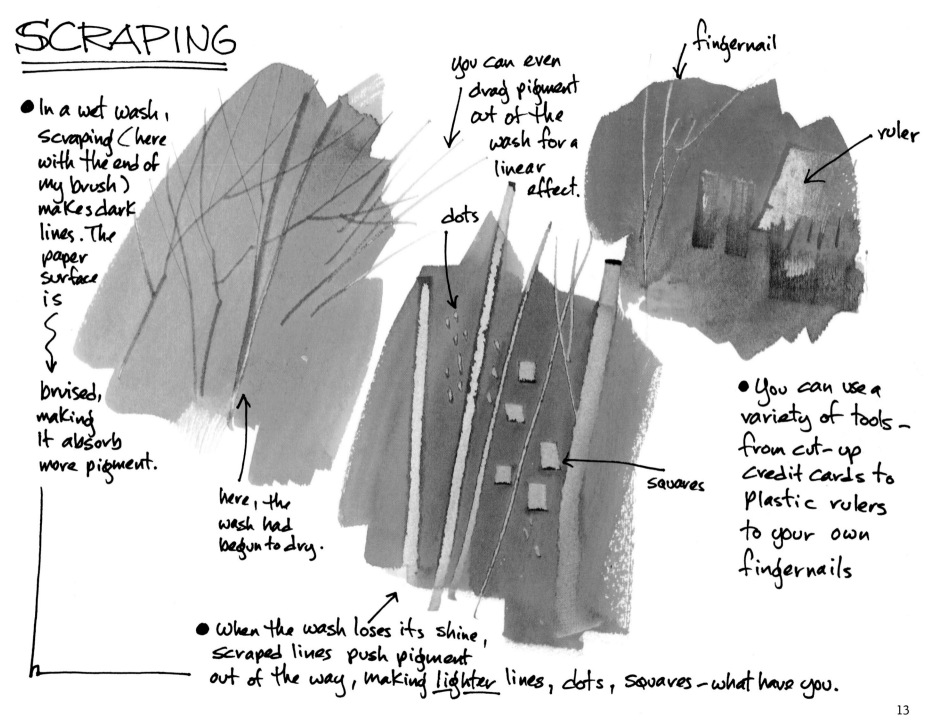

- In a wet wash, scraping (here with the end of my brush) makes dark lines. The paper surface is { bruised, making it absorb more pigment.

here, the wash had begun to dry.

you can even drag pigment out of the wash for a linear effect.

dots

squares

fingernail

ruler

- You can use a variety of tools - from cut-up credit cards to plastic rulers to your own fingernails

- When the wash loses its shine, scraped lines push pigment out of the way, making <u>lighter</u> lines, dots, squares - what have you.

13

SPONGES

- natural sea sponges
- manmade

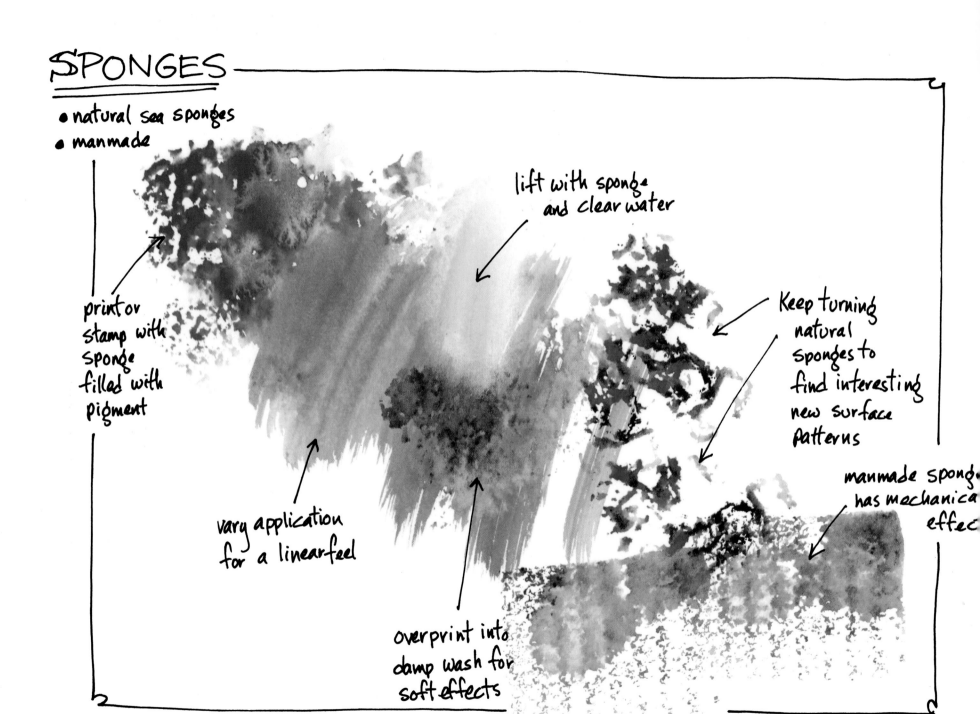

lift with sponge and clear water

print or stamp with sponge filled with pigment

Keep turning natural sponges to find interesting new surface patterns

vary application for a linear feel

manmade sponge has mechanical effect

overprint into damp wash for soft effects

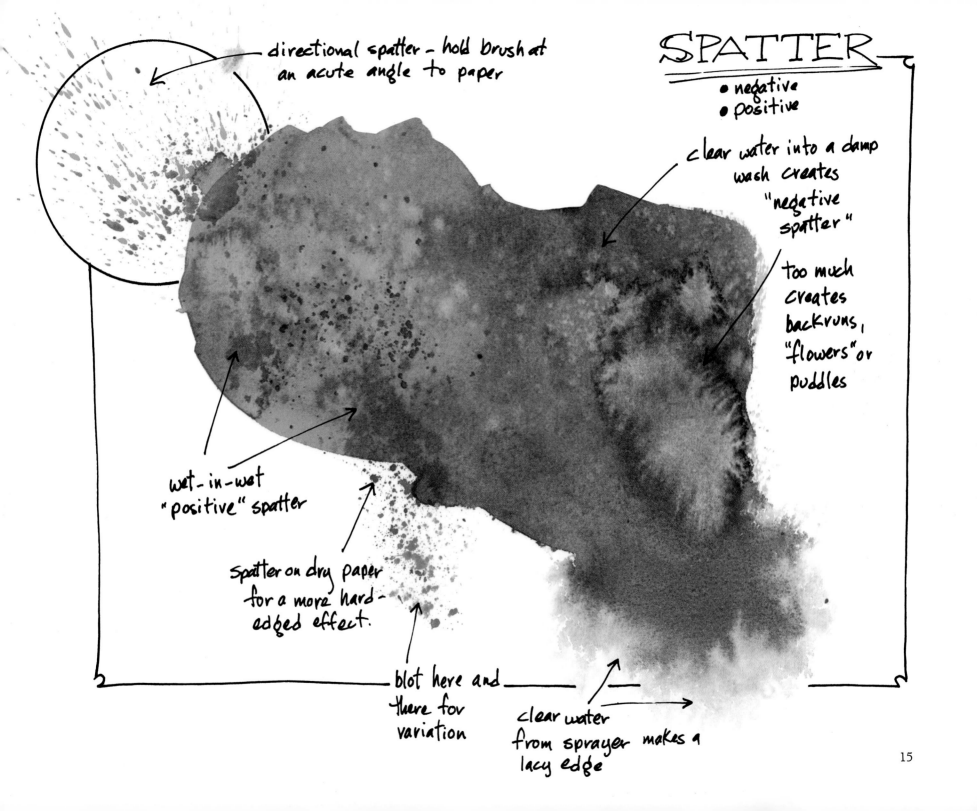

directional spatter - hold brush at an acute angle to paper

SPATTER
• negative
• positive

clear water into a damp wash creates "negative spatter"

too much creates backruns, "flowers" or puddles

wet-in-wet "positive" spatter

Spatter on dry paper for a more hard-edged effect.

blot here and there for variation

clear water from sprayer makes a lacy edge

15

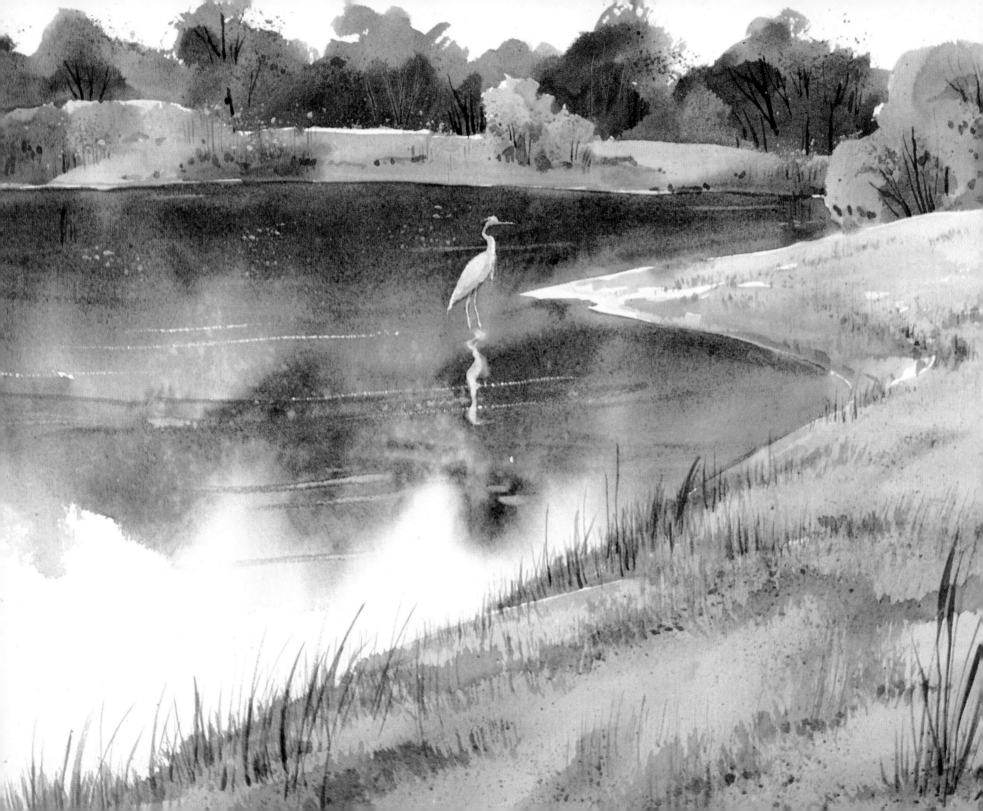

WATER TEXTURES

One of the first things that students invariably ask is "How do I paint water?" It's a tricky subject, as fluid as the water itself, but it doesn't have to be. It follows the same simple rules as painting anything else — observation, logic and application, with a dash of adventure thrown in to season the pot. If you so choose, you can use traditional layering techniques to make this liquid subject much easier to handle; a simple step-by-step approach with drying time between steps can tame even the most turbulent white water. So let's "get our feet wet" and jump right in. The water's fine (and not nearly as daunting as it may seem).

In this chapter we'll cover still, reflective water — a matter of suggesting the glassy surface and adding reflections; moving water, with its appearance dictated by the direction of the water's flow; choppy water, with its randomly broken surface textures; white water; and waterfalls. Armed with these suggestions, you should be able to tackle just about any situation that presents itself — or find a way to do it on your own. My examples are intended mainly to remove some of the mystery and to give you suggestions, not as hard-and-fast rules.

Heron Lake 15" × 22"

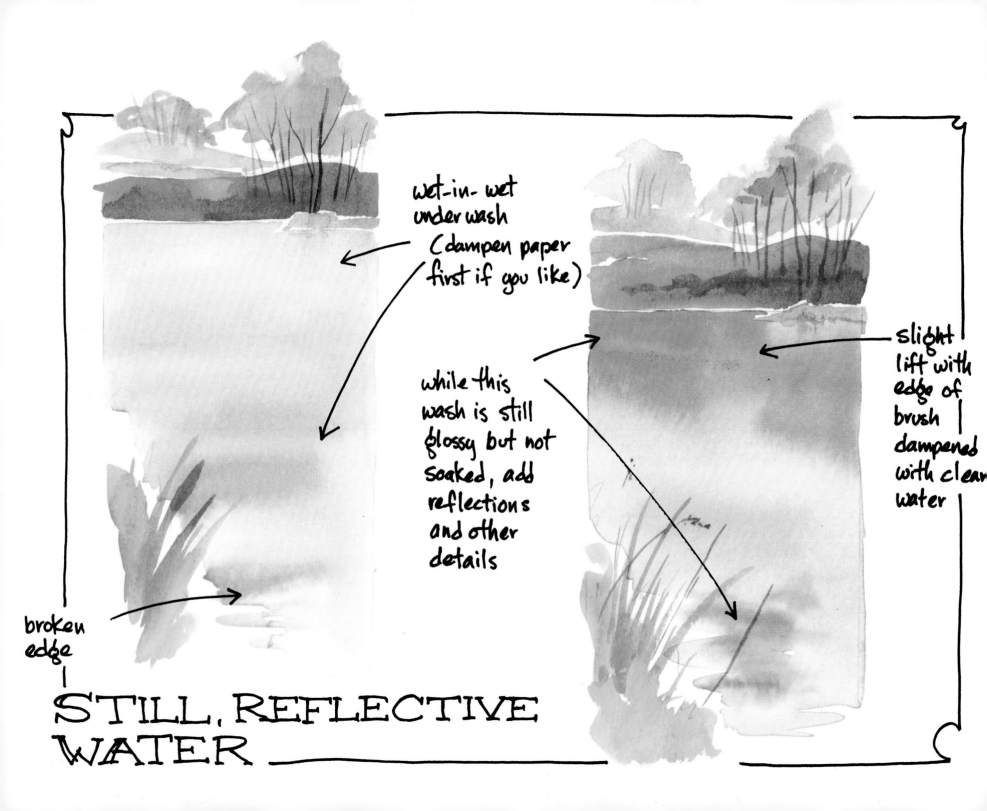

wet-in-wet under wash (dampen paper first if you like)

while this wash is still glossy but not soaked, add reflections and other details

slight lift with edge of brush dampened with clear water

broken edge

STILL, REFLECTIVE WATER

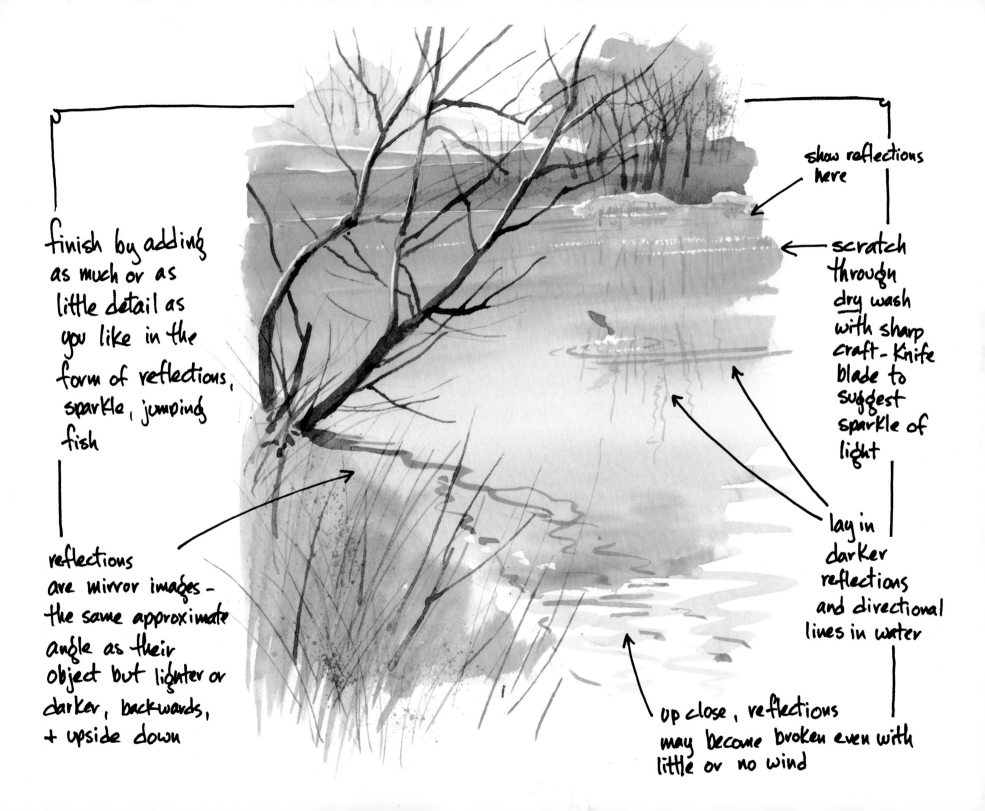

finish by adding as much or as little detail as you like in the form of reflections, sparkle, jumping fish

reflections are mirror images - the same approximate angle as their object but lighter or darker, backwards, + upside down

show reflections here

scratch through dry wash with sharp craft-knife blade to suggest sparkle of light

lay in darker reflections and directional lines in water

up close, reflections may become broken even with little or no wind

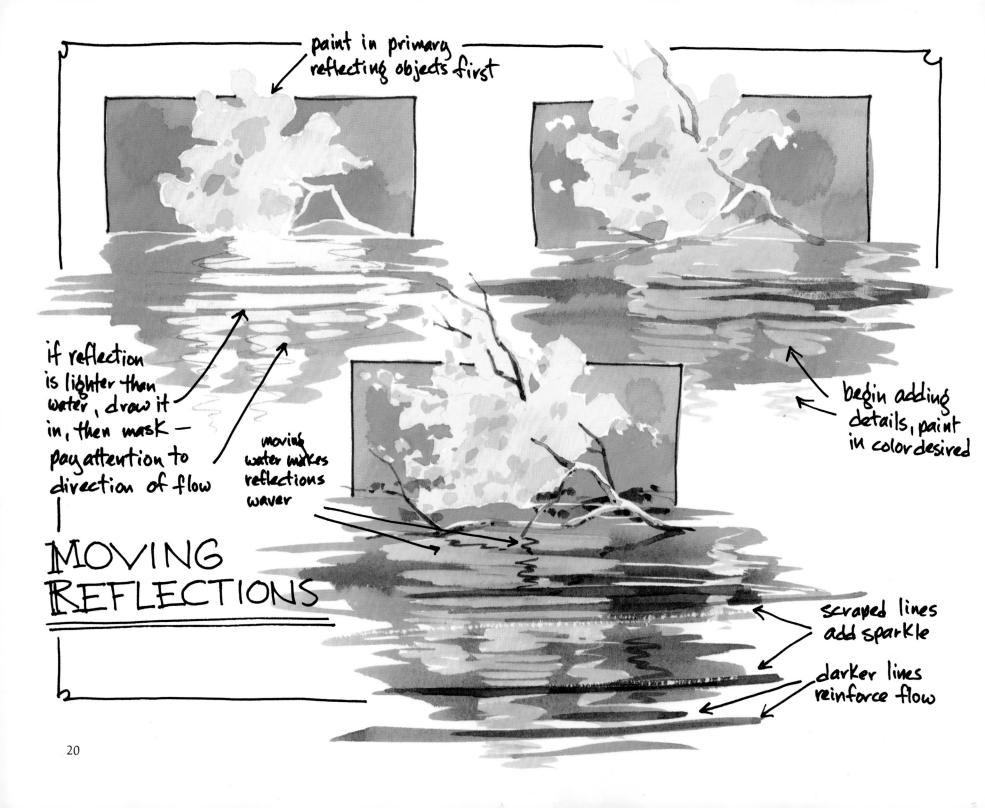

paint in primary
reflecting objects first

if reflection
is lighter than
water, draw it
in, then mask —
pay attention to
direction of flow

moving
water makes
reflections
waver

begin adding
details, paint
in color desired

MOVING
REFLECTIONS

scraped lines
add sparkle

darker lines
reinforce flow

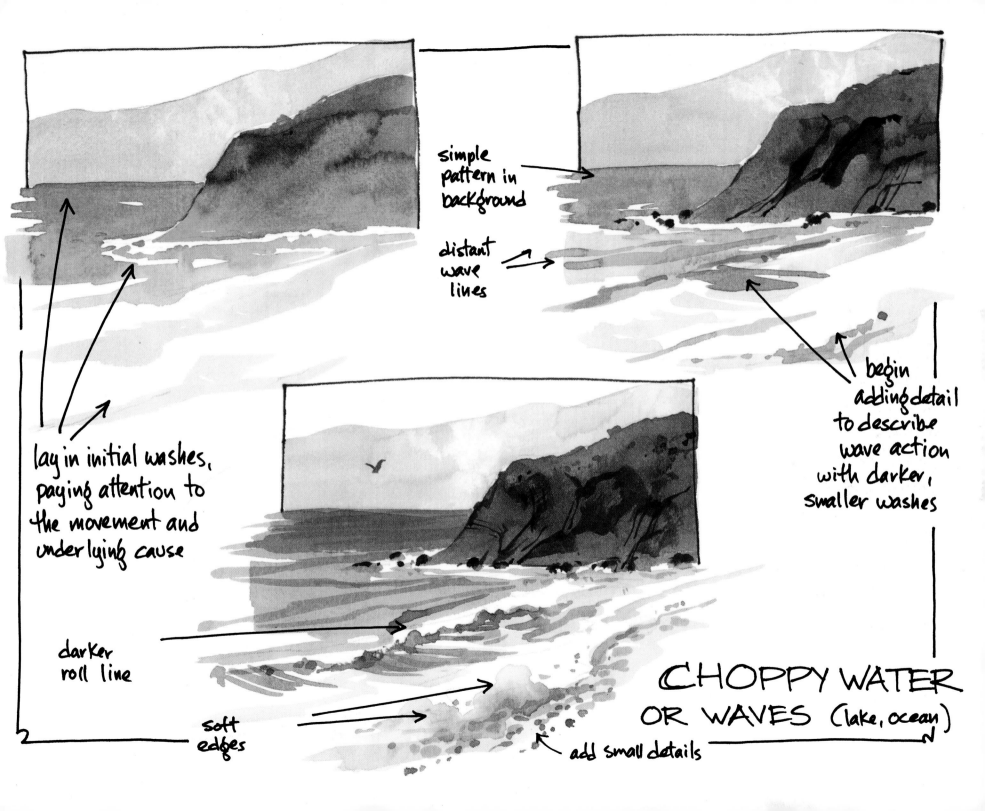

simple
pattern in
background

distant
wave
lines

begin
adding detail
to describe
wave action
with darker,
smaller washes

lay in initial washes,
paying attention to
the movement and
underlying cause

darker
roll line

soft
edges

add small details

CHOPPY WATER
OR WAVES (lake, ocean)

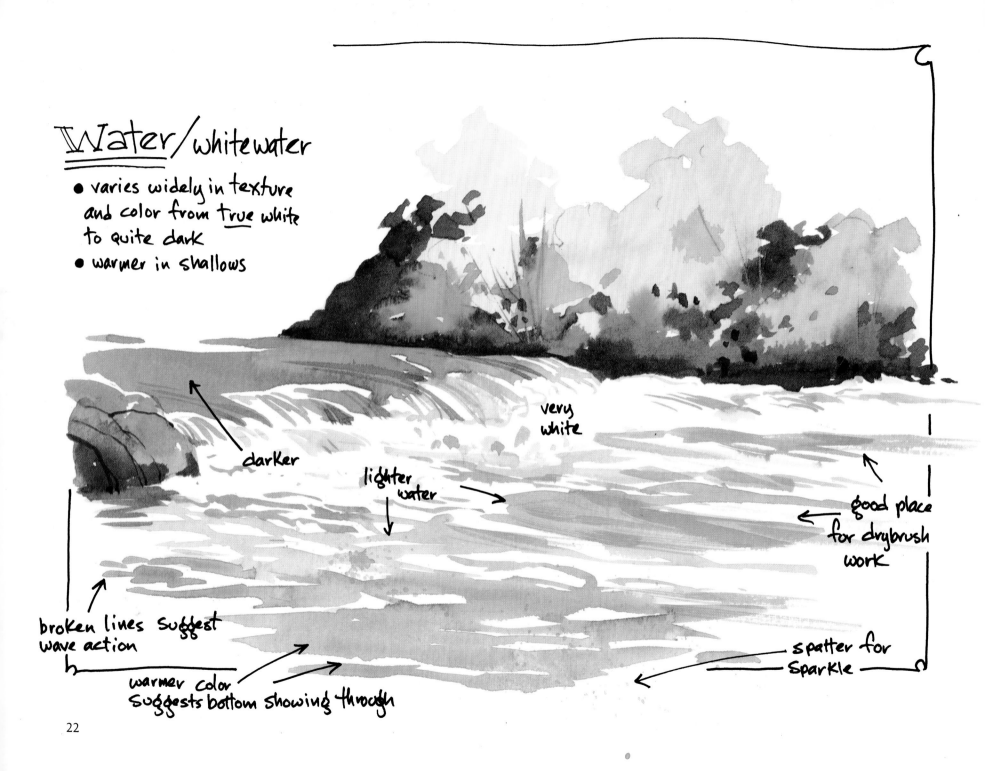

Water/whitewater

- varies widely in texture and color from true white to quite dark
- warmer in shallows

darker

very white

lighter water

good place for drybrush work

broken lines suggest wave action

warmer color suggests bottom showing through

spatter for sparkle

22

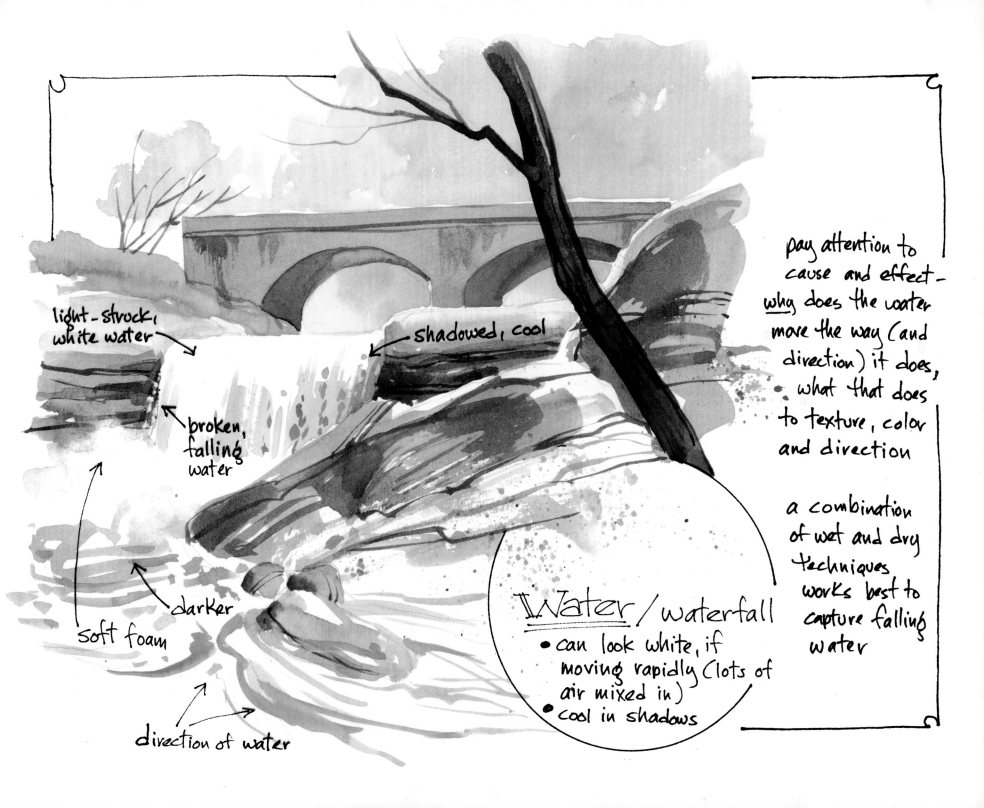

light-struck, white water

shadowed, cool

broken, falling water

darker

soft foam

direction of water

pay attention to cause and effect — why does the water move the way (and direction) it does, what that does to texture, color and direction

a combination of wet and dry techniques works best to capture falling water

Water/waterfall
- can look white, if moving rapidly (lots of air mixed in)
- cool in shadows

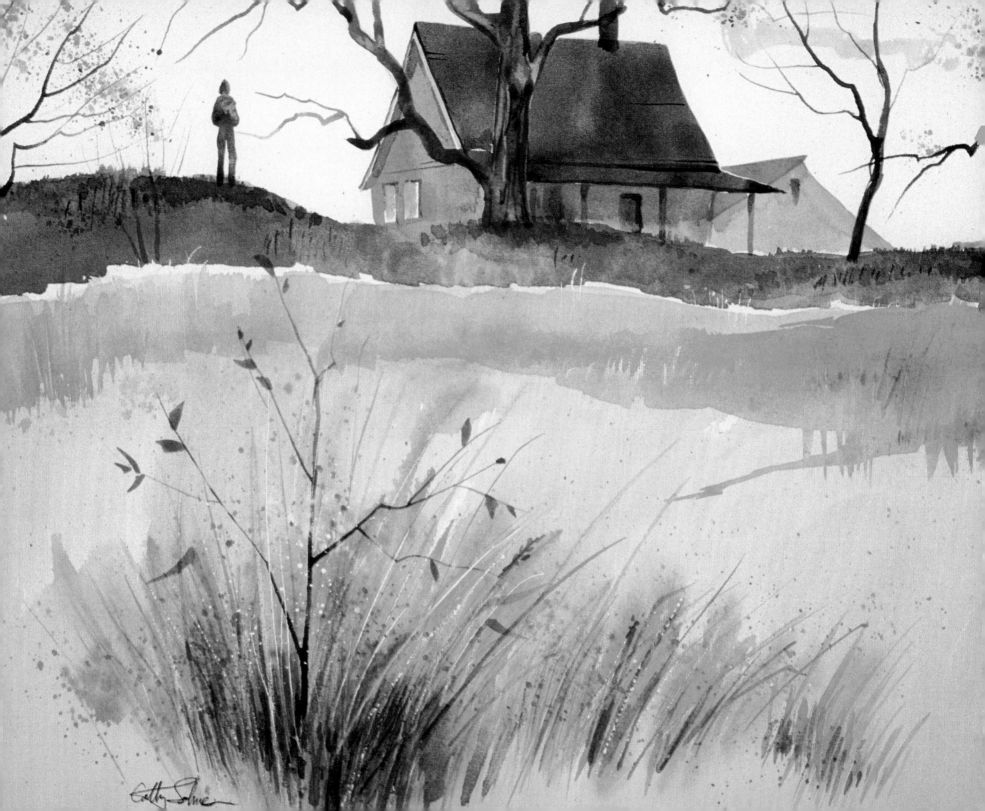

FOLIAGE

Did you ever notice how much of landscape is made up of foliage? Trees, bushes, shrubs—they all have leaves (or needles) at most seasons of the year. Unless you are painting a seascape, you're going to face the question of just *how* you want to handle this challenge—even in the desert there is the low-growing foliage of creosote and rabbit bush. Then there's the question of distance: If the foliage you paint is in the background, you'll simplify elements, just hinting at texture; if it's the stuff of your foreground, you'll want to pay close attention to how individual leaf shapes affect the overall results. Middle ground foliage is a compromise of suggested detail and simplified texture.

There are a number of ways to approach the subject—wet-in-wet, scumbling, drybrush details. Try a natural sponge to lay in the leafy forms, constantly turning the sponge to vary the surface you touch to your paper. Or spatter the pigment through a hand-torn stencil; if you prefer, just direct it carefully from a stiff brush. I prefer an inexpensive stencil brush, but an old oil-painting bristle brush works as well.

As the seasons change, so does your challenge. The sparse young leaves of early spring may be handled in one way (spatter? drybrush?), the full-blown, lusty foliage of July in another. Deciduous trees that lose their foliage look one way; evergreen another. Try out these techniques, or mix and match to best fit the situation you find yourself in.

Remember what you're looking at: hundreds of thousands of individual leaves on each tree—millions, perhaps. There's no way to paint each one, so you're free to take off from there and experiment to capture the *feeling* of foliage.

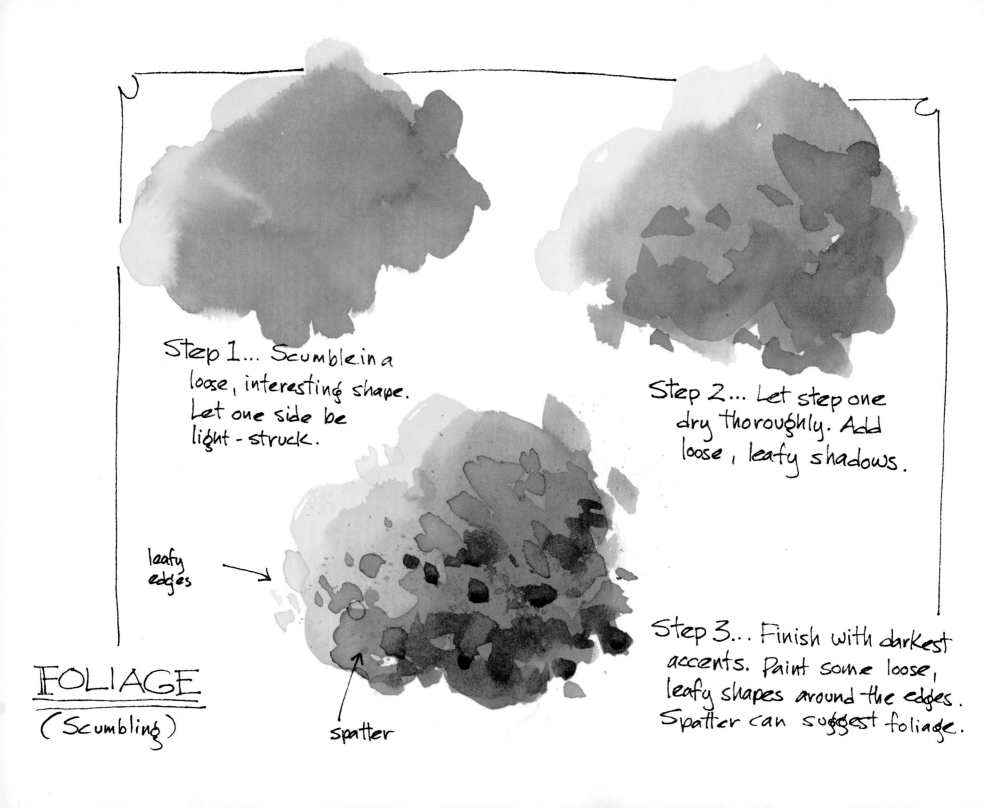

Step 1... Scumble in a loose, interesting shape. Let one side be light-struck.

Step 2... Let step one dry thoroughly. Add loose, leafy shadows.

leafy edges

spatter

Step 3... Finish with darkest accents. Paint some loose, leafy shapes around the edges. Spatter can suggest foliage.

FOLIAGE
(Scumbling)

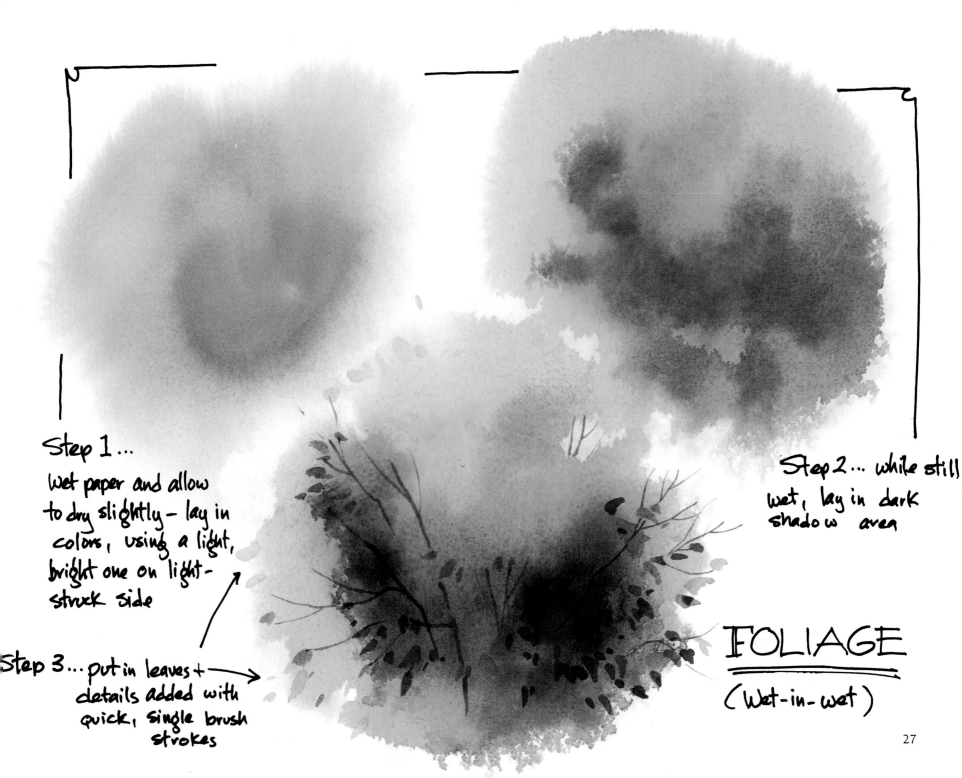

Step 1...
Wet paper and allow
to dry slightly — lay in
colors, using a light,
bright one on light-
struck side

Step 3...put in leaves +
details added with
quick, single brush
strokes

Step 2... while still
wet, lay in dark
shadow area

FOLIAGE
(Wet-in-wet)

27

lots of variation

Step 1... wet sponge in pigment, using your lightest color

Spattered foliage works well, too, either freehand or directed through a torn mask or stencil. Use alone or in addition to other methods.

Step 2... mix plenty of medium-value pigment & develop shape, turning sponge for variety

FOLIAGE
(Natural Sponge)

Step 3... use a strong, rich hue for shadows, since the color dilutes in the super-absorbent sponge

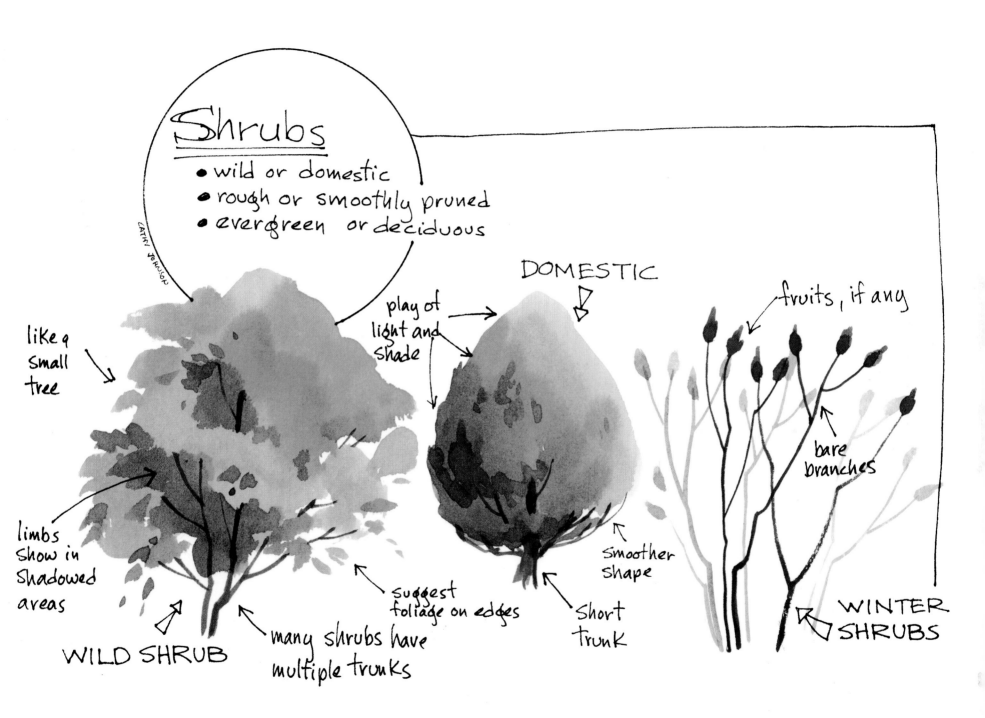

Shrubs

- wild or domestic
- rough or smoothly pruned
- evergreen or deciduous

CATHY JOHNSON

DOMESTIC

fruits, if any

like a small tree

play of light and shade

limbs show in shadowed areas

suggest foliage on edges

Smoother shape

bare branches

Short Trunk

WILD SHRUB

many shrubs have multiple trunks

WINTER SHRUBS

29

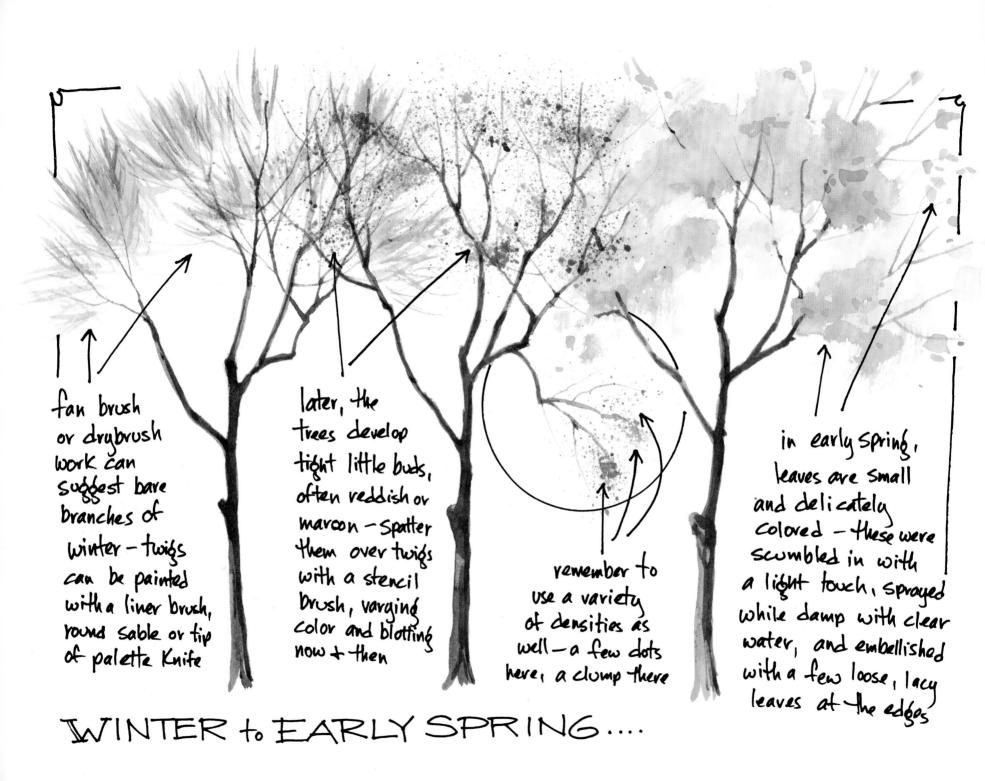

fan brush
or drybrush
work can
suggest bare
branches of
winter — twigs
can be painted
with a liner brush,
round sable or tip
of palette knife

later, the
trees develop
tight little buds,
often reddish or
maroon — spatter
them over twigs
with a stencil
brush, varying
color and blotting
now + then

remember to
use a variety
of densities as
well — a few dots
here, a clump there

in early spring,
leaves are small
and delicately
colored — these were
scumbled in with
a light touch, sprayed
while damp with clear
water, and embellished
with a few loose, lacy
leaves at the edges

WINTER to EARLY SPRING....

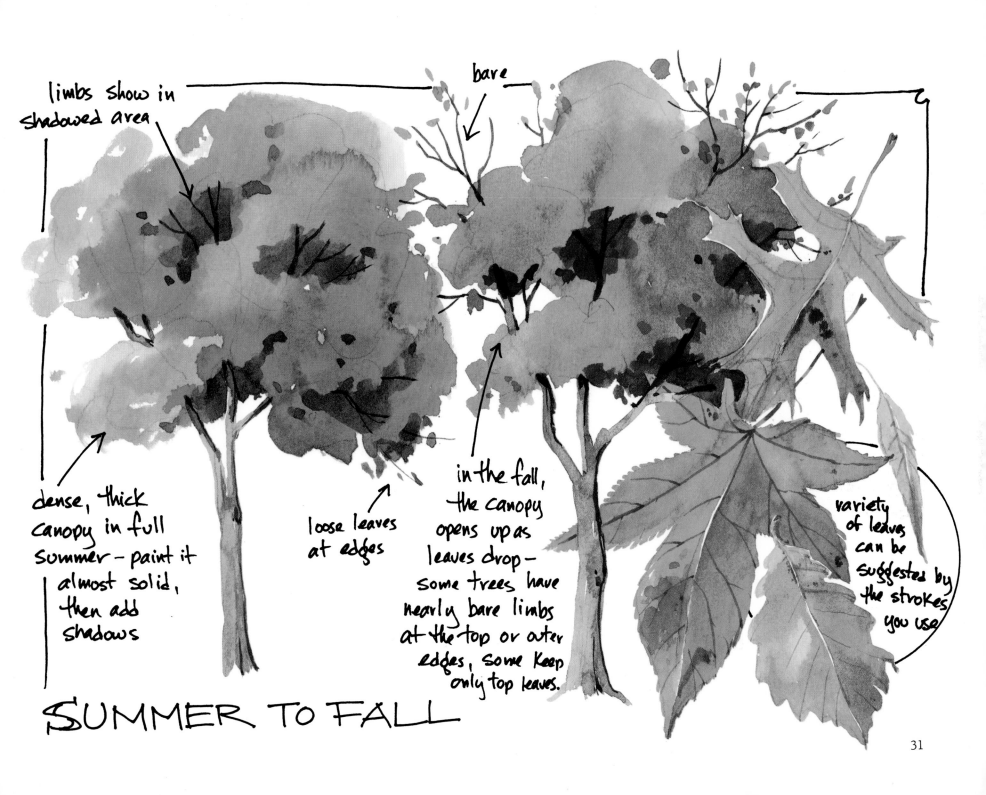

limbs show in
shadowed area

bare

dense, thick
canopy in full
summer – paint it
almost solid,
then add
shadows

loose leaves
at edges

in the fall,
the canopy
opens up as
leaves drop –
some trees have
nearly bare limbs
at the top or outer
edges, some keep
only top leaves.

variety
of leaves
can be
suggested by
the strokes
you use

SUMMER TO FALL

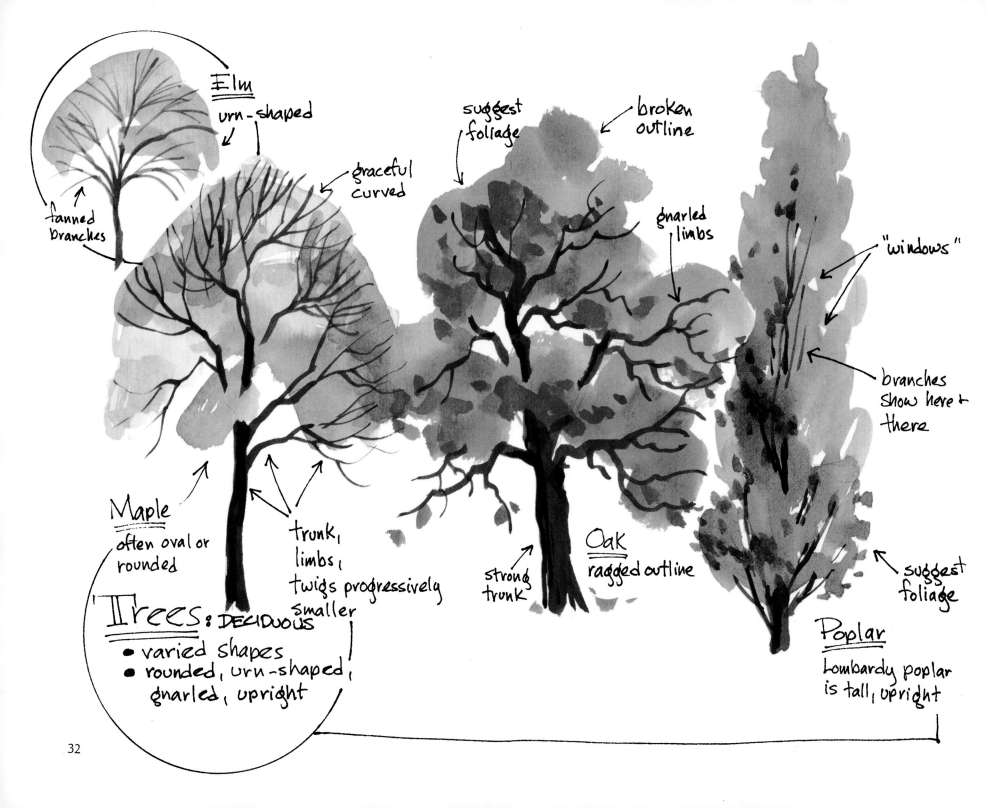

Elm
urn-shaped

fanned branches

graceful curved

suggest foliage

broken outline

gnarled limbs

"windows"

branches show here & there

Maple
often oval or rounded

trunk, limbs, twigs progressively smaller

Oak
ragged outline

strong trunk

suggest foliage

Poplar
Lombardy poplar is tall, upright

Trees: DECIDUOUS
• varied shapes
• rounded, urn-shaped, gnarled, upright

32

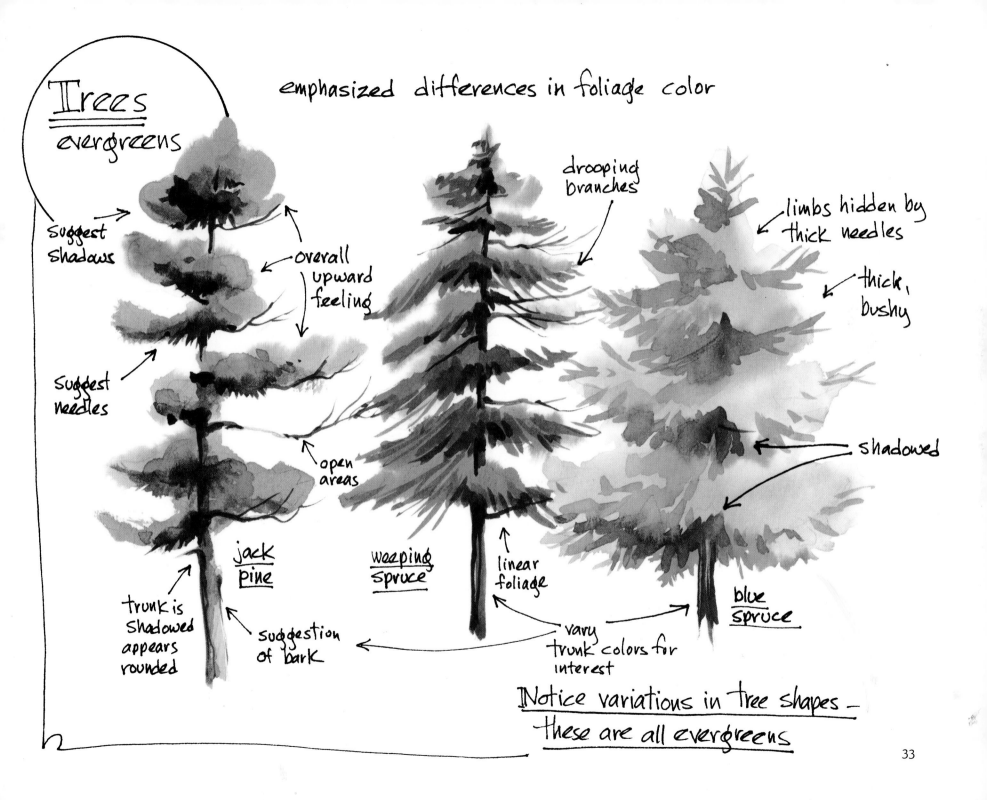

Trees
evergreens

emphasized differences in foliage color

suggest shadows

overall upward feeling

drooping branches

limbs hidden by thick needles

thick, bushy

suggest needles

open areas

shadowed

jack pine

weeping spruce

linear foliage

blue spruce

trunk is shadowed appears rounded

suggestion of bark

vary trunk colors for interest

Notice variations in tree shapes — these are all evergreens

33

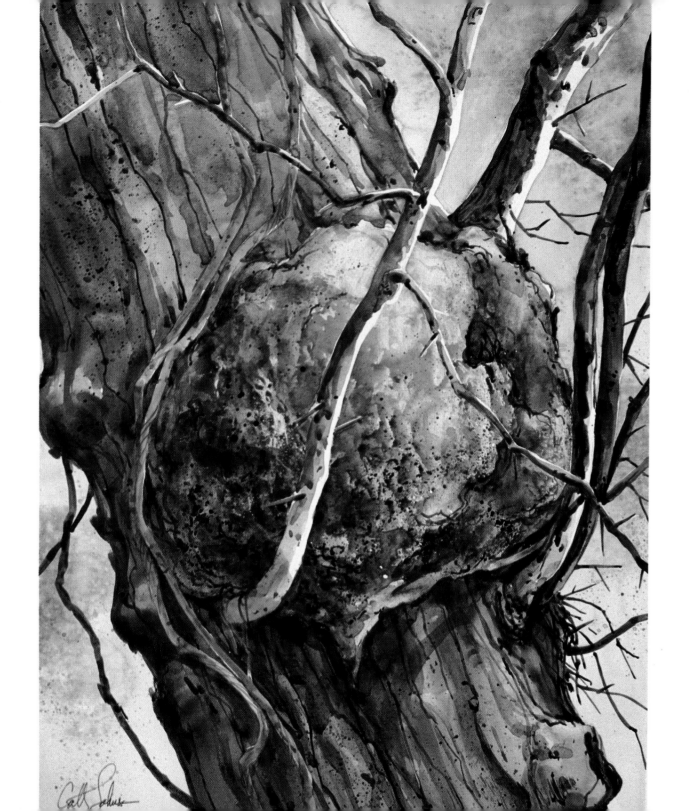

TREE BARK

Painting trees is more than a matter of how you depict foliage, of course. Each species of tree has a unique and characteristic growth habit and a bark pattern devised to protect the tree from insect damage and the ravages of weather. This corky bark acts as insulation and armor.

From a distance, bark textures can be merely suggested — or ignored altogether if the trees are in the background. For those trees close enough to begin to differentiate themselves from the masses, a few lines added to the overall wash will be sufficient. But if you are working in close-up, bark patterns take on additional importance. They lend interest, believability and tactile sense. If your painting is based in realism, these bark textures become of paramount importance.

In this chapter, we will cover six of the most distinctive bark patterns: cottonwood, shagbark, birch, oak, sycamore and cedar. From these few, you'll find similarities to draw on — oak is not that different from walnut, paloverde has something in common with birch. We'll suggest ways to handle bark up close or at a distance and explore the possibilities of drybrush. With your own careful observations you'll be able to easily adapt the basic techniques to suit the situation.

Locust Gall 15" × 22"

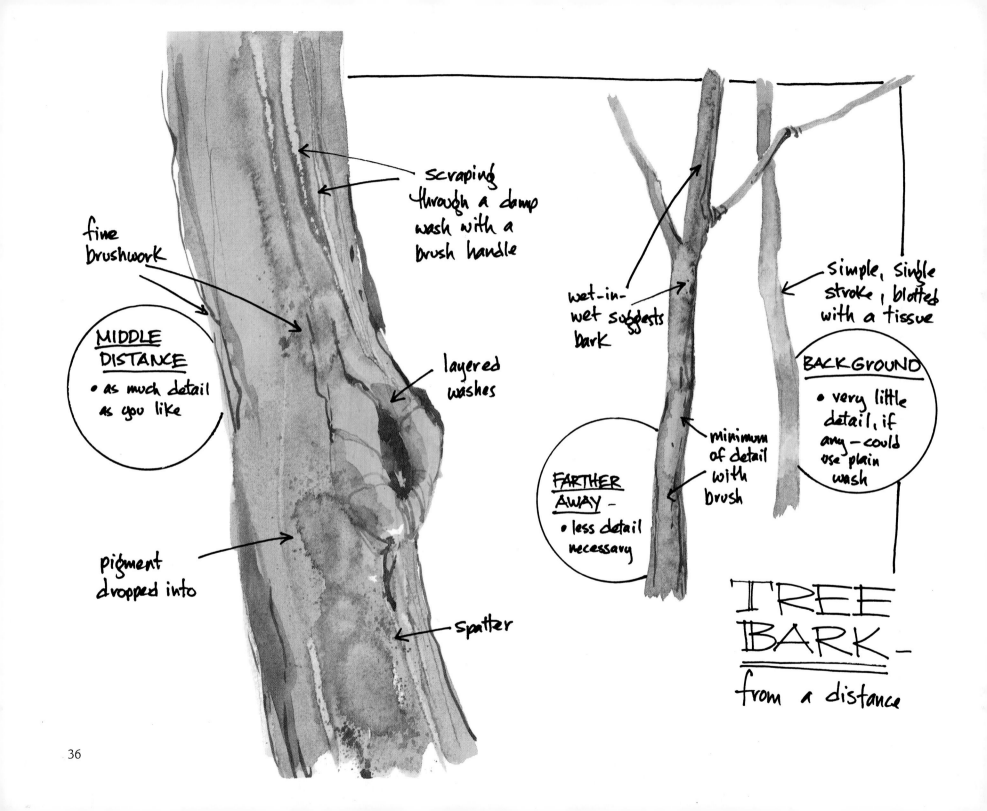

scraping
through a damp
wash with a
brush handle

fine
brushwork

MIDDLE
DISTANCE
• as much detail
 as you like

layered
washes

pigment
dropped into

spatter

wet-in-
wet suggests
bark

FARTHER
AWAY —
• less detail
 necessary

minimum
of detail
with
brush

Simple, Single
stroke, blotted
with a tissue

BACKGROUND
• very little
 detail, if
 any — could
 use plain
 wash

TREE
BARK —
from a distance

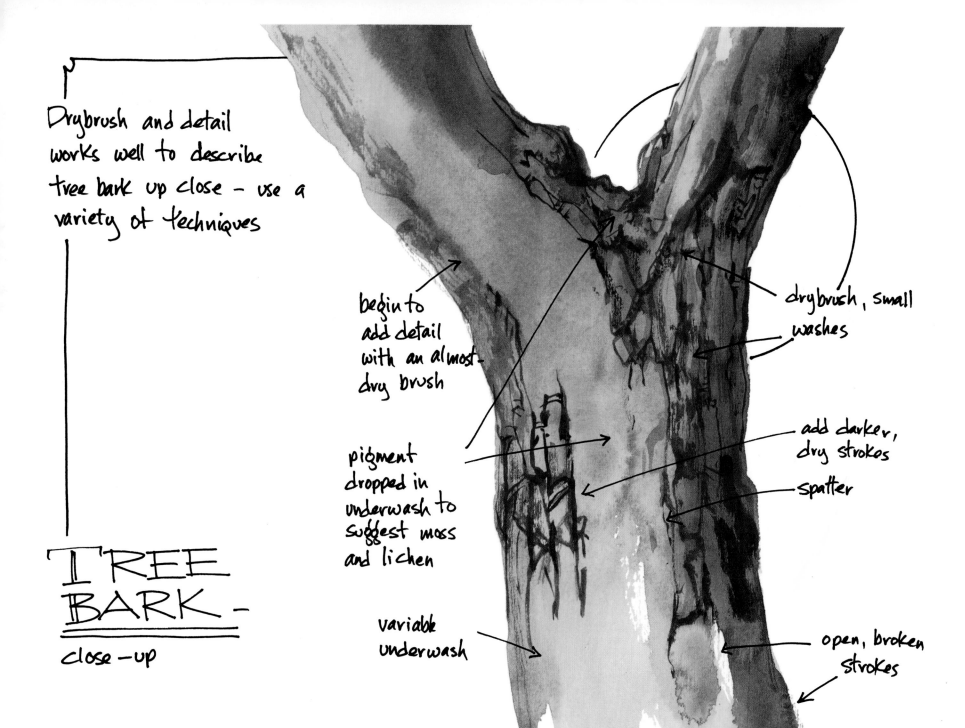

Drybrush and detail works well to describe tree bark up close – use a variety of techniques

begin to add detail with an almost-dry brush

drybrush, small washes

pigment dropped in underwash to suggest moss and lichen

add darker, dry strokes

spatter

TREE BARK –
close –up

variable underwash

open, broken strokes

37

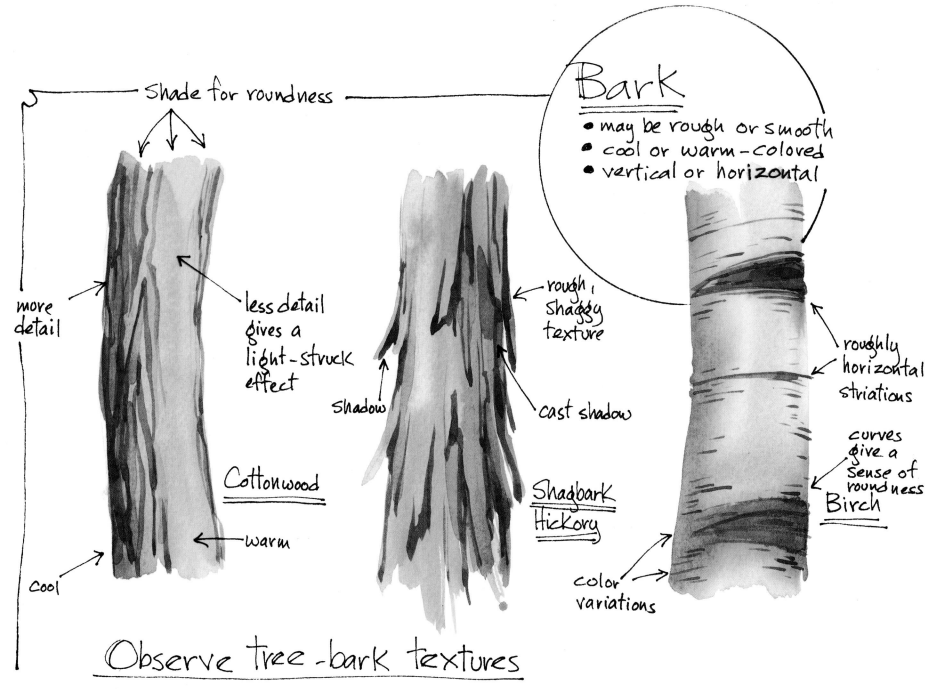

shade for roundness

Bark
- may be rough or smooth
- cool or warm-colored
- vertical or horizontal

more detail

less detail gives a light-struck effect

Cottonwood

warm

Cool

rough, shaggy texture

Shadow

cast shadow

Shagbark Hickory

roughly horizontal striations

curves give a sense of roundness

Birch

color variations

Observe tree-bark textures

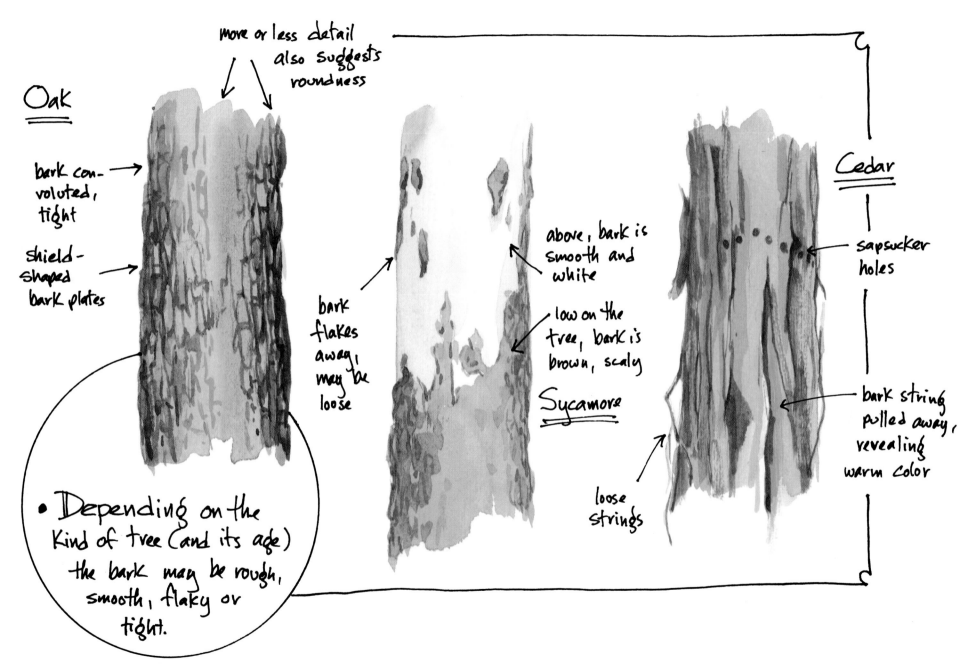

Oak

more or less detail
also suggests
roundness

bark con-
voluted,
tight

shield-
shaped
bark plates

• Depending on the
kind of tree (and its age)
the bark may be rough,
smooth, flaky or
tight.

bark
flakes
away,
may be
loose

above, bark is
smooth and
white

low on the
tree, bark is
brown, scaly

Sycamore

Cedar

sapsucker
holes

bark string
pulled away,
revealing
warm color

loose
strings

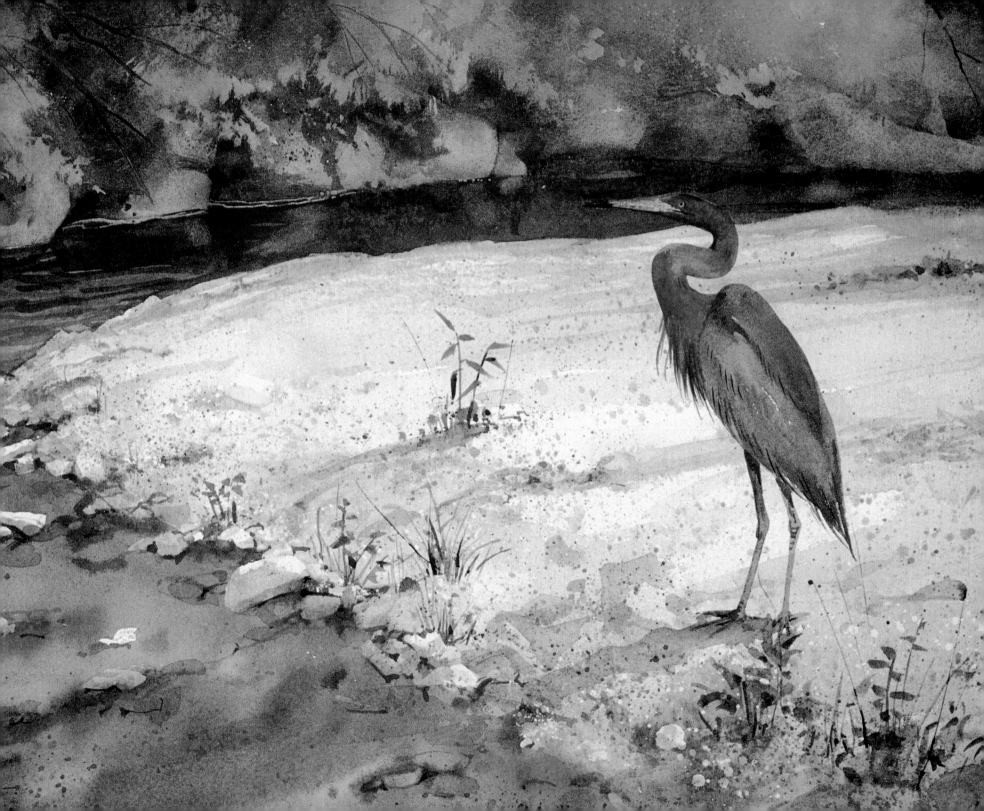

Chapter Six

EARTH, PEBBLES, SAND

The earth we stand on is too important to be ignored; how you choose to depict this resource can say much about the landscape you want to explore. Are you on a beach with sparkling white sand, in the South with its ruddy soil, or in the Midwest, with yard-deep glacial soils as rich and brown as chocolate? Has this once rich resource, on the other hand, eroded badly, faded with overuse or disappeared altogether? Do you want to suggest a sandy beach, a stubbly cornfield, a textural mixture of pebbles and dirt?

Oddly enough, foregrounds seem to be a stumbling block for many people. What kind of detail and how much are matters of much concern. In this chapter we will explore a number of ways of dealing with dirt—at a distance or up close, simplifying forms or adding as much detail as you like.

And although it may seem the obvious choice to use an earth color (burnt umber, raw umber, burnt sienna, raw sienna, yellow ochre) to paint the earth, remember to vary the flat, opaque pigment with color: subtle blue shadows, a rosy tinge in the sun, a sparkle of sand. Because even if the overall hue is one of the browns, the liveliness of this resource underfoot can be suggested with color to make a more interesting painting. Add these variations wet-in-wet or come back when dry with transparent glazes and your foregrounds will no longer trouble you; you'll direct the eye to an area as simple or as complex as you like; *you're* in control.

Dry Fork, Fishing River 22" × 30"

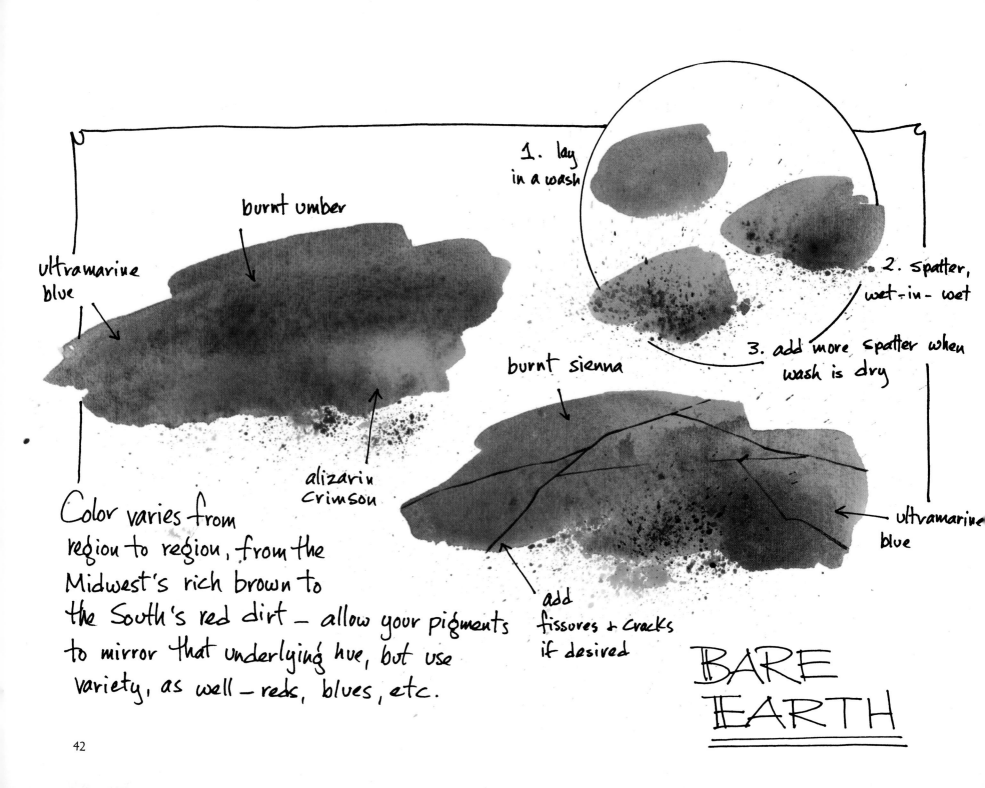

ultramarine
blue

burnt umber

1. lay
in a wash

2. spatter,
wet-in-wet

3. add more spatter when
wash is dry

burnt sienna

alizarin
crimson

ultramarine
blue

Color varies from
region to region, from the
Midwest's rich brown to
the South's red dirt — allow your pigments
to mirror that underlying hue, but use
variety, as well — reds, blues, etc.

add
fissures + cracks
if desired

BARE
EARTH

ROCKY EARTH OR GRAVEL

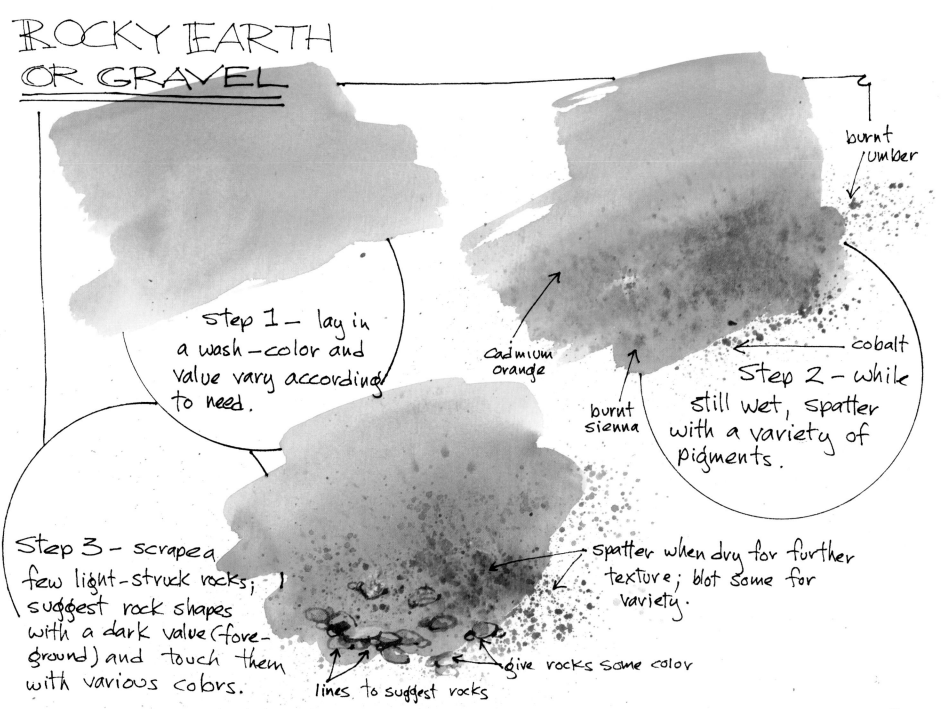

Step 1 — lay in a wash—color and value vary according to need.

Step 2 — while still wet, spatter with a variety of pigments.

burnt umber

cobalt

Cadmium orange

burnt sienna

Step 3 — scrape a few light-struck rocks; suggest rock shapes with a dark value (foreground) and touch them with various colors.

spatter when dry for further texture; blot some for variety.

give rocks some color

lines to suggest rocks

43

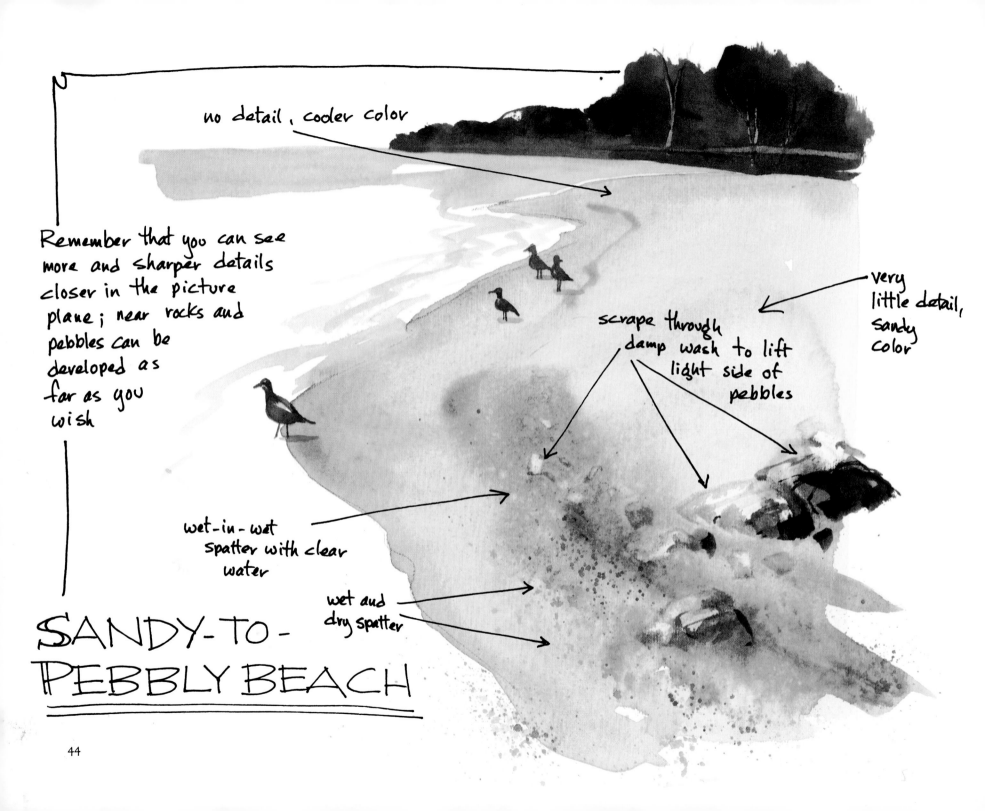

no detail, cooler color

Remember that you can see
more and sharper details
closer in the picture
plane; near rocks and
pebbles can be
developed as
far as you
wish

very
little detail,
sandy
color

scrape through
damp wash to lift
light side of
pebbles

wet-in-wet
spatter with clear
water

wet and
dry spatter

SANDY-TO-
PEBBLY BEACH

44

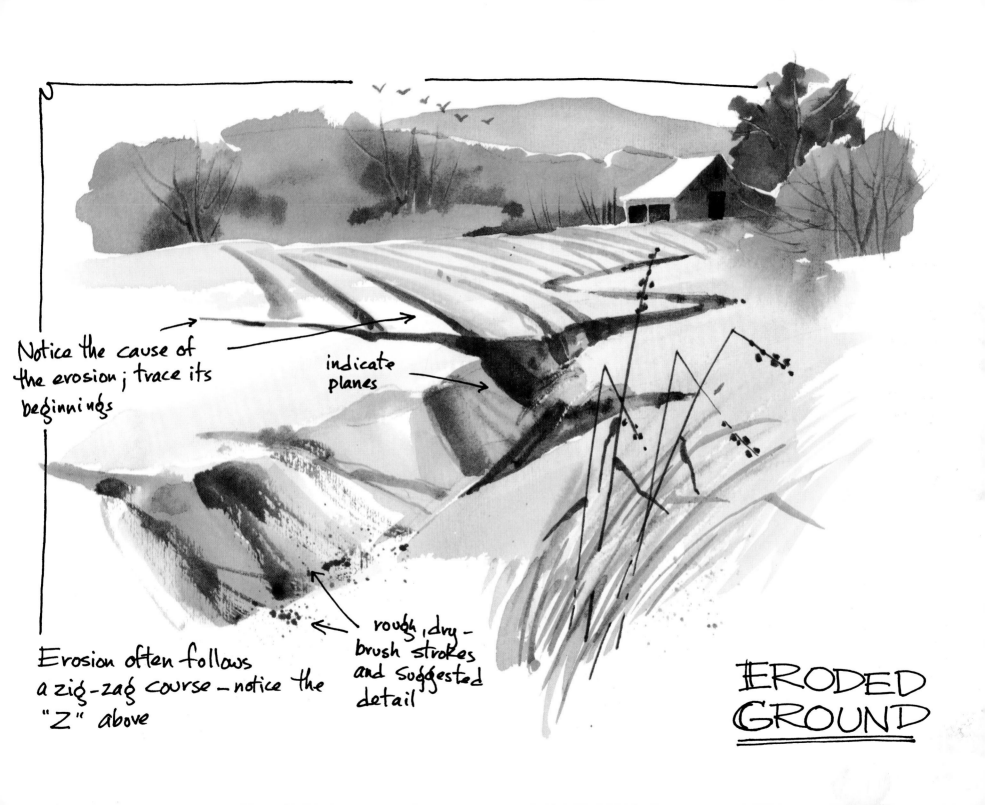

Notice the cause of
the erosion; trace its
beginnings

indicate
planes

Erosion often follows
a zig-zag course — notice the
"Z" above

rough, dry-
brush strokes
and suggested
detail

ERODED
GROUND

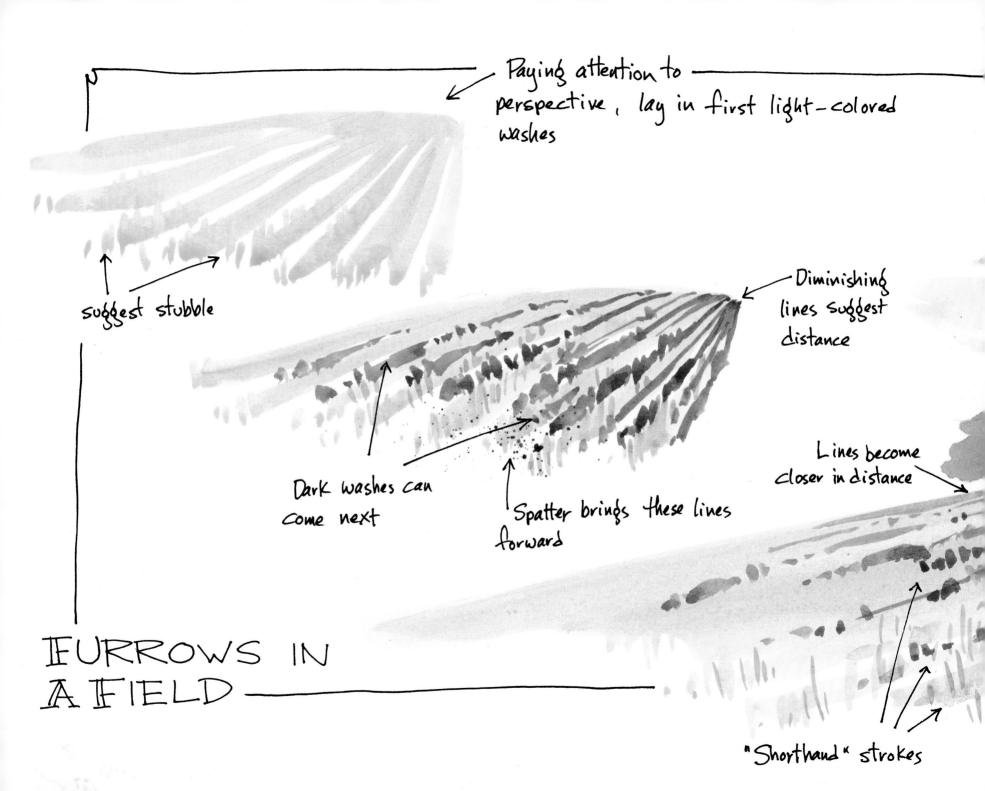

Paying attention to perspective, lay in first light-colored washes

suggest stubble

Diminishing lines suggest distance

Dark washes can come next

Spatter brings these lines forward

Lines become closer in distance

FURROWS IN A FIELD

"Shorthand" strokes

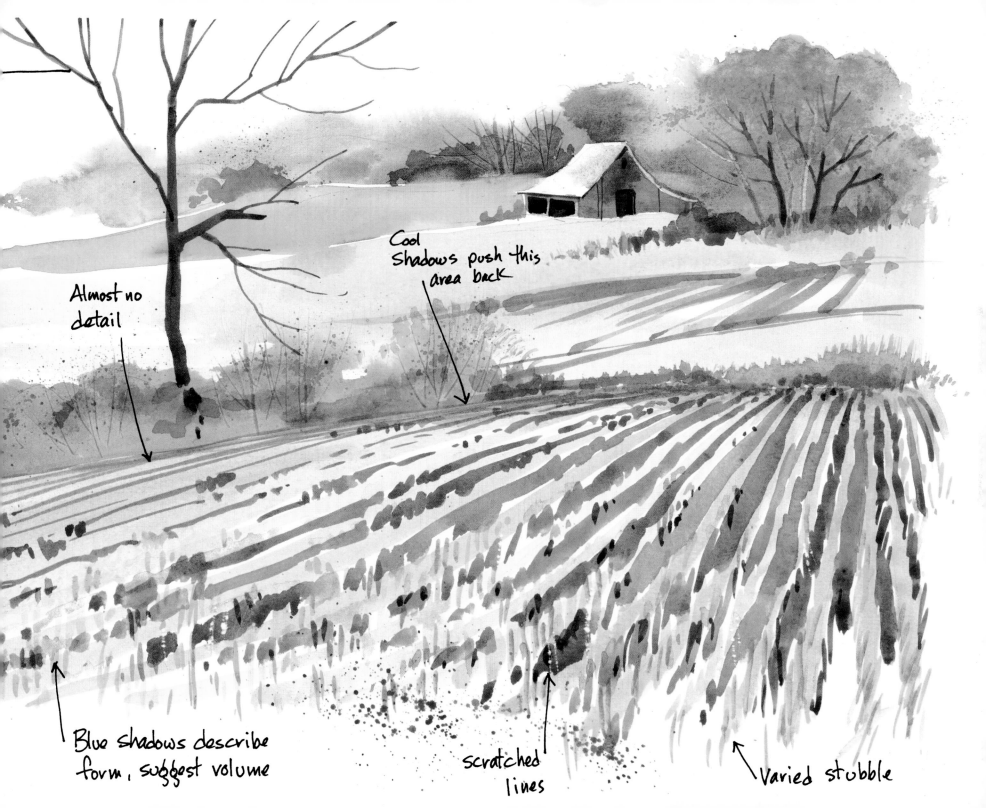

Almost no
detail

Cool
Shadows push this
area back

Blue shadows describe
form, suggest volume

scratched
lines

Varied stubble

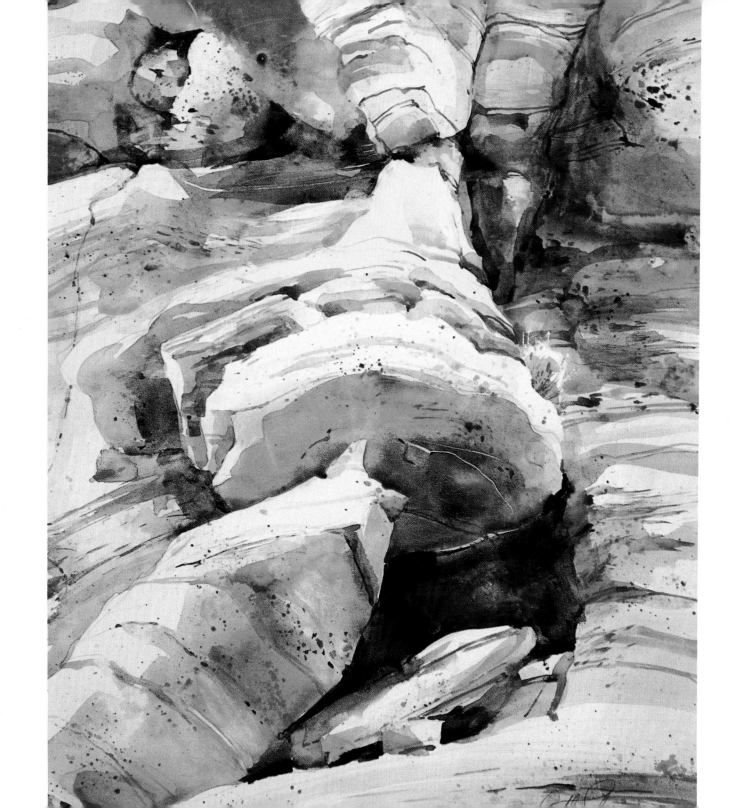

Chapter Seven

ROCKS

From a geologist's point of view, rocks are a wide-open subject—as many-colored as the rainbow, as richly textured as the sea. There are smooth rocks and rough rocks, rocks born in the liquid cauldron of a volcano or laid down over eons at the bottom of some prehistoric inland ocean. There are rocks sculpted by the wind or rounded by the patient action of water. There are rocks as pocked and punctuated as a sponge and rocks striated with delicate lines as fine as a feather's barbs. There are, in other words, as many forms and textures for the artist to explore as there are for the dedicated geologist—and as you can tell, this is one of my favorite subjects.

Capturing the varied forms of rocks, whether they are as faceted as a crystal or as voluptuously curved as a shoulder, is a constant challenge. It's necessary to pay attention not only to overall form but to the effects of light and shadow and how they help describe texture. But it's not as difficult as it sounds. Again, a logical approach can make even the most complex rock form easy to capture on paper: Look for the backbone of form first, *then* worry about detail.

Use color to give a sense of place—Nevada's redstone formations are very different from the pale, lichen-and-moss-painted limestone of northern Missouri, where I live. The Payne's gray rocks of coastal Maine—remnants of ancient volcanoes—and the pinkish glacial erratics of the upper Midwest are a pleasure to paint. Texture comes into play when colors are similar. The rugged, iron-stained limestone of the Missouri Ozarks is very different from the slick rocks of the Southwest's canyon lands, though both share a reddish hue.

And of course, we use rocks as a resource. Here, we've suggested several ways to depict the rock walls of an old building using the same principles, and thrown in a bit of brickwork while we're at it—these man-made "stones" may be more uniform than nature's rocks, but they can still challenge the artist.

Redstone 15" × 22"

49

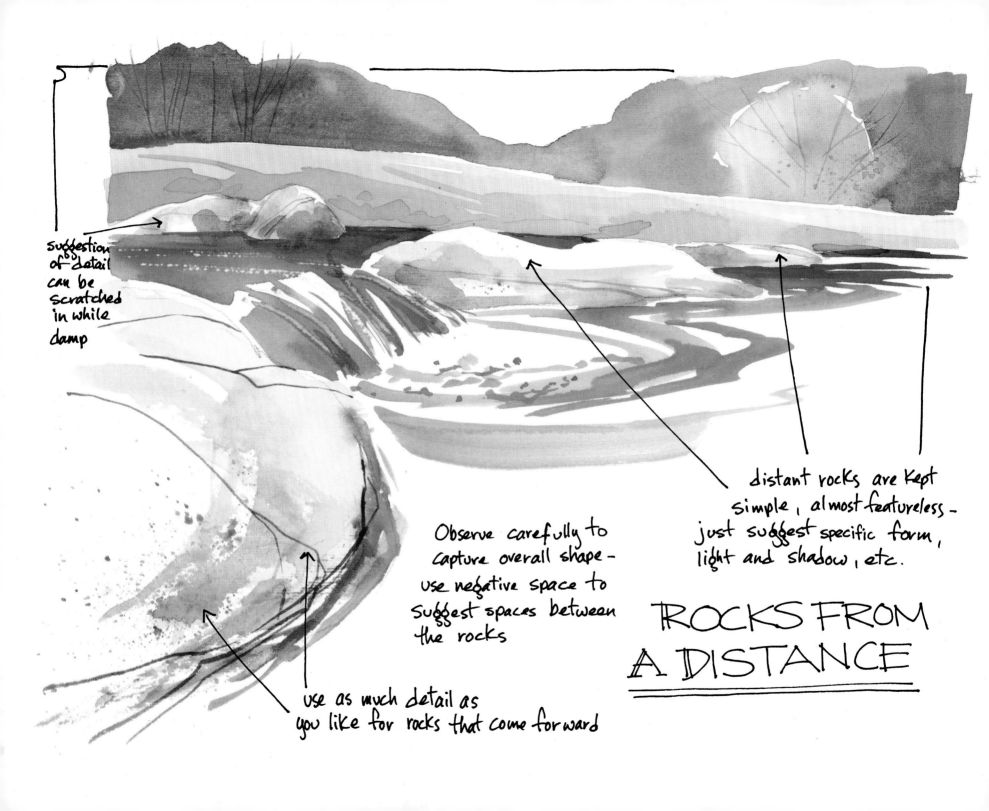

suggestion
of detail
can be
scratched
in while
damp

Observe carefully to
capture overall shape -
use negative space to
suggest spaces between
the rocks

distant rocks are kept
simple, almost featureless -
just suggest specific form,
light and shadow, etc.

ROCKS FROM
A DISTANCE

use as much detail as
you like for rocks that come forward

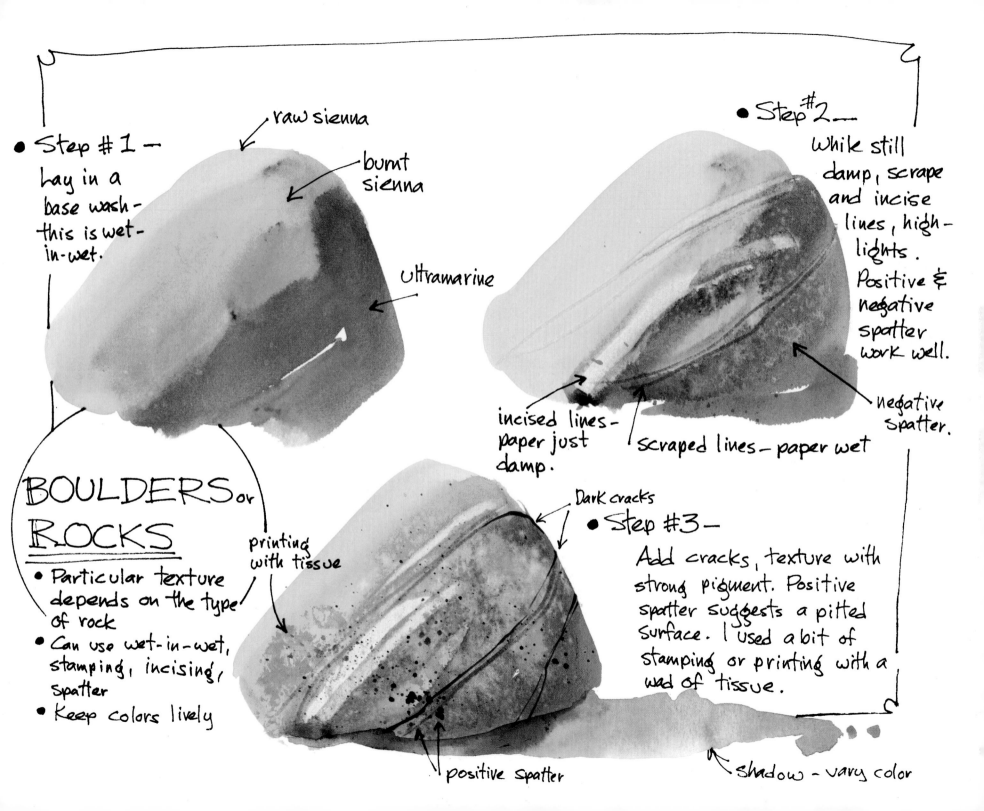

• Step #1 —
Lay in a base wash — this is wet-in-wet.

raw sienna

burnt sienna

Ultramarine

• Step #2 —
While still damp, scrape and incise lines, high-lights. Positive & negative spatter work well.

incised lines — paper just damp.

scraped lines — paper wet

negative spatter.

BOULDERS or ROCKS

• Particular texture depends on the type of rock
• Can use wet-in-wet, stamping, incising, spatter
• Keep colors lively

printing with tissue

Dark cracks

• Step #3 —
Add cracks, texture with strong pigment. Positive spatter suggests a pitted surface. I used a bit of stamping or printing with a wad of tissue.

positive spatter

shadow — vary color

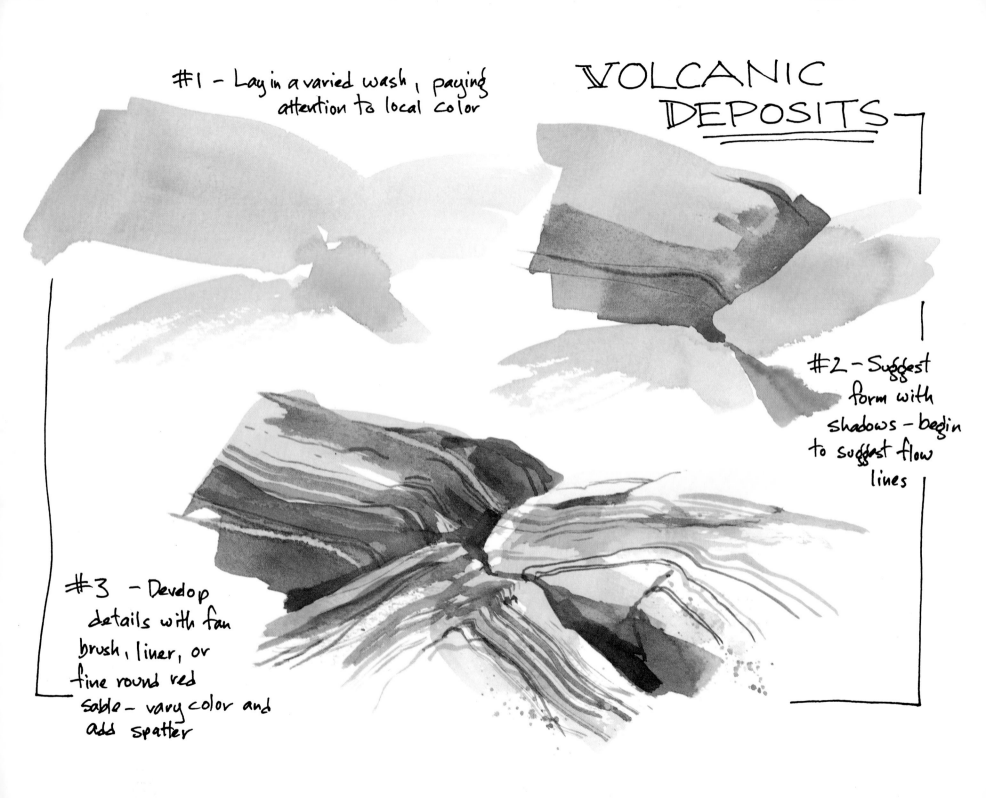

#1 - Lay in a varied wash, paying attention to local color

VOLCANIC DEPOSITS

#2 - Suggest form with shadows - begin to suggest flow lines

#3 - Develop details with fan brush, liner, or fine round red sable - vary color and add spatter

SANDSTONE

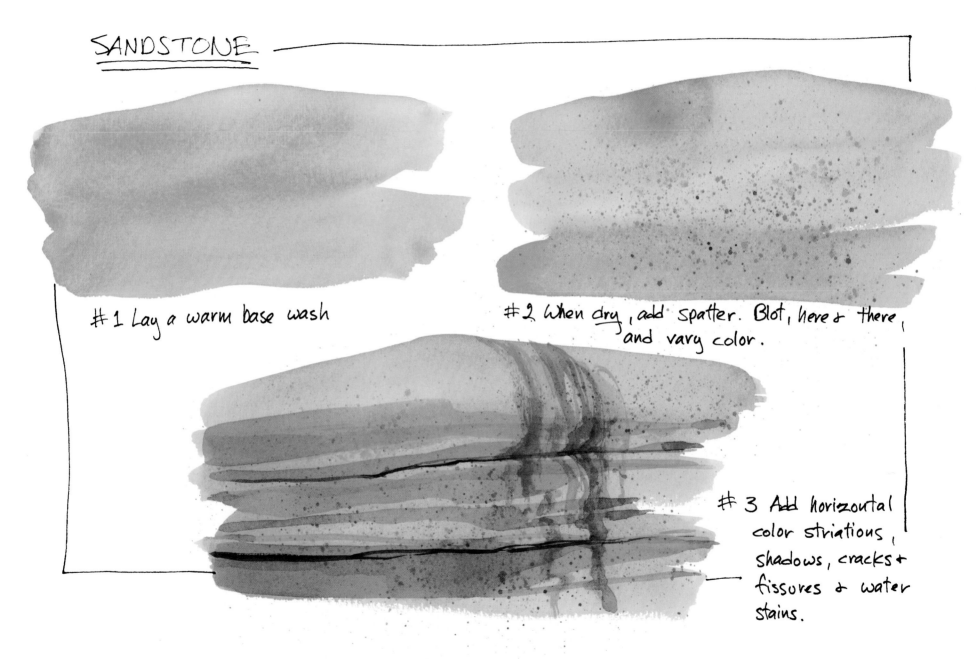

#1 Lay a warm base wash

#2 When dry, add spatter. Blot, here & there and vary color.

#3 Add horizontal color striations, shadows, cracks & fissures & water stains.

LIMESTONE ROCKS

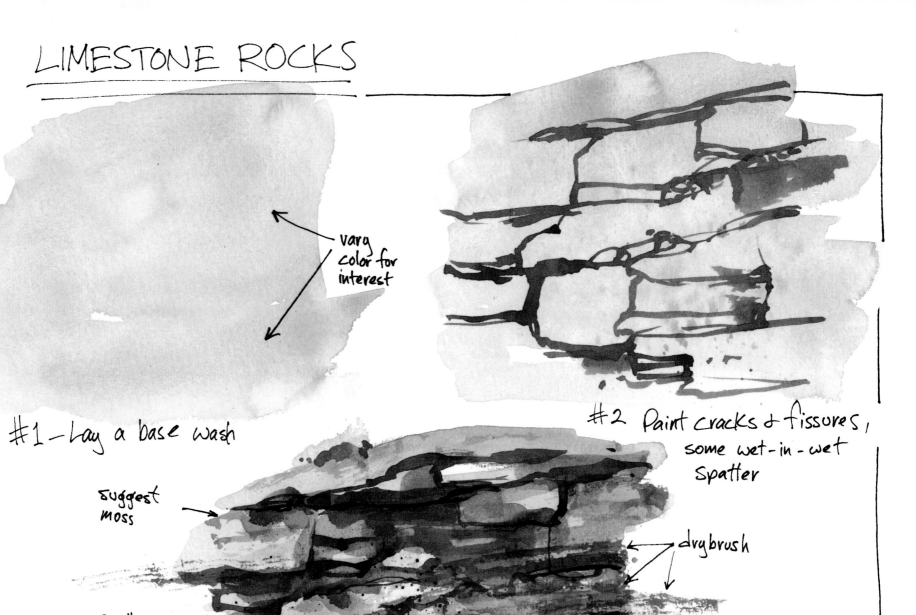

vary color for interest

#1 — Lay a base wash

#2 Paint cracks & fissures, some wet-in-wet spatter

suggest moss

Spatter

drybrush

#3 Add shadows, using variations of warm & cool for tension. More spatter, more deep fissures, some dry brush

54

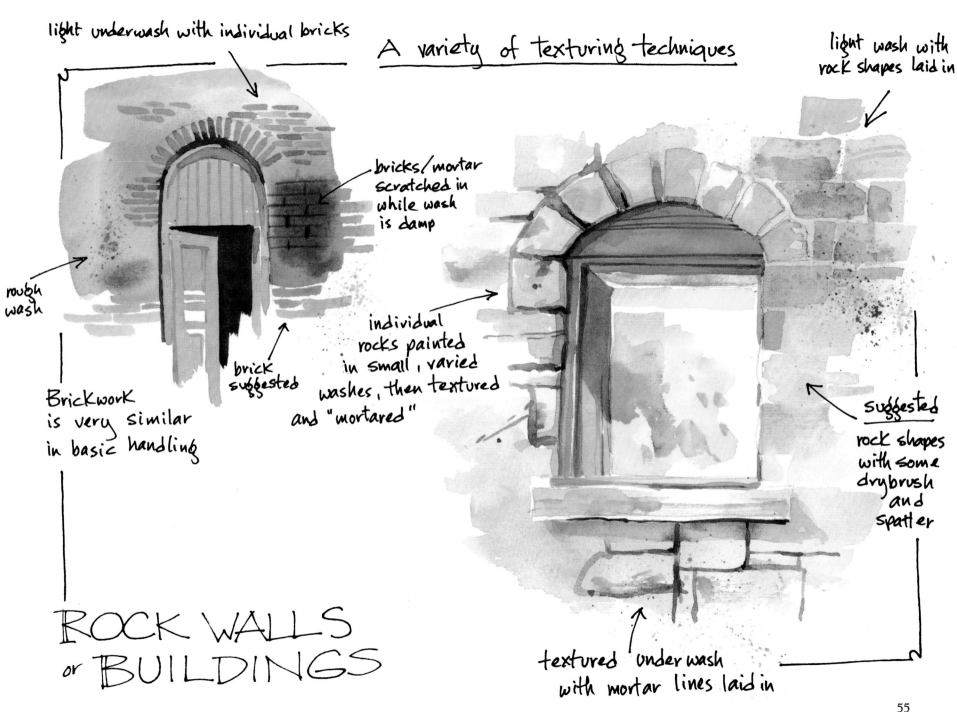

light underwash with individual bricks

A variety of texturing techniques

light wash with rock shapes laid in

bricks/mortar scratched in while wash is damp

rough wash

brick suggested

individual rocks painted in small, varied washes, then textured and "mortared"

suggested rock shapes with some drybrush and spatter

Brickwork is very similar in basic handling

ROCK WALLS or BUILDINGS

textured under wash with mortar lines laid in

55

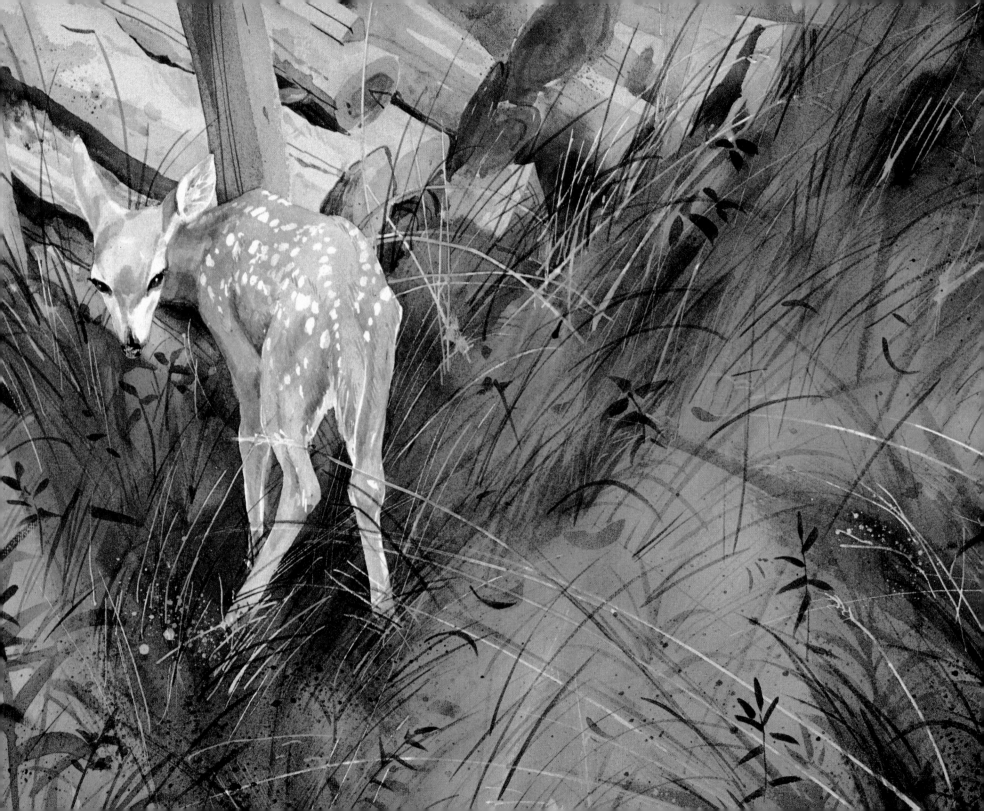

GRASSES AND WEEDS

From the manicured lawns of a proud old neighborhood to a field on its unkempt way to becoming a young forest, grasses and weeds provide texture and color underfoot. You can use as much or as little detail as you like to get your point across. In the distance, a well-kept lawn may be suggested by a simple, smooth wash of color; on the other hand, rough foreground weeds provide a woven tapestry of linear forms. It's a challenge, but not an insurmountable one.

A kaleidoscope of ways exists to suggest this richness. A fan brush can be manipulated to depict everything from a fine, smooth lawn to a rugged, windswept meadow. A sponge can add still more texture. You can even paint with a frayed bit of rope. Maskoid can keep some areas lighter for tonal variations, and spatter can suggest a multitude of forms. Wet-in-wet handling will give you softer shapes, suggesting distance; drybrush work brings detail into sharp focus.

Use directional strokes to direct the eye into the picture plane or make an "arrow" of a clump of grass; redirect with a few well-placed leaves. Try the Winslow Homer approach and embellish a smooth wash with a few individual blades. Unify foregrounds with these grassy textures. It's all in what you want to say and how much importance you want this area of your painting to claim.

Andy's Fawn 15" × 22"

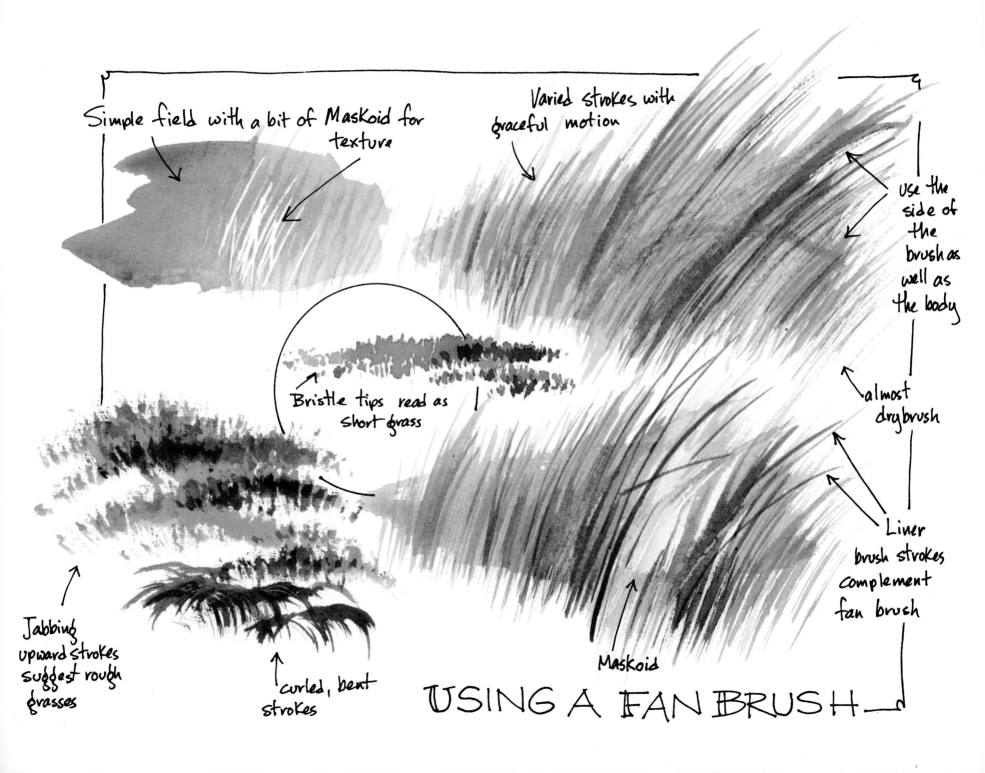

Simple field with a bit of Maskoid for texture

Varied strokes with graceful motion

Use the side of the brush as well as the body

Bristle tips read as short grass

almost drybrush

Liner brush strokes complement fan brush

Jabbing upward strokes suggest rough grasses

curled, bent strokes

Maskoid

USING A FAN BRUSH

GRASS-TWO VERSIONS

varied
underwash

Winslow Homer-
style

leaf & weed
shapes

suggest a few
blades of grass

spatter, both
positive (pigment) and
negative (clear water)

varied
underwash

short, choppy
strokes for grass
(fan brush)

fan brush

texture stamped
on with Saran Wrap

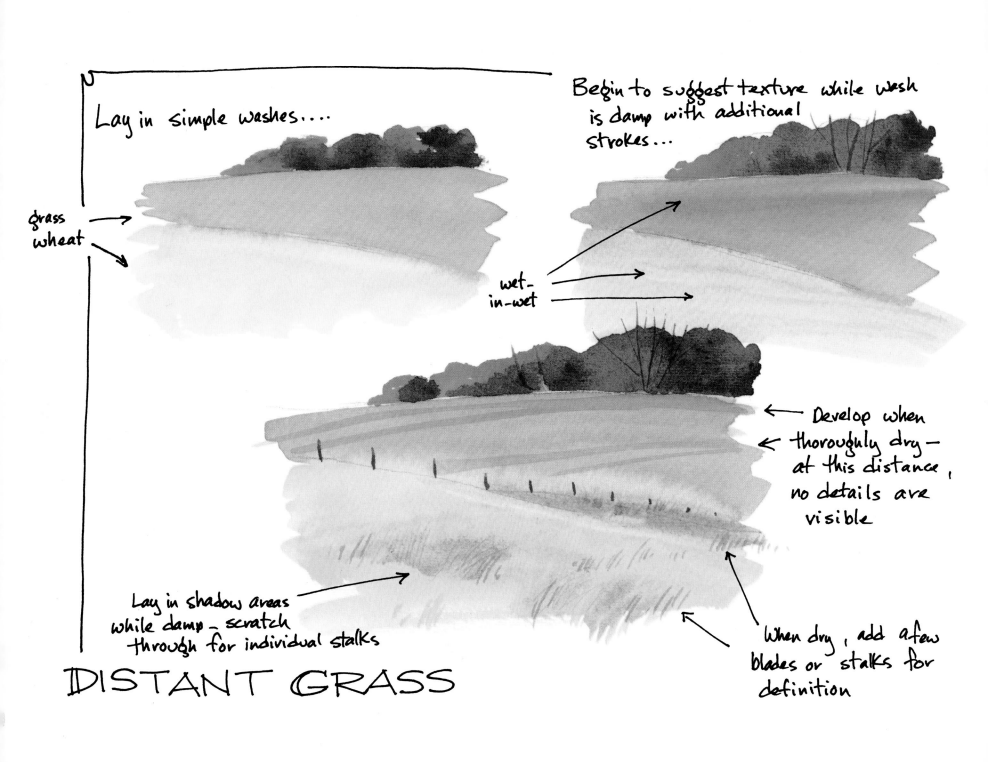

Lay in simple washes....

grass
wheat

Begin to suggest texture while wash
is damp with additional
strokes...

wet-
in-wet

Develop when
thoroughly dry —
at this distance,
no details are
visible

Lay in shadow areas
while damp — scratch
through for individual stalks

When dry, add a few
blades or stalks for
definition

DISTANT GRASS

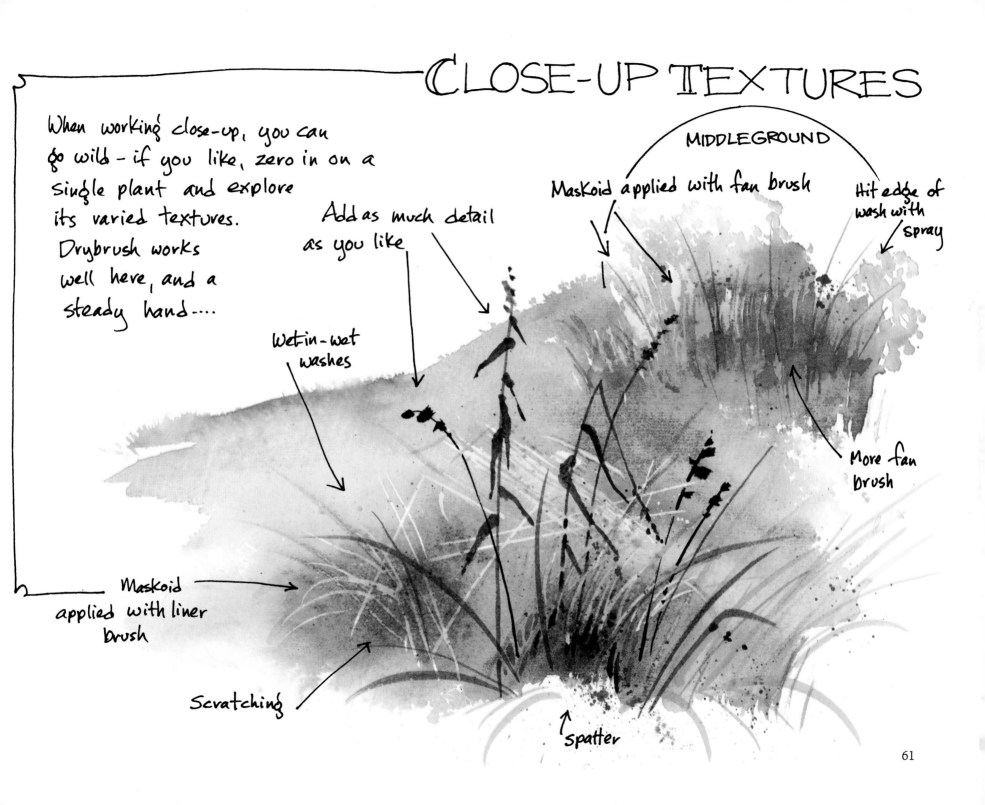

When working close-up, you can
go wild – if you like, zero in on a
single plant and explore
its varied textures.
Drybrush works
well here, and a
steady hand....

Add as much detail
as you like

MIDDLEGROUND

Maskoid applied with fan brush

Hit edge of
wash with
spray

Wet-in-wet
washes

More fan
brush

Maskoid
applied with liner
brush

Scratching

spatter

61

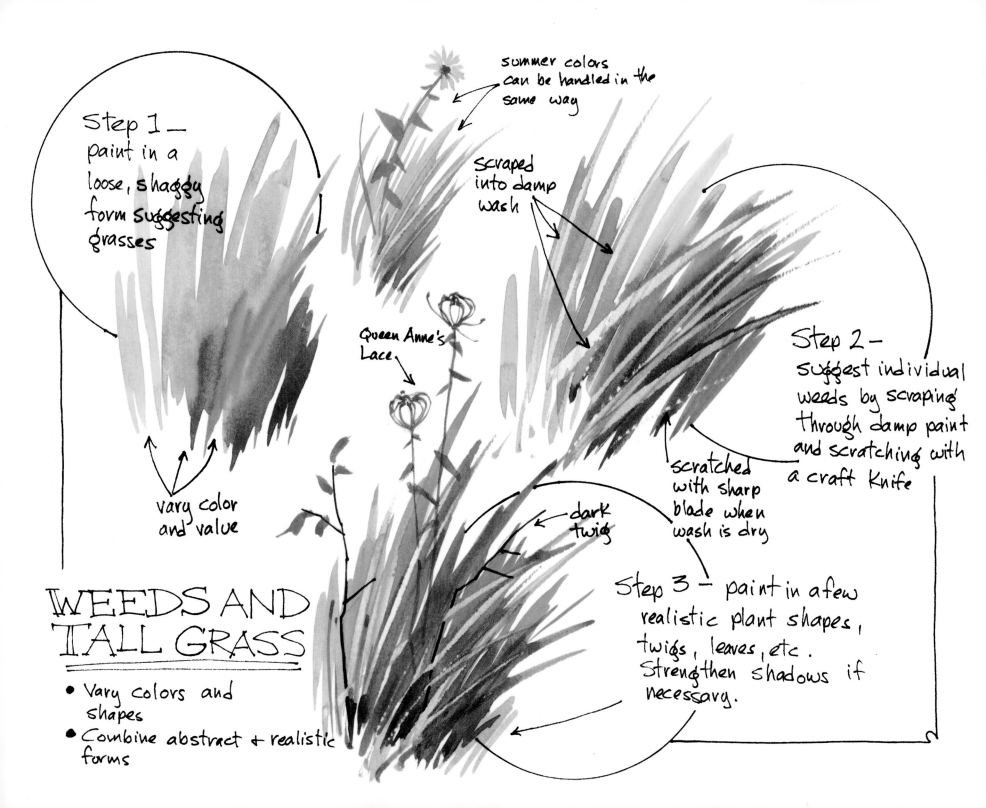

summer colors can be handled in the same way

Step 1 — paint in a loose, shaggy form suggesting grasses

scraped into damp wash

Queen Anne's Lace

vary color and value

Step 2 — suggest individual weeds by scraping through damp paint and scratching with a craft knife

scratched with sharp blade when wash is dry

dark twig

Step 3 — paint in a few realistic plant shapes, twigs, leaves, etc. Strengthen shadows if necessary.

WEEDS AND TALL GRASS

- Vary colors and shapes
- Combine abstract + realistic forms

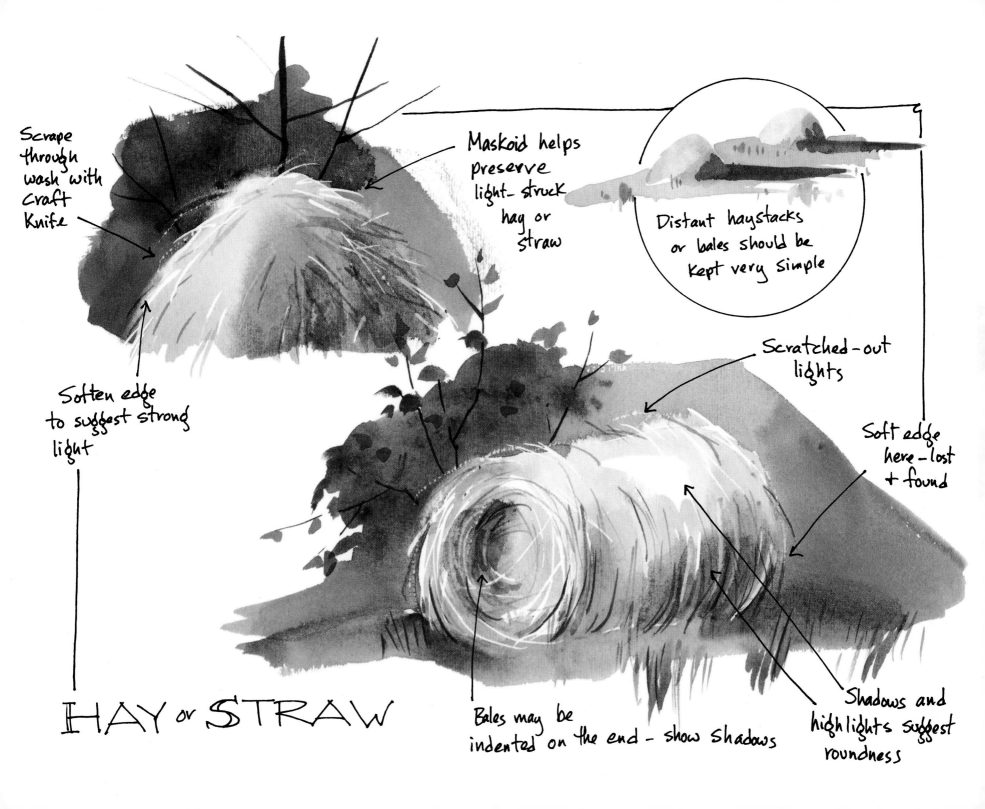

Scrape through wash with Craft Knife

Maskoid helps preserve light-struck hay or straw

Distant haystacks or bales should be kept very simple

Soften edge to suggest strong light

Scratched-out lights

Soft edge here - lost + found

HAY or STRAW

Bales may be indented on the end - show shadows

Shadows and highlights suggest roundness

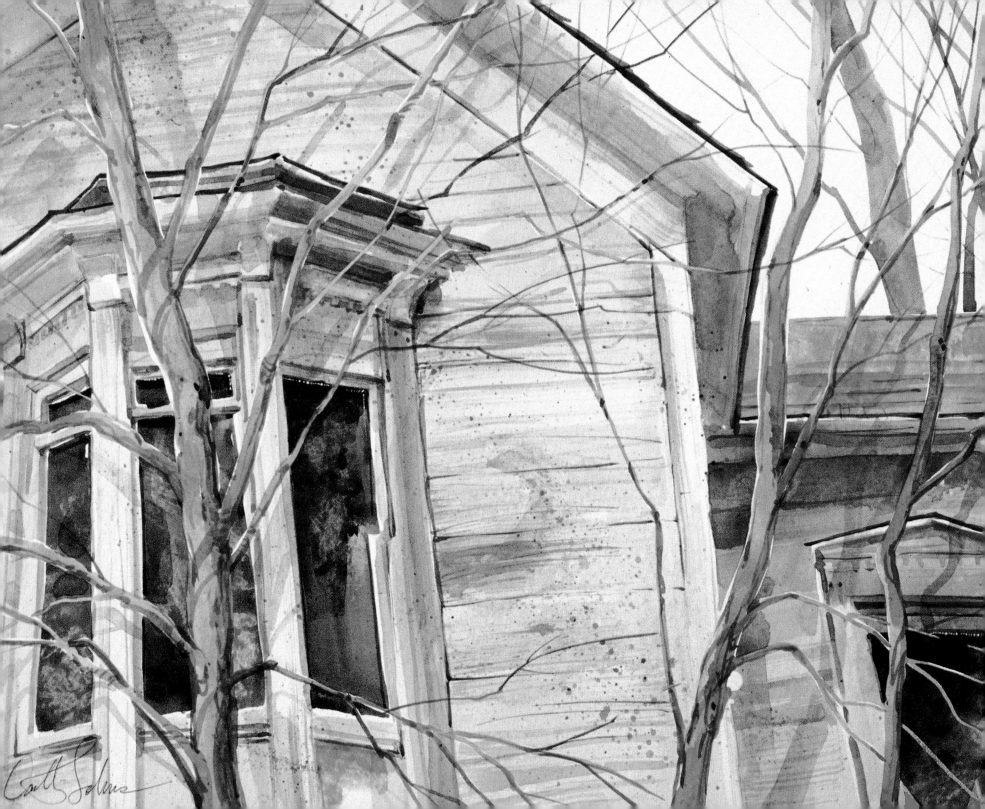

WEATHERED WOOD

Capturing the texture of old wood is one of the most satisfying tricks the watercolorist can pull off. When it's right, it conveys a sense of antiquity and perseverance—you suggest a mood as well as an object.

Whether your subject is an ancient fence post or the ornate, peeling trim on a fading Victorian house, you can choose how much or how little detail it will take to achieve your ends. It depends partly, of course, on distance. Close up you may wish to explore layer after layer of glaze and tiny detail in the exposed grain of the wood; at a distance, only a hint of such detail is necessary—or possible. It depends, too, on whether the wood is bare or painted—the effects of weather on these very different kinds of wood produce anything from deep grooves and a healthy crop of lichen to a kind of alligator crackling.

In most cases, a simple, varied underwash followed by additional glazing and a final layer of detail work will be sufficient. You can suggest light and shadow with that original wash or reserve that first step for local color only, coming back with a glaze to find your shadows.

Old fences have a special charm; there are so many kinds and styles and conditions, some indigenous to their geographical area, that you can suggest place with a simple architectural device. A white picket fence speaks of small-town Americana; a leaning slat fence feels like the Eastern seaboard. Weathered logs laid in the characteristic zigzag pattern of a rail fence is typically Southern or Midwestern.

Like all weathered wood, fences can be handled with a kind of creative logic. Ask yourself how much detail you need to get your point—or your mood—across. Ask yourself how to proceed from simple washes to glazes to detail, and then just do it!

Brunke's House 15″ × 22″

TREE STUMP

Lay on as many layers as you like for detail

— drybrush

— spatter

Viewed from the end, logs (or stumps) may show cut lines, growth rings, differences between heart — wood and outer layers — these are suggested with the same steps as above.

Step 1 — Preliminary wash establishes local color

Step 2 — Add color variations while the first wash is damp, then complete additional modeling washes

Step 3 — Drybrush, spatter or any other texturing technique can add depth and definition

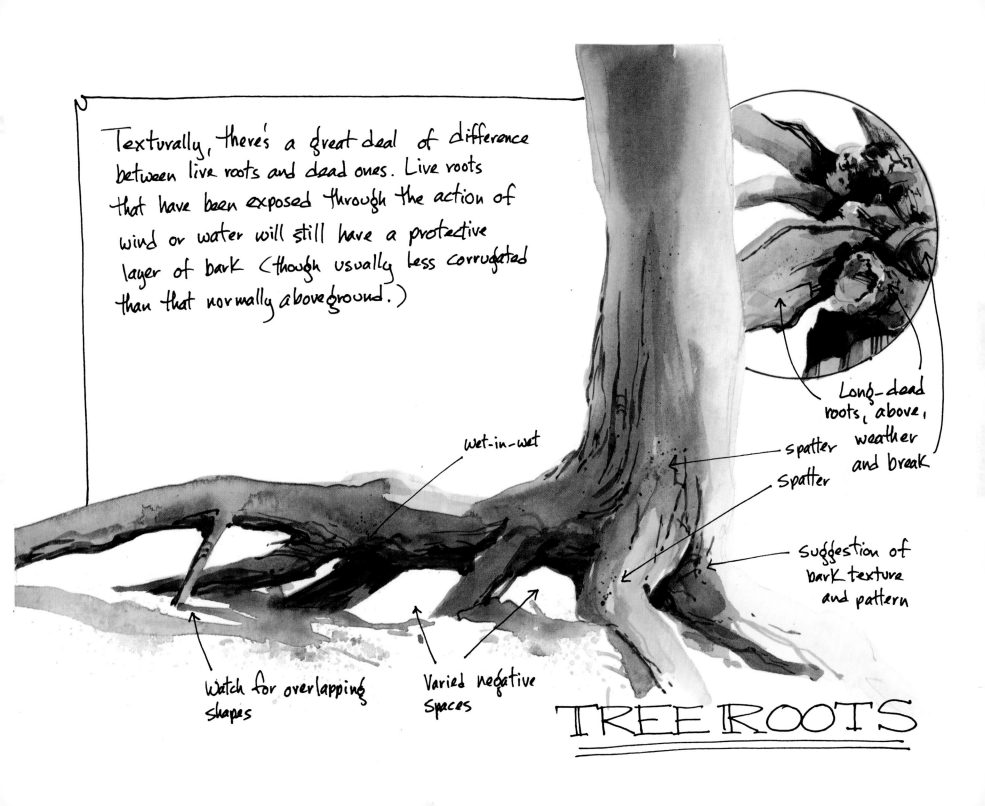

Texturally, there's a great deal of difference between live roots and dead ones. Live roots that have been exposed through the action of wind or water will still have a protective layer of bark (though usually less corrugated than that normally aboveground.)

wet-in-wet

spatter

Spatter

Long-dead roots, above, weather and break

suggestion of bark texture and pattern

Watch for overlapping shapes

Varied negative Spaces

TREE ROOTS

There are almost as many kinds of fencing material as there _____
are methods of building them — as there are people to build
them, for that matter. Each material weathers differently,
and the distance from your eye to the fence affects texture

This old rail fence is
very weathered, but at this
distance it's enough to
just suggest shadows
and shapes

Close-up, this
becomes almost a portrait of
a fence post. Texture was
suggested with preliminary washes,
some wet-in-wet; dry brush and
detail work with a fine sable
brush, and with scumbling,
spatter and
finger-painting

An old drift fence
looks right with single
strokes

WEATHERED FENCING

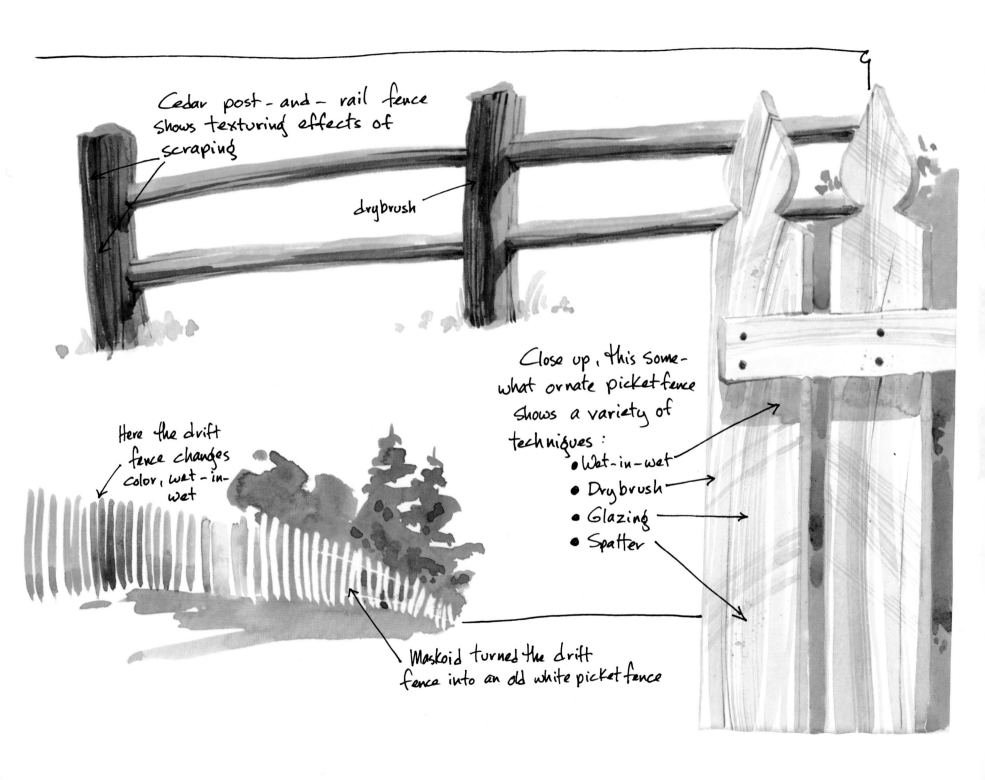

Cedar post - and - rail fence shows texturing effects of scraping

drybrush

Close up, this some-what ornate picket fence shows a variety of techniques:
- Wet-in-wet
- Drybrush
- Glazing
- Spatter

Here the drift fence changes color, wet-in-wet

Maskoid turned the drift fence into an old white picket fence

WEATHERED WOOD:

OLD SIDING

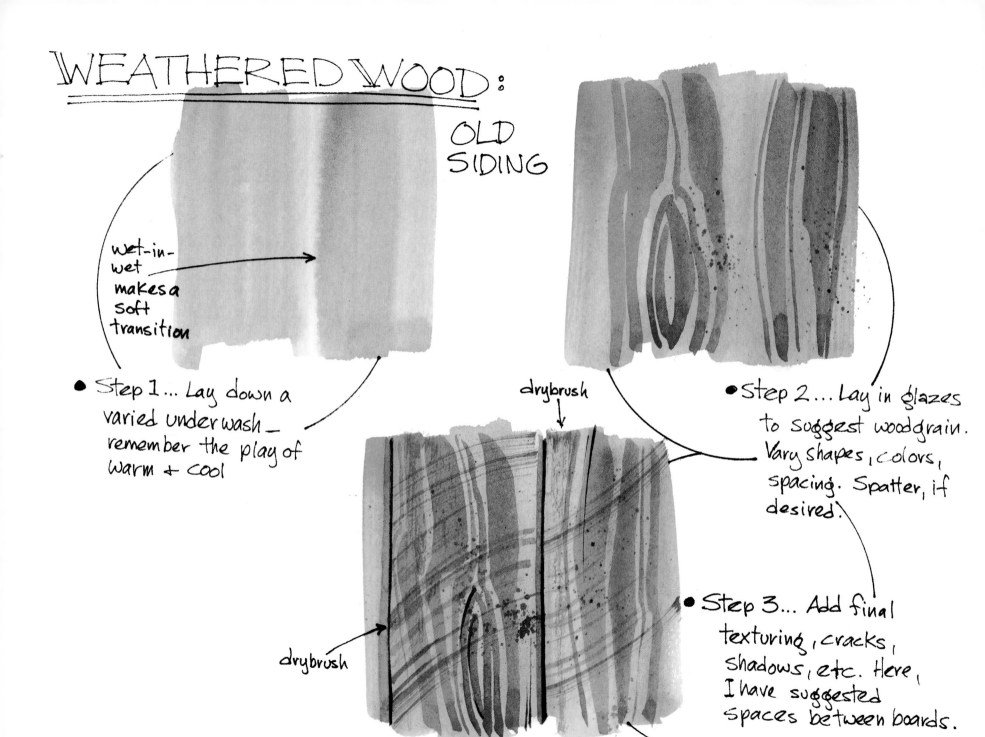

wet-in-wet makes a soft transition

drybrush

drybrush

• Step 1... Lay down a varied underwash — remember the play of warm + cool

• Step 2... Lay in glazes to suggest woodgrain. Vary shapes, colors, spacing. Spatter, if desired.

• Step 3... Add final texturing, cracks, shadows, etc. Here, I have suggested spaces between boards.

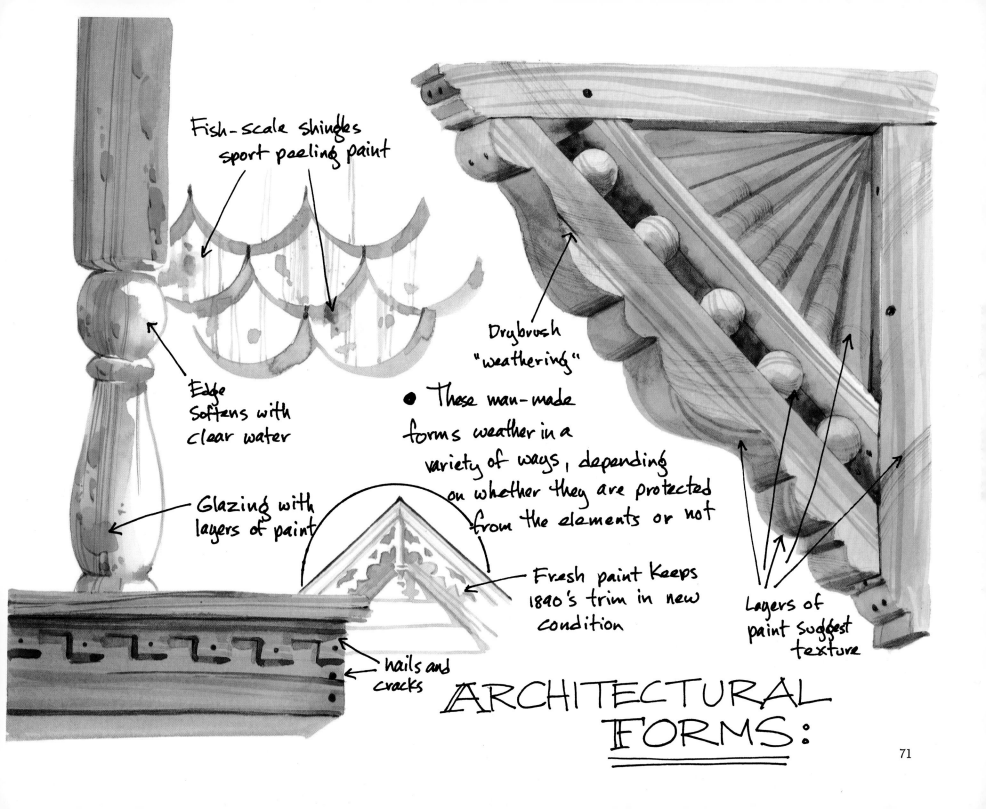

Fish-scale shingles
sport peeling paint

Edge
softens with
clear water

Glazing with
layers of paint

Drybrush
"weathering"

● These man-made
forms weather in a
variety of ways, depending
on whether they are protected
from the elements or not

Fresh paint keeps
1890's trim in new
condition

nails and
cracks

Layers of
paint suggest
texture

ÆRCHITECTURAL
FORMS:

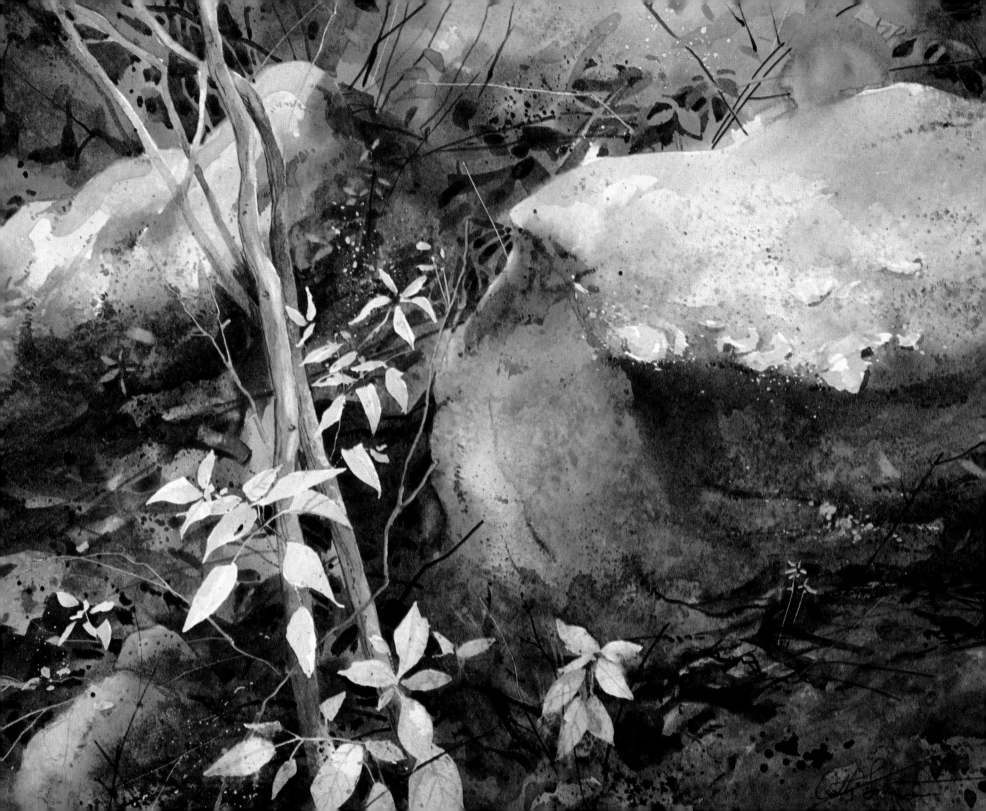

LICHEN AND MOSS

These tiny vegetative life-forms can add more than texture to your work; they can add color. Most mosses, it's true, are a distinctive acidic green—but think how that can liven up a winter scene where the only other colors are the blue of sky and shadows and the varied grays of tree trunks. When mosses are full of moisture they are especially neon; when they're desiccated with drought, the colors are muted, subtle. Even the texture of dry moss is different, no longer velvet but more like a wiry brush. Lichen, on the other hand, can have a great variety of colors, bringing your work to life—kind of fitting for these ancient life-forms. Look closely at surfaces like rocks and tree bark. There you'll find bright splashes of orange and gold and blue-green among the gray of the more common lichen. Some are even black.

Like moss, lichen changes color and character with moisture, brightening and softening when it rains; the color of a lichen-covered tree trunk on a rainy November day is as lovely as any sunset. If you choose to depict an almost microscopic close-up, you'll find a broad range of forms, from the lacy branches of reindeer lichen to the brightly colored helmets worn by British soldier lichen to the gold or brown-filled bowls of cup lichen, all to be handled with careful and creative logic.

You can suggest these textures with underwashes of local color modeled with drybrush work. Stamping with a wad of paper towel or with a natural sponge dipped into pigment can suggest mossy textures. Where lichen is sparse, the variable-sized dots of spatter are a good substitute. And if light strikes individual forms, you may want to scrape through your wash for some light details.

Wet-in-wet work can stand in for these life-forms from a distance; drybrush can suggest any amount of detail. You can even drop rubbing alcohol into a wet wash to depict the rounded forms of shield lichen.

In an Ozark Dell 15″ × 22″

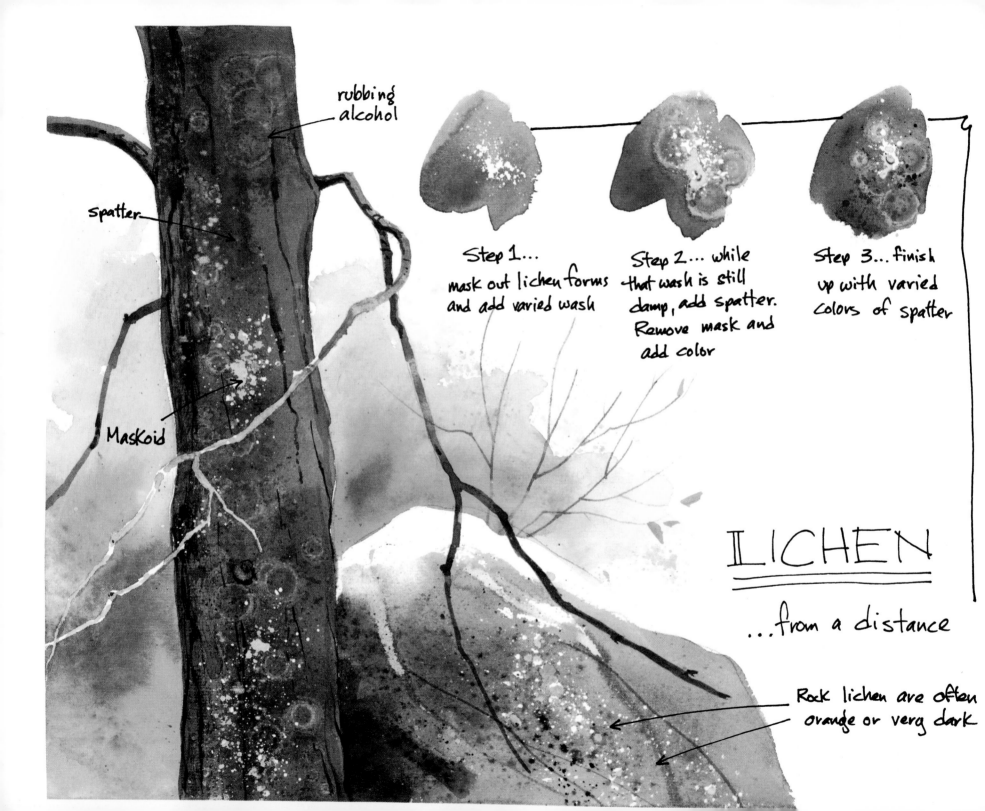

rubbing alcohol

spatter

Maskoid

Step 1... mask out lichen forms and add varied wash

Step 2... while that wash is still damp, add spatter. Remove mask and add color

Step 3... finish up with varied colors of spatter

LICHEN

...from a distance

Rock lichen are often orange or very dark

Even up close and finely detailed, three steps can suggest nearly any sort of lichen —

- Step 1... first washes
- Step 2... when dry, add secondary washes to begin to explore form, light and shadow
- Step 3... finish up with small, sharp details, usually your darkest darks

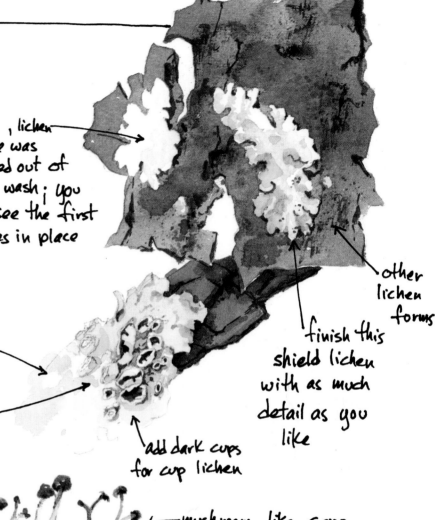

Here, lichen shape was masked out of bark wash; you can see the first washes in place

other lichen forms

finish this shield lichen with as much detail as you like

first washes

develop further

add dark cups for cup lichen

LICHEN

up close....

mushroom-like caps

rough "branches"

tight little scales

British soldier lichen or Cladonia

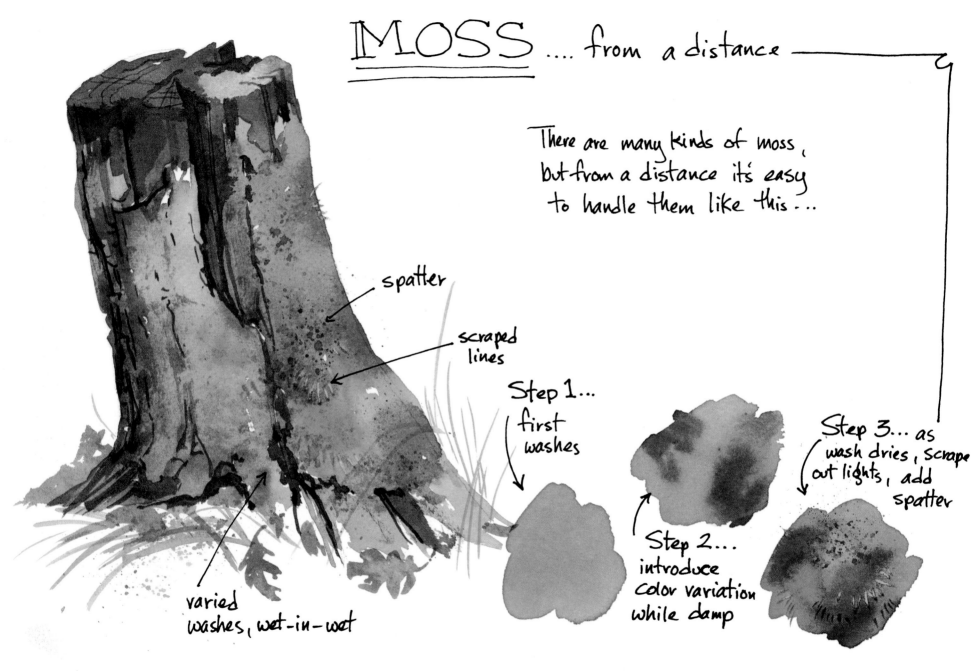

MOSS.... from a distance

There are many kinds of moss, but from a distance it's easy to handle them like this...

spatter

scraped lines

varied washes, wet-in-wet

Step 1... first washes

Step 2... introduce color variation while damp

Step 3... as wash dries, scrape out lights, add spatter

MOSS... close up

Unless you're doing a botanical study of a particular species of moss, something similar to this handling would probably be sufficient. Here, the basic three-step process is enhanced with Maskoid, applied with a bamboo pen

fan brush used to suggest lacy edge

masked out

wet-in-wet

small sable brush used for details

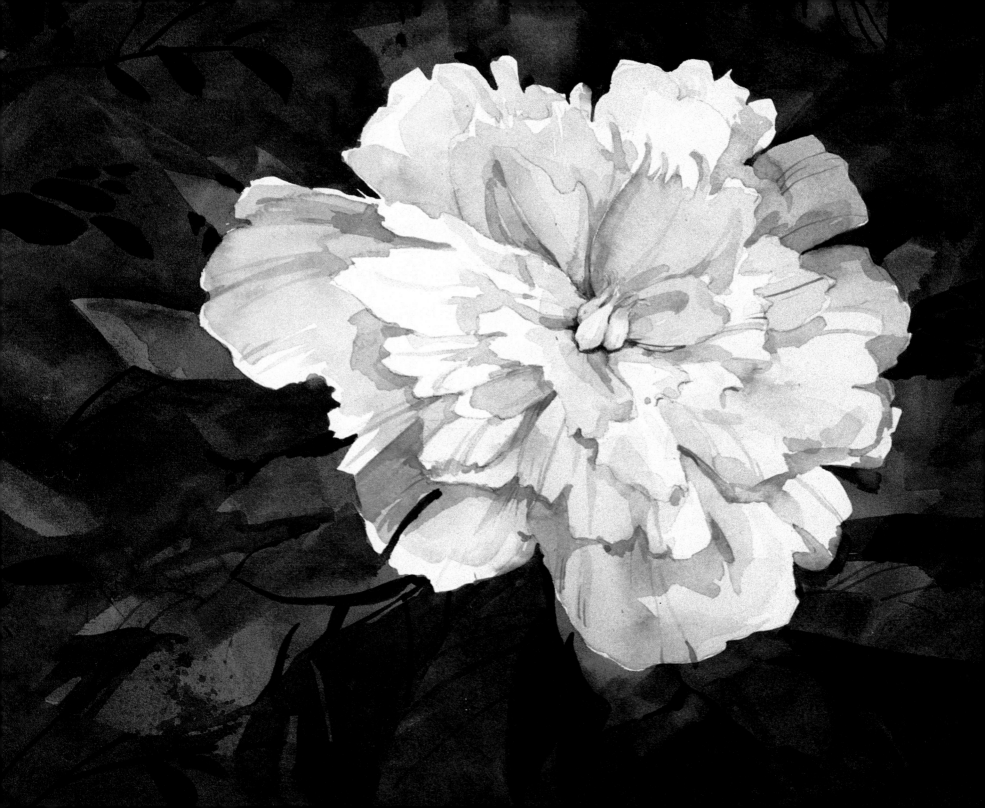

FLOWERS

Perhaps you don't think of flowers when you think of texture, but if you can accurately depict their tactile properties, the reality of these lovely things is easier to capture.

Brainstorm a bit: What kinds of textures are we talking about when we think of flowers? There are more than you think. Roses, petunias, morning glories, pansies and iris are matte-textured—that is, there's little or no shiny highlight to worry about. Poppies, buttercups, strawflowers and some Hawaiian flowers, on the other hand, have a gloss that looks almost lacquered; still others, like peonies, have a more subtle, buffed glow. Some have overall texture created by many tiny flowers clustered on a single stalk: lilacs, snowballs, alyssum, forget-me-not, snapdragon and wild elder flowers fit this description. Some flower heads are complex shapes, such as carnations, asters, cockscomb, zinnias and marigolds. And some petals are themselves deeply ridged, like many of the members of the composite family, whose most common member is the daisy.

Here are a few techniques that can be helpful in capturing the variety of textures: When painting shiny flowers in watercolor, you must remember to retain that white paper to suggest highlights—or resort to scraping, erasing or opaque white. Textured or ridged petals can best be suggested with the same three simple washes used elsewhere—a local color wash, a bit of deeper definition and a detail wash. You can carry this as far as you like. When painting flowers with a complicated overall shape, try to map out the basic forms. Use value to make sense of the many shapes you see, and again, those same three basic washes can do it all.

Peony, Morning Light 11" × 15"

pay attention to the shapes of the highlights — they follow the form of the petals

iris and roses are among the most popular of matte-finish flowers

allow variation in values in a single petal to suggest gloss

a simple preliminary wash with no highlight sets the stage here

poppies and buttercups are among our shiniest flowers

retain that shiny, white-paper sparkle, either by painting around (as was done here) or by using Maskoid

second washes

add as much detail as you like, but keep that velvety matte finish

SHINY or MATTE SURFACES

ROUGH, COMPLEX SHAPES and TEXTURED PETALS

other complex flowers are zinnias, mums — and dandelions

final details add believability and sparkle

the final washes capture texture, form and shadow — here, violet was used to complement the yellow

a simple, almost solid wash of this lipstick red was used over the whole flower head

second washes of stronger yellow

map out and simplify shadow shades for your secondary wash

the preliminary yellow wash has little tonal variation

the stem received the same three washes

many flowers, especially those in the daisy clan, have textured petals that give interest to a fairly simple flower-shape

FLOWERS WITH AN OVERALL TEXTURE

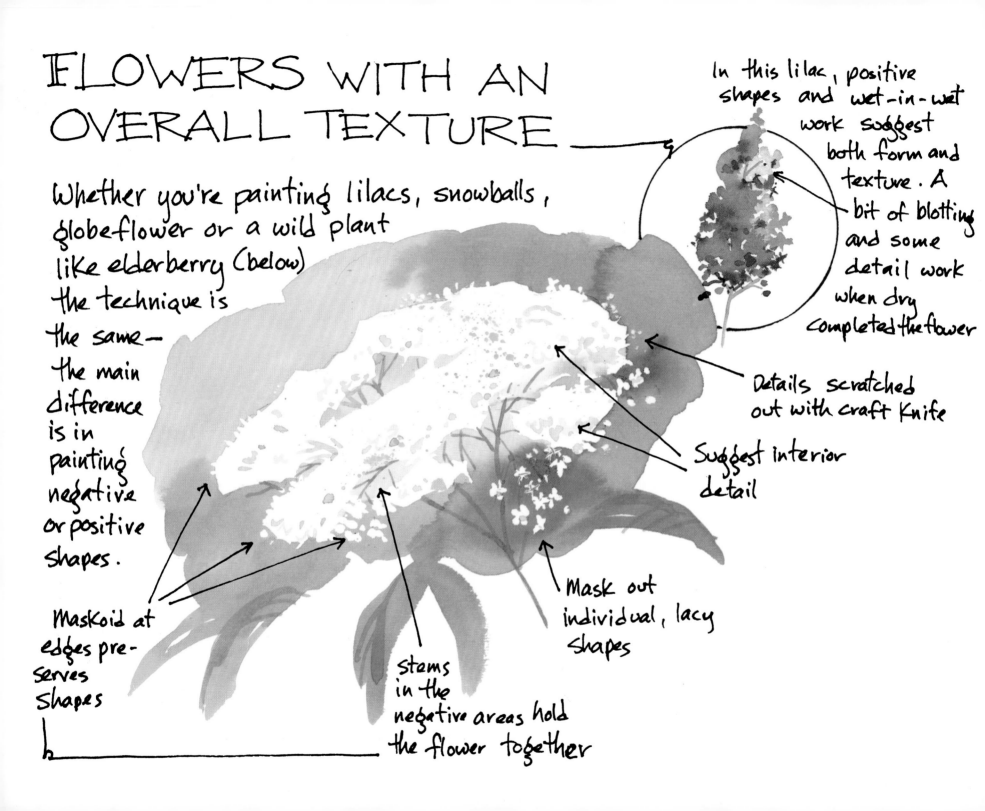

In this lilac, positive shapes and wet-in-wet work suggest both form and texture. A bit of blotting and some detail work when dry completed the flower

Whether you're painting lilacs, snowballs, globeflower or a wild plant like elderberry (below) the technique is the same — the main difference is in painting negative or positive shapes.

Details scratched out with craft knife

Suggest interior detail

Maskoid at edges preserves shapes

Stems in the negative areas hold the flower together

Mask out individual, lacy shapes

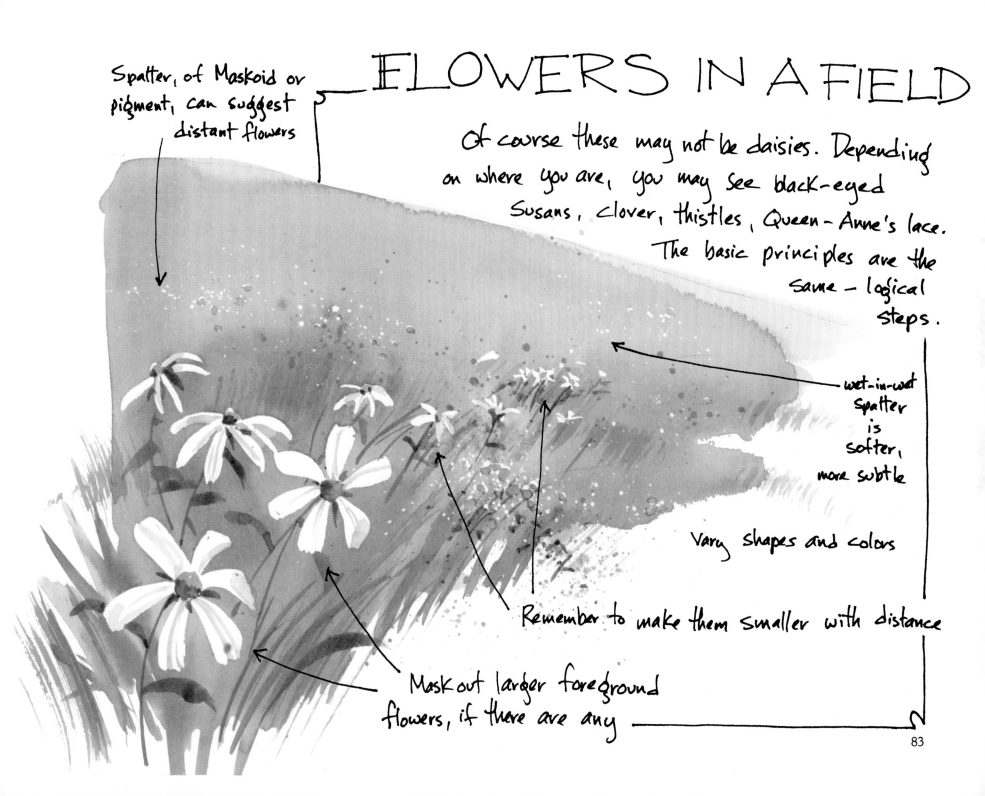

FLOWERS IN A FIELD

Spatter, of Maskoid or pigment, can suggest distant flowers

Of course these may not be daisies. Depending on where you are, you may see black-eyed Susans, clover, thistles, Queen-Anne's lace. The basic principles are the same – logical steps.

wet-in-wet spatter is softer, more subtle

Vary shapes and colors

Remember to make them smaller with distance

Mask out larger foreground flowers, if there are any

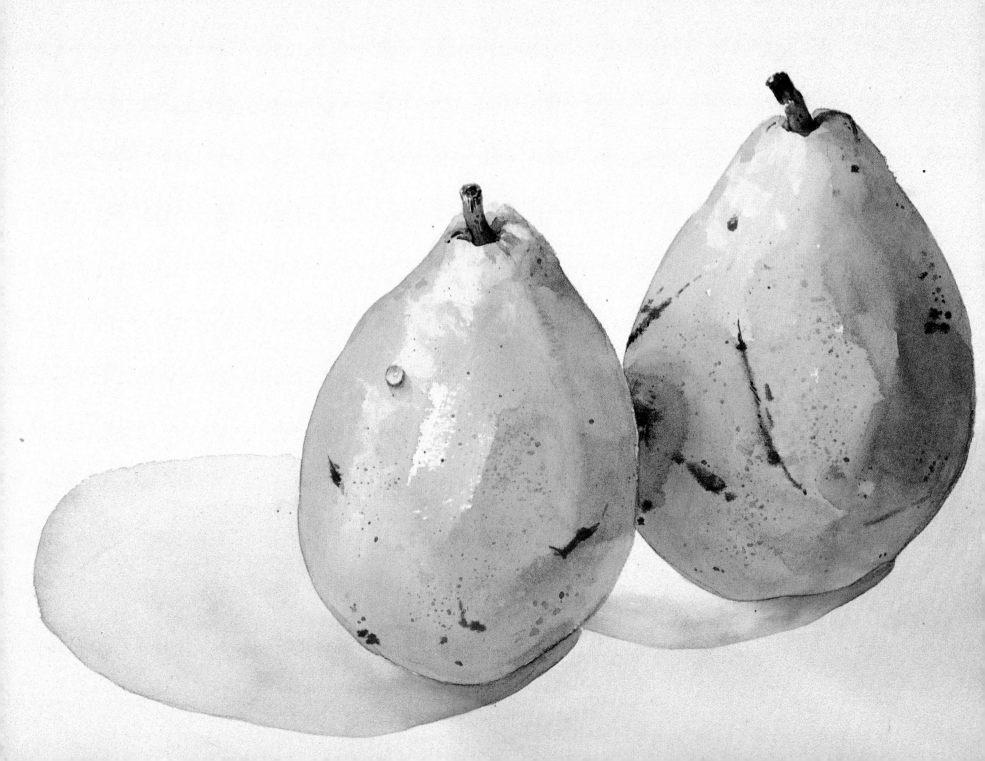

FRUITS AND VEGETABLES

These wonderfully varied shapes and textures have fascinated artists from the Old Masters down to the present. How many still life paintings have you seen that utilize the ruddy shine of apples or the voluptuous glow of peaches, the bloom of grapes bursting with flavor you can almost taste? They're challenging to paint and always will be.

The textures of the particular subjects you've chosen can help you depict them with grace and beauty; surface characteristics can say as much as overall shape or color. Would you believe a banana that was as shiny and unblemished as a winesap? Part of what a banana *is* is soft, unhighlighted color and those distinctive dark bruises. A matte-finish green pepper wouldn't look very appetizing, and a potato with a shine would make you wonder what on earth you were looking at. It's in seeing and capturing those differences on paper that you can bring your still lifes to *real* life.

Plan ahead. That's good advice not only for Scouts and builders of bridges but for anyone wanting to capture a specific subject, a specific effect. Save the white of your paper, either by masking or painting around, to suggest the shine on a crisp, red apple. Plan shadow areas to capture form as well as texture. Allow your lights and darks to accentuate texture.

It's not necessary, of course, to paint a portrait of a particular potato or pear. Charles Demuth, in fact, often used a technique that looked rather as if he had quickly blotted a wet, free wash, making an extremely effective textural surface without a trace of overworking. Look for ways to *suggest* texture without the necessity of carefully painting each blemish and mark. Blotting, finger painting, stamping and drybrush are only a few of the techniques possible.

A Pair of Pears 11″×15″

APPLES and OTHER SHINY FRUITS

1.- Lay in a preliminary wash — in this case I used a yellow-green not only to make a color vibration but to capture the color variation of the apple

Be sure to keep that shine — mask it out if you need to

2. — Add secondary washes, following form of fruit. Let some variation in value suggest roundness, light and shadow

3. — Final details finish up, some painted and some scratched out with a craft knife

Lines add to the illusion of roundness

Here, I masked out the rather complex sparkle

Details complete the illusion

Knife blade used here

Blue, orange's complement, used in shadow area.

BANANAS and OTHER LUSTERLESS FRUITS

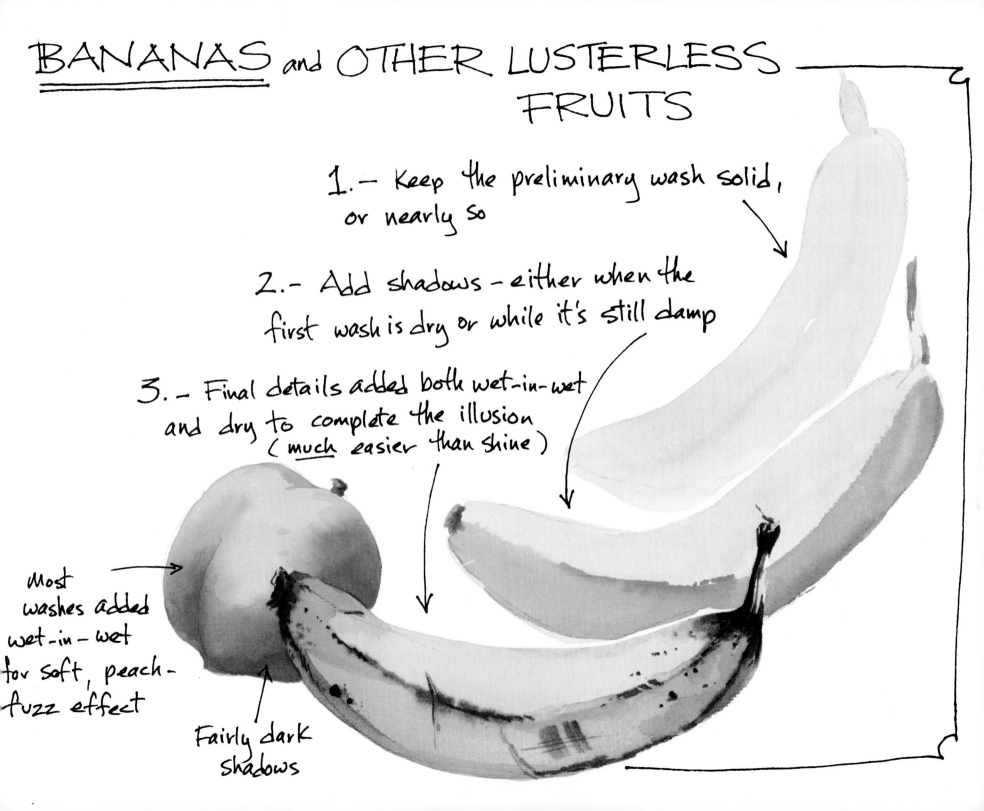

1.— Keep the preliminary wash solid, or nearly so

2.— Add shadows – either when the first wash is dry or while it's still damp

3.— Final details added both wet-in-wet and dry to complete the illusion (<u>much</u> easier than shine)

Most washes added wet-in-wet for soft, peach-fuzz effect

Fairly dark shadows

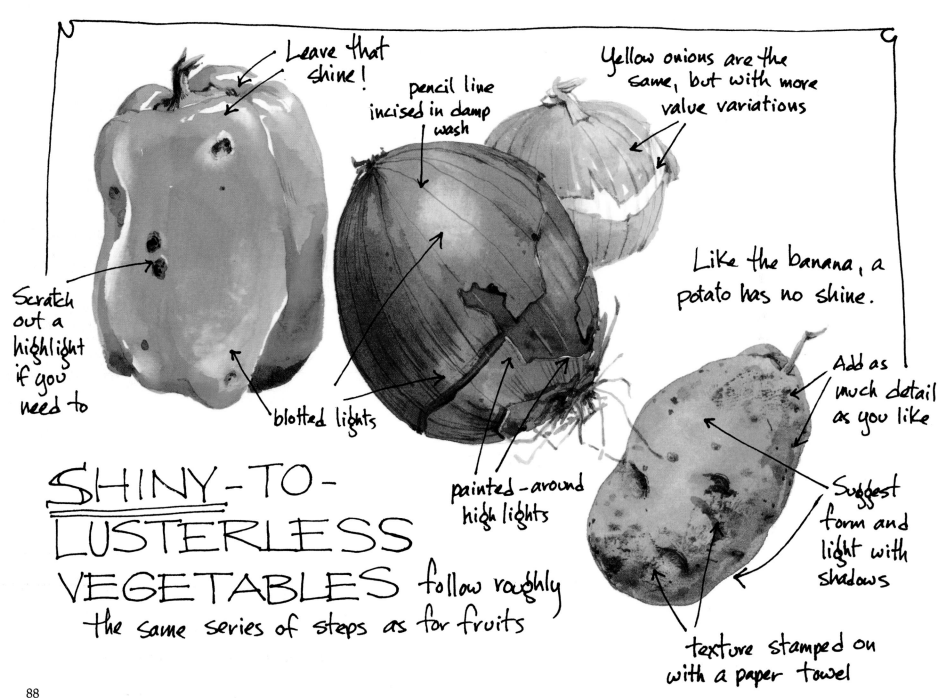

Leave that shine!

pencil line incised in damp wash

Yellow onions are the same, but with more value variations

Scratch out a highlight if you need to

blotted lights

painted-around high lights

Like the banana, a potato has no shine.

Add as much detail as you like

Suggest form and light with shadows

texture stamped on with a paper towel

SHINY-TO-
LUSTERLESS
VEGETABLES follow roughly
the same series of steps as for fruits

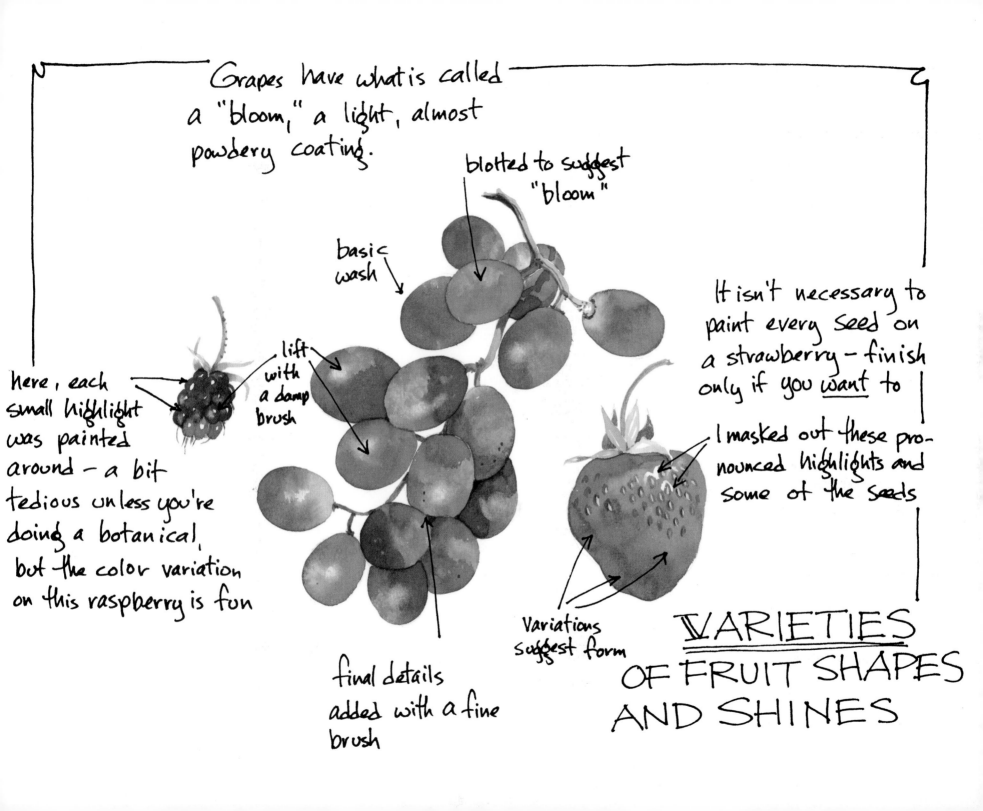

Grapes have what is called a "bloom," a light, almost powdery coating.

blotted to suggest "bloom"

basic wash

It isn't necessary to paint every seed on a strawberry — finish only if you <u>want</u> to

here, each small highlight was painted around — a bit tedious unless you're doing a botanical, but the color variation on this raspberry is fun

lift with a damp brush

I masked out these pronounced highlights and some of the seeds

Variations suggest form

final details added with a fine brush

VARIETIES OF FRUIT SHAPES AND SHINES

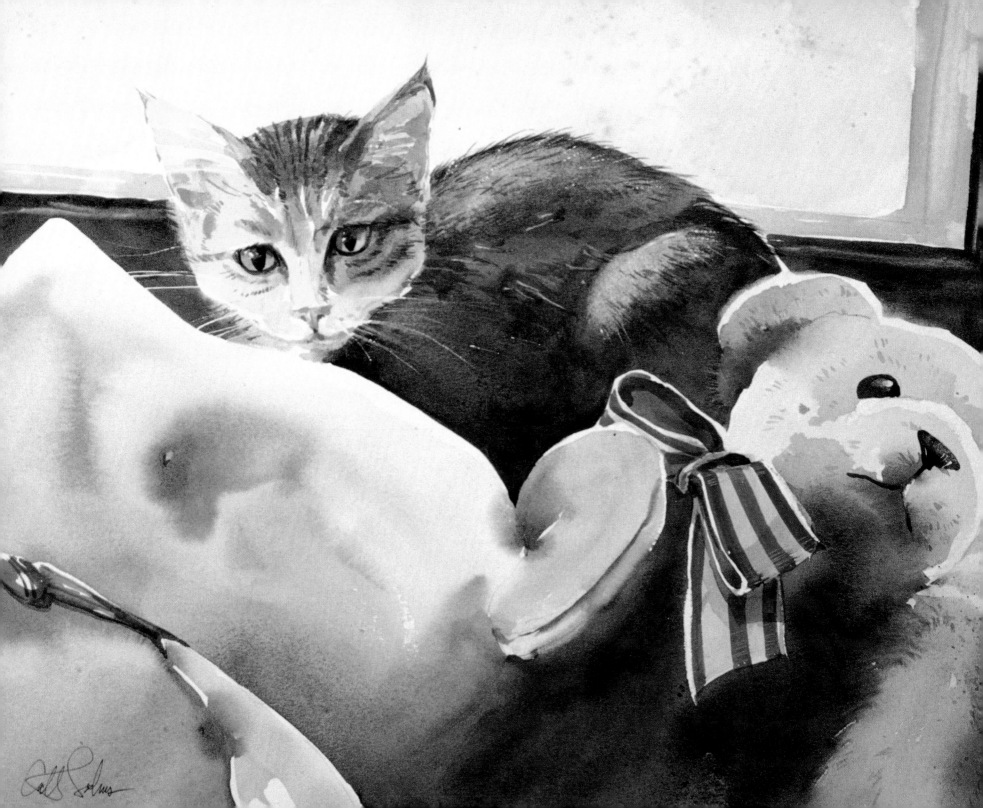

Chapter Thirteen
F U R

The burgeoning interest in wildlife art in the last few years makes this chapter—forgive the pun—a natural. And after capturing the spark of life in the eyes and the dynamics of the overall shape, fur texture adds most to your work.

Bears, raccoons, bison and other furred creatures are wonderful in watercolor; capturing them on paper is most satisfying. Deer, antelope, and other smoother-haired animals are perhaps less challenging (a local color wash with a bit of suggested detail is almost always sufficient). The longer-haired creatures pose a number of dilemmas. How much detail shall I attempt, a rough approximation of texture or an every-hair-on-its-back rendering? What technique best captures what I see—or what I want to see when I'm finished?

Part of your decision will rest, of course, on the distance of your subject. If the bear is in the back or middle ground, there's no need—and no way—to paint more than the roughest suggestion of fur. If he is your main subject, close as the family dog, then you'll probably want to suggest a bit more detail. (On the other hand, if the bear *is* as close as your dog, you're in a world of trouble.) There are still a variety of possible techniques to choose from, however; drybrush, wet-in-wet, straight washes or any combination of these may best satisfy you.

Smooth, shiny animals are fun to paint, as well. The family pets can stand in here for their wild cousins. Many of my own favorite paintings have been of my cats—selling one of these is out of the question. And then of course there is the variety of *stuffed* pets we find around us; the teddy bear decade is not over by a long shot, and these cuddly toys can add a friendly, approachable element to an otherwise overly serious still life.

Margaret and Friends 15″ × 22″

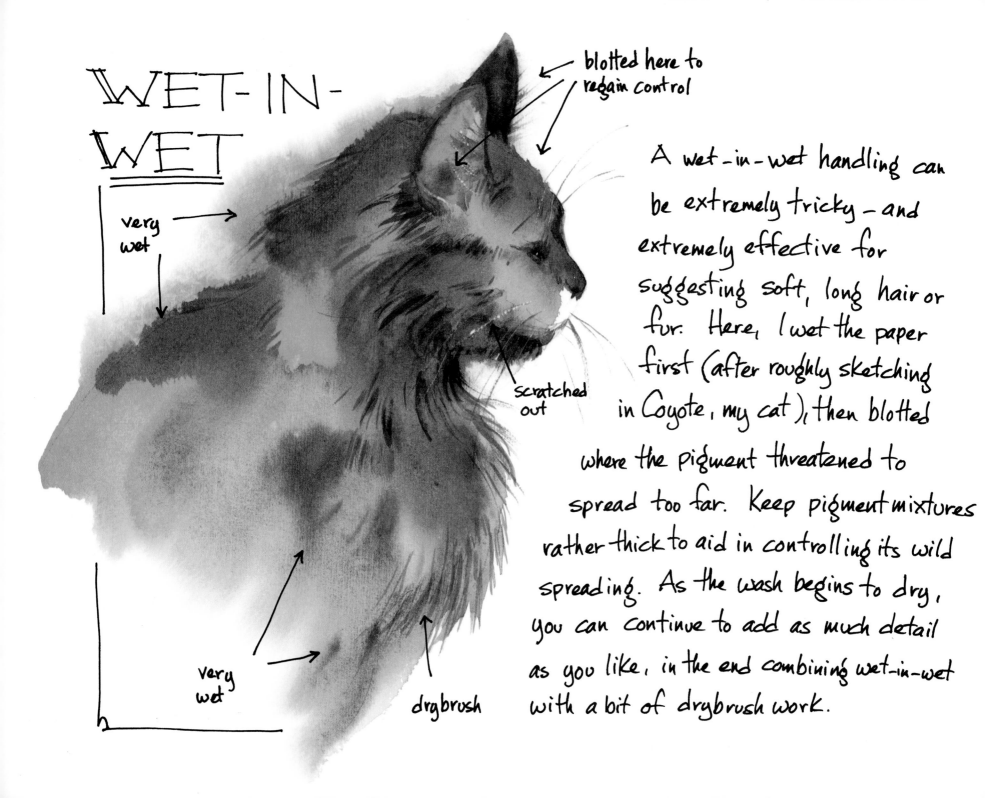

WET-IN-WET

very wet

blotted here to regain control

scratched out

A wet-in-wet handling can be extremely tricky — and extremely effective for suggesting soft, long hair or fur. Here, I wet the paper first (after roughly sketching in Coyote, my cat), then blotted where the pigment threatened to spread too far. Keep pigment mixtures rather thick to aid in controlling its wild spreading. As the wash begins to dry, you can continue to add as much detail as you like, in the end combining wet-in-wet with a bit of drybrush work.

very wet

drybrush

DRYBRUSH

Drybrush can be accomplished in several ways: Here, a small (#1) sable brush was used to make repeated strokes of darker color over an underwash. If you prefer, you could also work with a larger round red sable with its bristles spread, a flat brush used the same way, or a fan brush. In any case, load the brush with pigment, remove excess moisture, and work until you get the amount of detail you want.

large round red sable

very little detail painted on an underwash

↑ flat brush

↑ fan brush

↑ no drybrush work here

lots of detail

underwash

93

FUR
from a distance

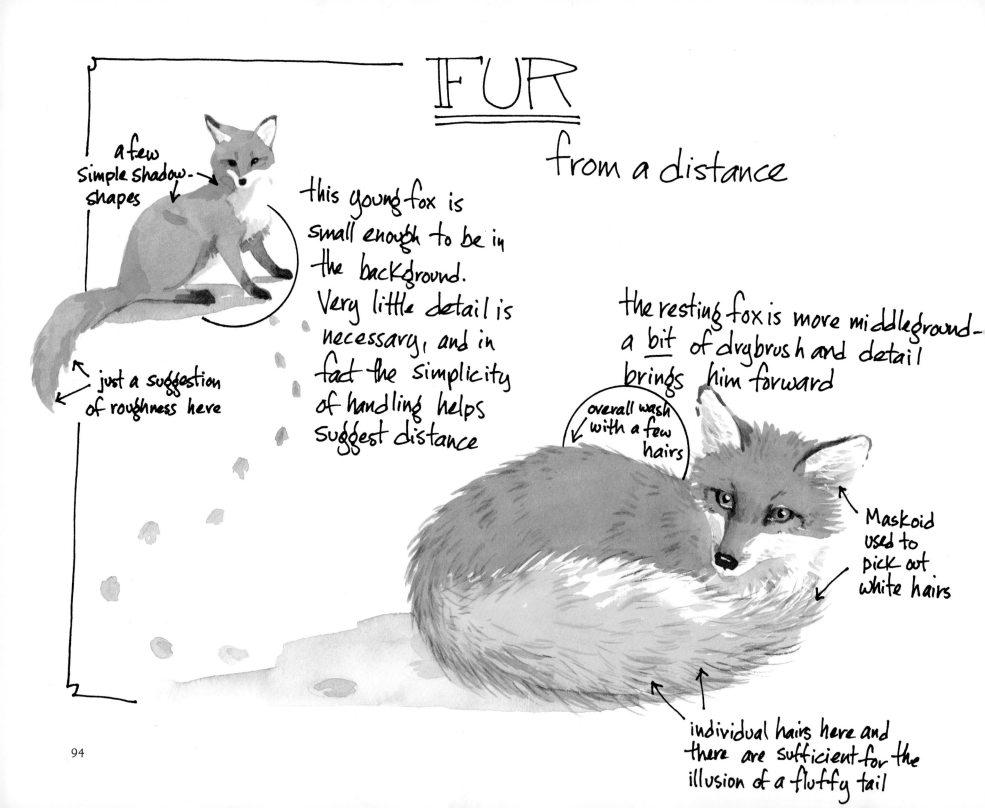

a few simple shadow-shapes

just a suggestion of roughness here

this young fox is small enough to be in the background. Very little detail is necessary, and in fact the simplicity of handling helps suggest distance

the resting fox is more middleground— a *bit* of drybrush and detail brings him forward

overall wash with a few hairs

Maskoid used to pick out white hairs

individual hairs here and there are sufficient for the illusion of a fluffy tail

94

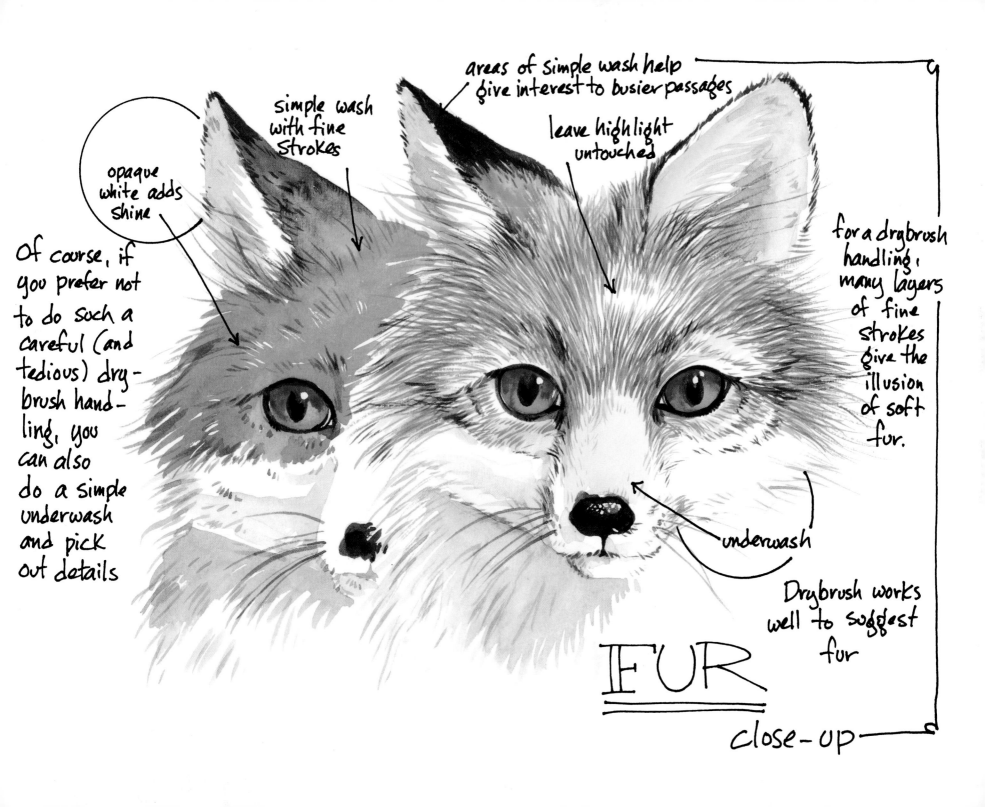

opaque white adds shine

simple wash with fine strokes

areas of simple wash help give interest to busier passages

leave highlight untouched

for a drybrush handling, many layers of fine strokes give the illusion of soft fur.

Of course, if you prefer not to do such a careful (and tedious) dry-brush hand-ling, you can also do a simple underwash and pick out details

underwash

Drybrush works well to suggest fur

FUR

close-up

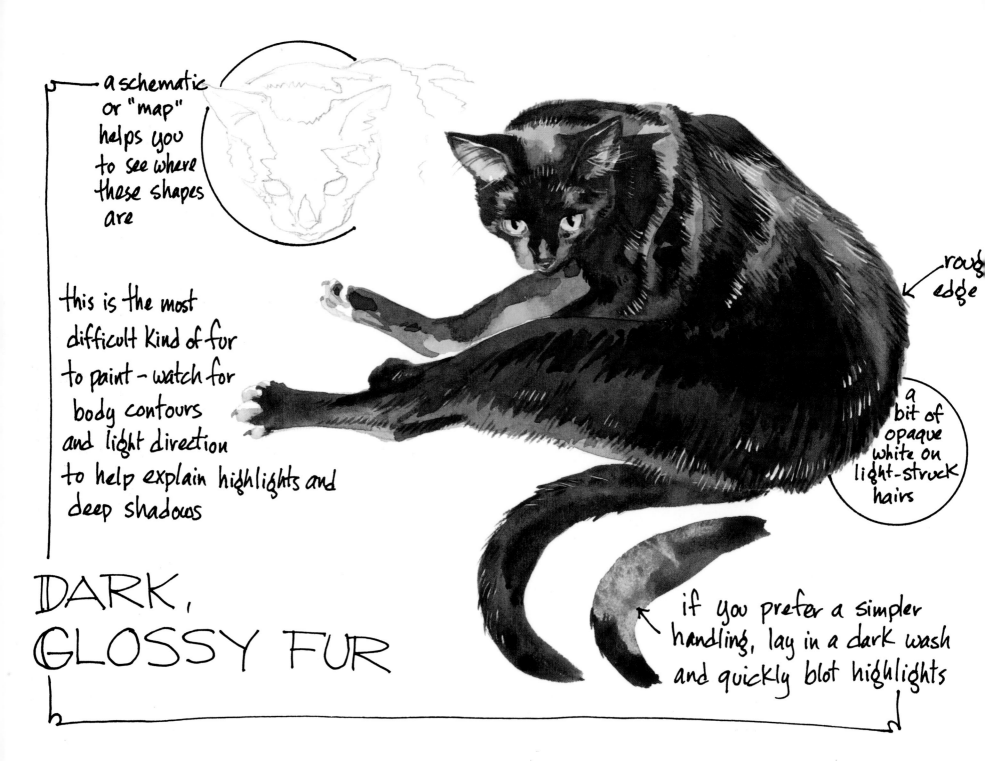

a schematic or "map" helps you to see where these shapes are

this is the most difficult kind of fur to paint - watch for body contours and light direction to help explain highlights and deep shadows

roug edge

a bit of opaque white on light-struck hairs

DARK, GLOSSY FUR

if you prefer a simpler handling, lay in a dark wash and quickly blot highlights

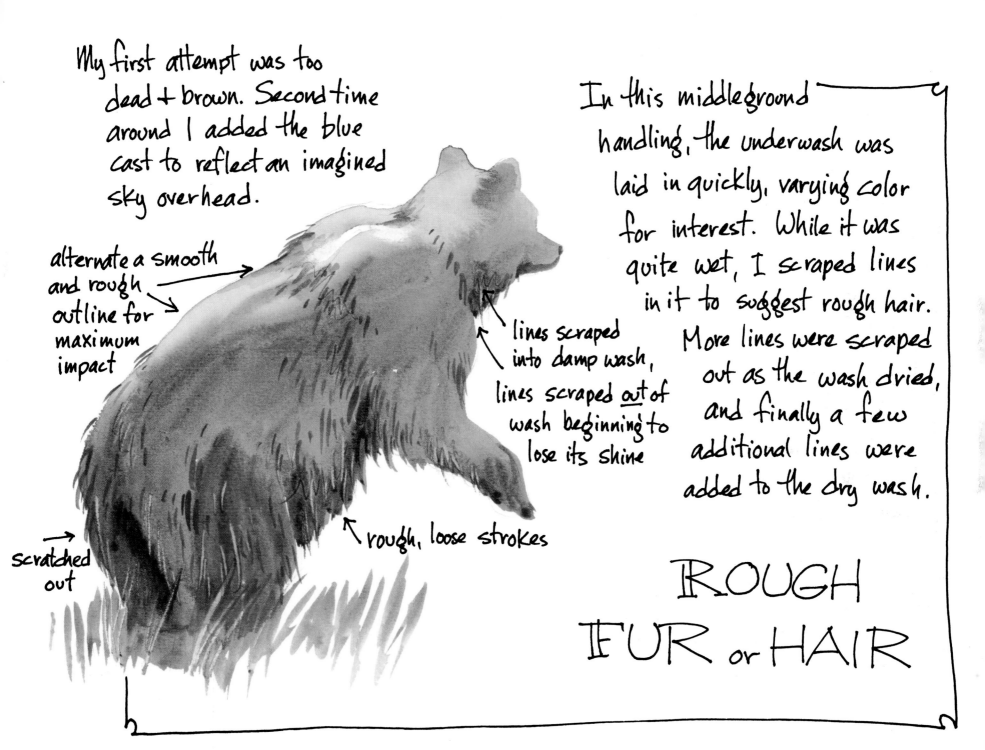

My first attempt was too dead + brown. Second time around I added the blue cast to reflect an imagined sky overhead.

alternate a smooth and rough outline for maximum impact

In this middleground handling, the underwash was laid in quickly, varying color for interest. While it was quite wet, I scraped lines in it to suggest rough hair. More lines were scraped out as the wash dried, and finally a few additional lines were added to the dry wash.

lines scraped into damp wash, lines scraped *out* of wash beginning to lose its shine

scratched out

↖ rough, loose strokes

ROUGH
FUR or HAIR

FUR PATTERNS

Depending on your distance from your subject, you may choose to go for more or less detail. For the pronghorn, I merely differentiated overall patterns and suggested a few hairs to tie areas together.

this is hot-press paper, so the underwash itself has a bit of texture

individual hairs

#1 brush used for these strokes

The young bobcat has a bit more detail, but the same basic technique — underwash (allowed to dry), modeling, and final details added with a fine sable brush.

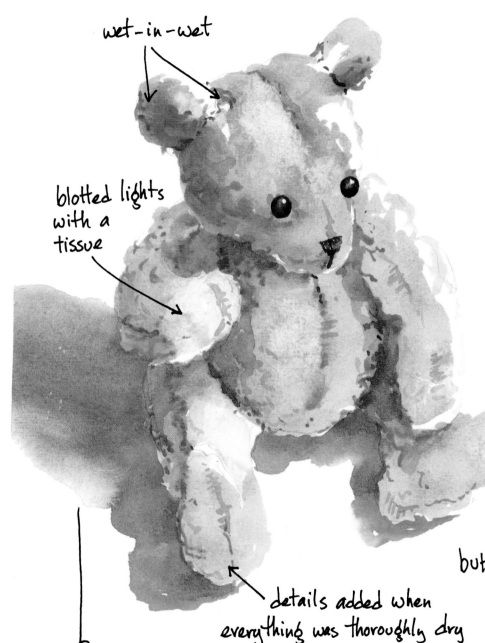

wet-in-wet

blotted lights with a tissue

details added when everything was thoroughly dry

FAKE FUR

Of course, manmade "fur" has many textures, from a deep, velvety pile to this nubbly sheep-skin effect. The basic approach is the same, but here I worked a bit longer with the underwash, blotting and dabbing in pigment to capture the curly fleece. Later, when the initial wash dried, I added the linear details, button eyes, and stitched-on nose. (I chose Miguel for his blue color!)

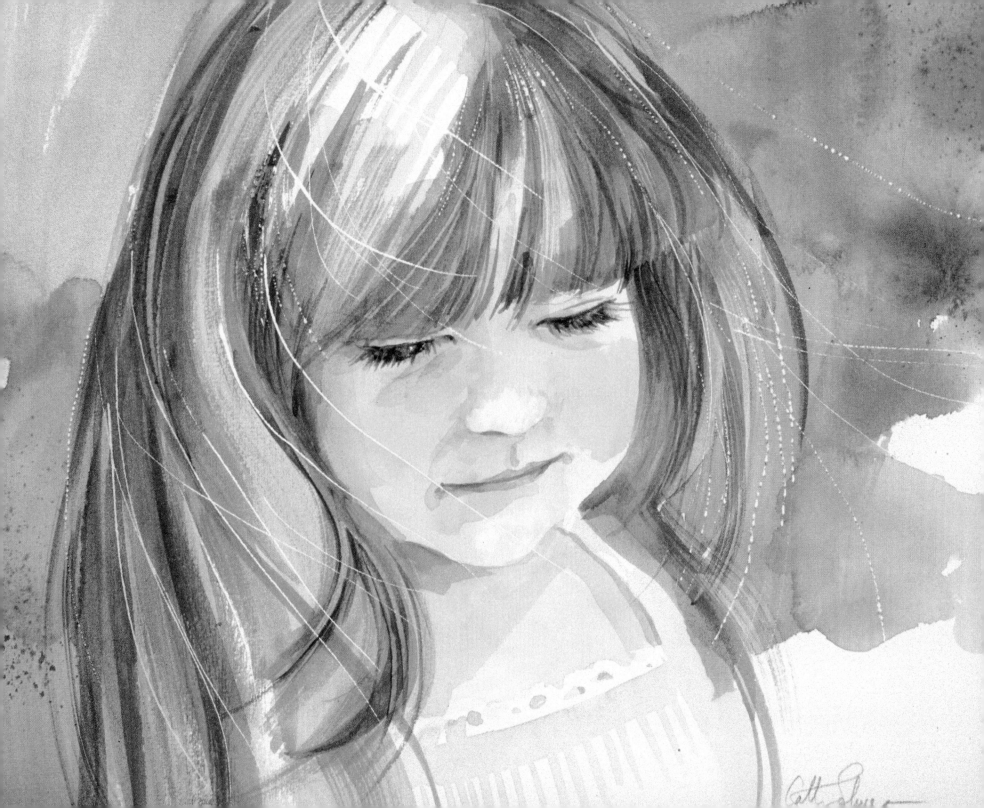

Chapter Fourteen

HAIR

Painting people is one of the most satisfying occupations; artists have been doing it for centuries. Whether you do a formal portrait or an informal one or simply add figures to your work for interest, painting hair will be a part of that expression. And texture is at the heart of the subject.

It's more than the hairdresser's definition of texture; whether the hair is coarse or fine is hardly a matter of concern to the painter. It's the visual texture that counts here, and hairstyle contributes immeasurably to the effect. Think how different long, straight hair is from tight curls when it comes to painting them. Think of how you might best depict waves, or ponytails, or braids.

Then there's facial hair. Eyebrows, mustaches and beards add a great deal to your finished painting; if you are trying for a close likeness, they're essential.

In most cases, the problem can be handled with amazing simplicity. What looks at first like a rather daunting affair can be simplified into those same three simple steps: local color wash, shadow wash (perhaps scraped back into while damp to suggest strands of hair) and details. Look at our examples: There's not that much difference in the overall *handling* of straight hair from that of the tight ringlets on page 104, but the final visual effects are as different as the hairstyles themselves.

It's not necessary to paint every hair; a suggestion is usually more evocative, more effective—and fresher, to boot. Even those tight curls needn't be overworked. A suggestion of drybrush work catches the overall feeling.

STRAIGHT HAIR

Step 1... Lay in a local color wash — in this case, burnt sienna.

Maintain some value variations and highlights

For blond hair, of course, begin with a pale, golden wash

Step 2... While the preliminary wash is still fairly wet, drop in cool shadows. Allow to dry somewhat, then scrape out highlights.

scraped out with the end of a brush

highlights, light-struck hairs scratched out with craft knife

drybrush

Step 3... Delineate strands and separate hairs with a fine sable brush or split hairs of a larger brush for drybrush effect. A trimmed fan brush works well, too.

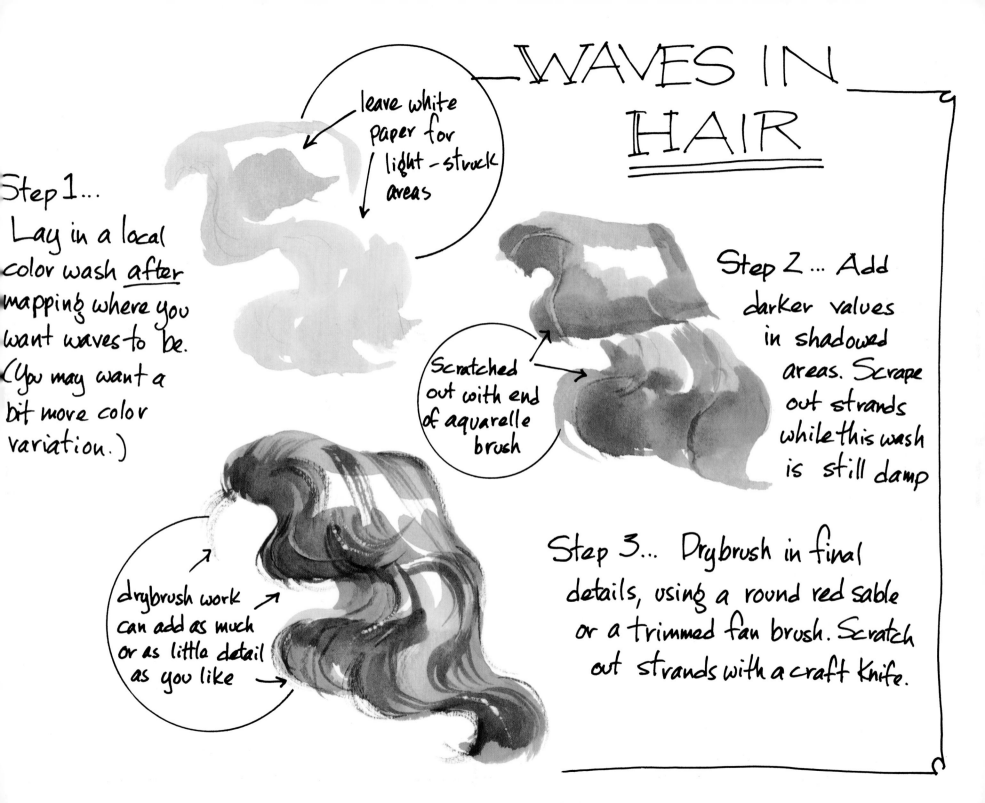

WAVES IN HAIR

leave white paper for light-struck areas

Step 1...
Lay in a local color wash <u>after</u> mapping where you want waves to be. (You may want a bit more color variation.)

Step 2... Add darker values in shadowed areas. Scrape out strands while this wash is still damp

Scratched out with end of aquarelle brush

Step 3... Drybrush in final details, using a round red sable or a trimmed fan brush. Scratch out strands with a craft knife.

drybrush work can add as much or as little detail as you like

CURLY HAIR

Step 1... Lay in a loose, somewhat lacy form with local color — for blonde you can use yellow ochre or raw Sienna.

scraped out with brush handle

Step 2... While this wash is still somewhat wet, come back in with a darker shadow wash. As the wash loses its shine you can incise highlights with a brush handle or finger nail.

Whatever its length, curly hair follows basically the same form

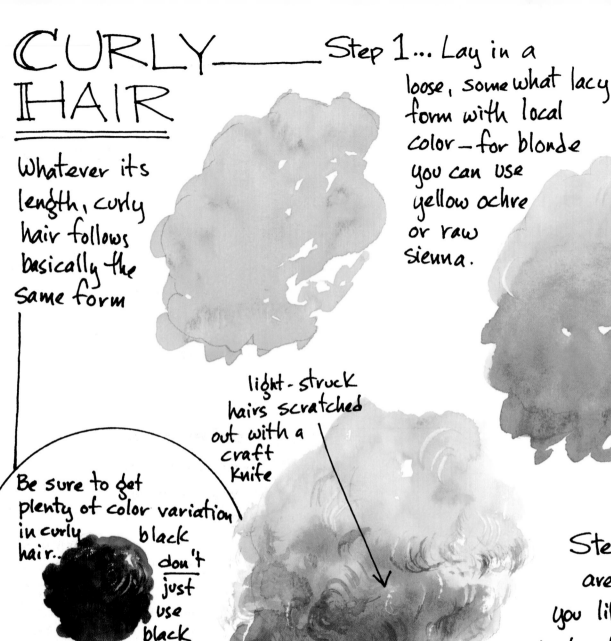

light-struck hairs scratched out with a craft knife

Be sure to get plenty of color variation in curly hair... black don't <u>just</u> use black pigment

Step 3... When the first washes are dry, add as much detail as you like using a small brush or a larger brush used drybrush-style. Here, a "barbered" fan brush was used to suggest ringlets.

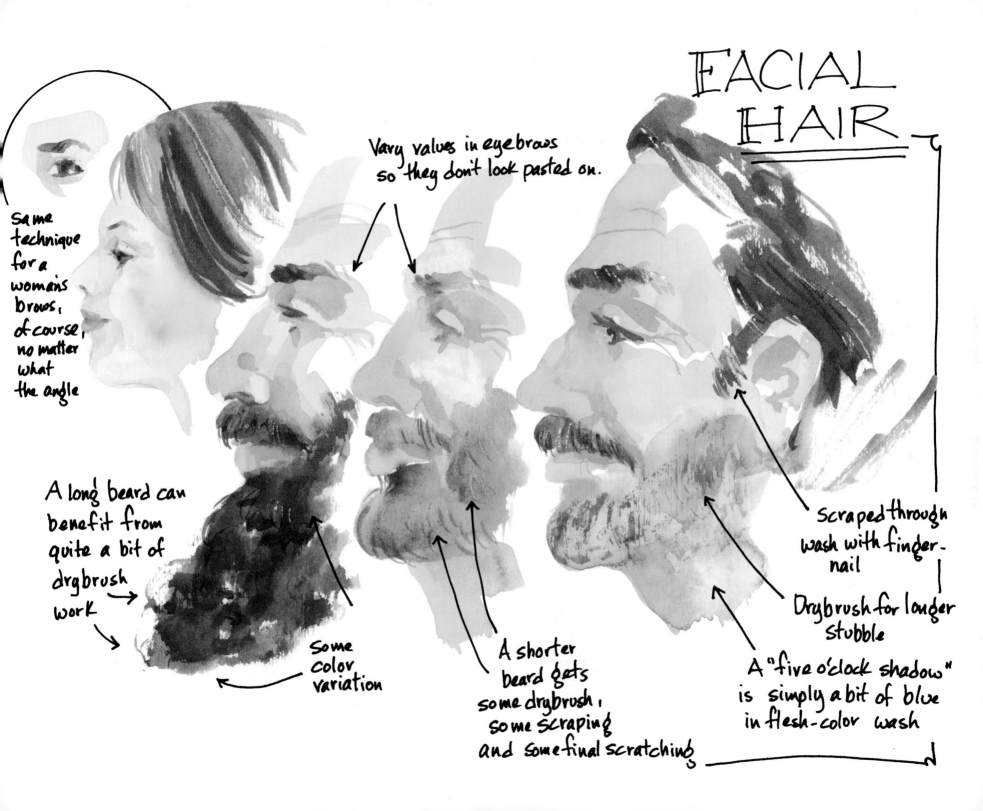

FACIAL HAIR

Vary values in eyebrows so they don't look pasted on.

Same technique for a woman's brows, of course, no matter what the angle

A long beard can benefit from quite a bit of drybrush work

Some color variation

A shorter beard gets some drybrush, some scraping and some final scratching

Scraped through wash with finger-nail

Drybrush for longer stubble

A "five o'clock shadow" is simply a bit of blue in flesh-color wash

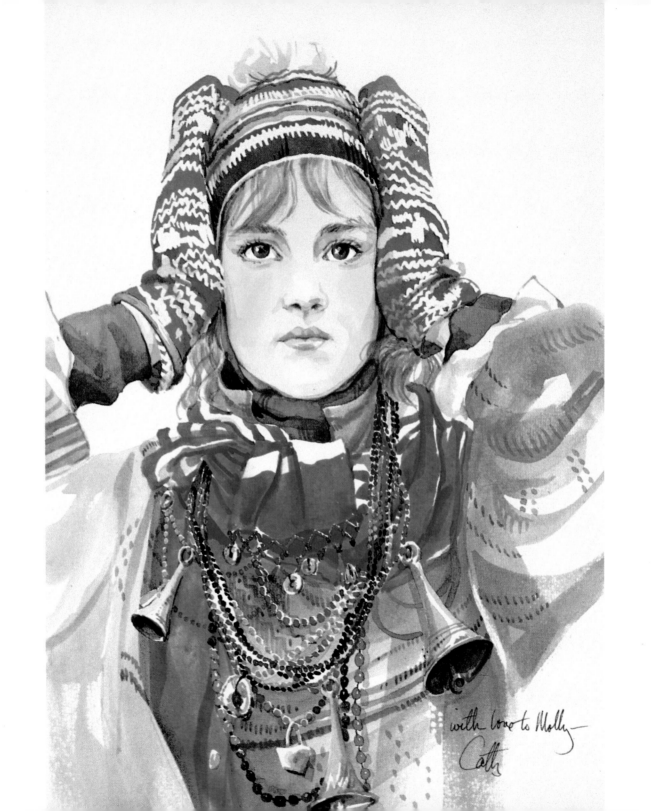

with love to Molly
Cath

SKIN TONES AND TEXTURES

Think of the varieties of textures within this single topic—a baby's cheek is very different from that of a sailor accustomed to long hours on the ocean under an unrelenting sky. A face with a fine, woven net of lines has a texture quite removed from that belonging to a fresh young girl.

The technique you choose can go a long way toward exploring these differences. Wet-in-wet can be used to suggest soft, delicate skin, while drybrush can add all the texture you'd ever need. A *combination* of these techniques can cover literally any situation, allowing you to lay in a soft undertone of color, then build up layers of character on top. Even the pigments you choose can add to the illusion of texture. Transparent pigments like alizarin crimson can really express a glow, while the graininess inherent in some of the opaque, separating pigments like burnt umber or burnt sienna (cooled with ultramarine or manganese) contributes a texture of its own.

When working with young skin, keep your washes relatively simple. Lay them in quickly and decisively, then get out. Don't keep working over the area or it will become muddied—and may develop rough textures where you want smooth ones. When you're working with a subject with a bit more character, however, you can add as many washes as you like, although it's usually more satisfactory to allow each to dry thoroughly before adding subsequent layers. Reserve the bolder colors for these older, more highly textured subjects, and watch for areas that add character—smile lines, crow's-feet, and so on.

And of course, the distance between you and your subject will again affect how much texture you want; distant subjects require almost none, while those close up can take as many layers as you like.

Molly in Mufti 11″ × 15″ Collection of Molly Hammer

SMOOTH, YOUNG SKIN

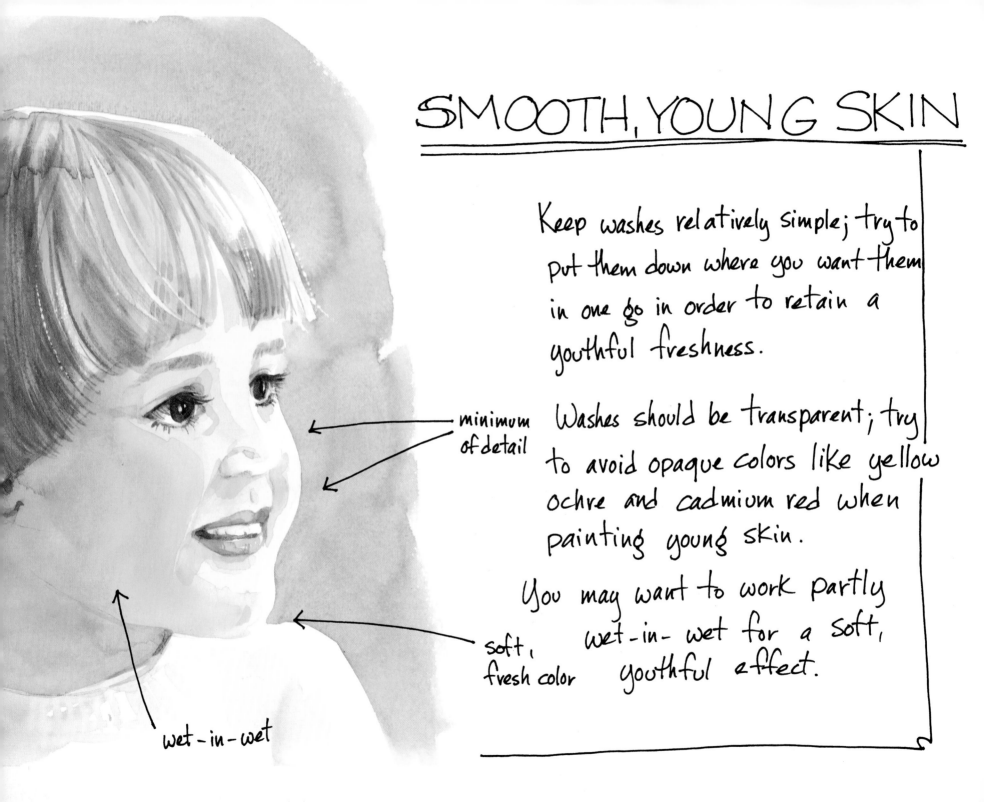

minimum of detail

soft, fresh color

wet-in-wet

Keep washes relatively simple; try to put them down where you want them in one go in order to retain a youthful freshness.

Washes should be transparent; try to avoid opaque colors like yellow ochre and cadmium red when painting young skin.

You may want to work partly wet-in-wet for a soft, youthful effect.

WEATHERED SKIN

When painting a complexion with a little more of life written on it, you can have fun adding detail: crow's feet, facial planes, veins, expression lines, etc.

Color can be as bold as you like; here you can use opaque pigments, including some burnt sienna mixed into the shadow areas. Watch for expressive shadows, like those thrown by the eye glasses.

fine brush for details, or scratch through a damp wash

layer as many washes as you like to get the effect you're after

strong color

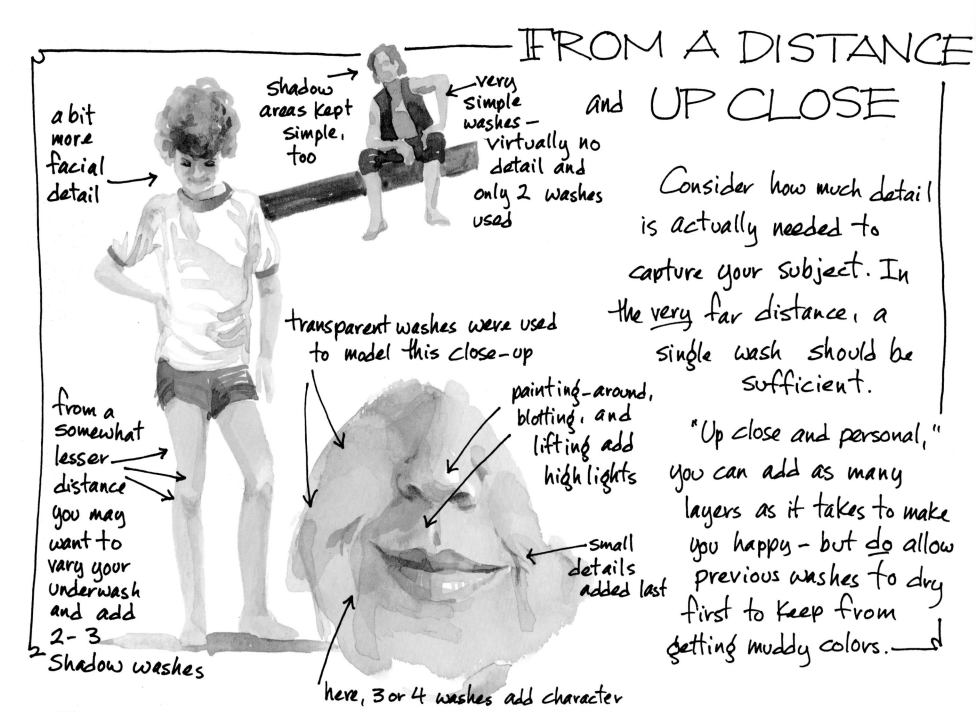

FROM A DISTANCE and UP CLOSE

a bit more facial detail

shadow areas kept simple, too

very simple washes — virtually no detail and only 2 washes used

from a somewhat lesser distance you may want to vary your underwash and add 2-3 shadow washes

transparent washes were used to model this close-up

painting-around, blotting, and lifting add highlights

small details added last

here, 3 or 4 washes add character

Consider how much detail is actually needed to capture your subject. In the *very* far distance, a single wash should be sufficient.

"Up close and personal," you can add as many layers as it takes to make you happy — but *do* allow previous washes to dry first to keep from getting muddy colors.

MISCELLANEOUS HINTS

wet-in-wet may work well when painting young skin

here, transparent layers were used for a fresh effect — and more control

edges softened with clear water

a little drybrush work can add character

Choose your pigments according to the effect you're after and the color of your subject's skin

new gamboge

alizarin crimson

ultramarine blue

yellow ochre

cadmium red medium

manganese blue

burnt umber

alizarin crimson

thalo blue

<u>TRANSPARENT</u>

<u>OPAQUE</u>

DARK

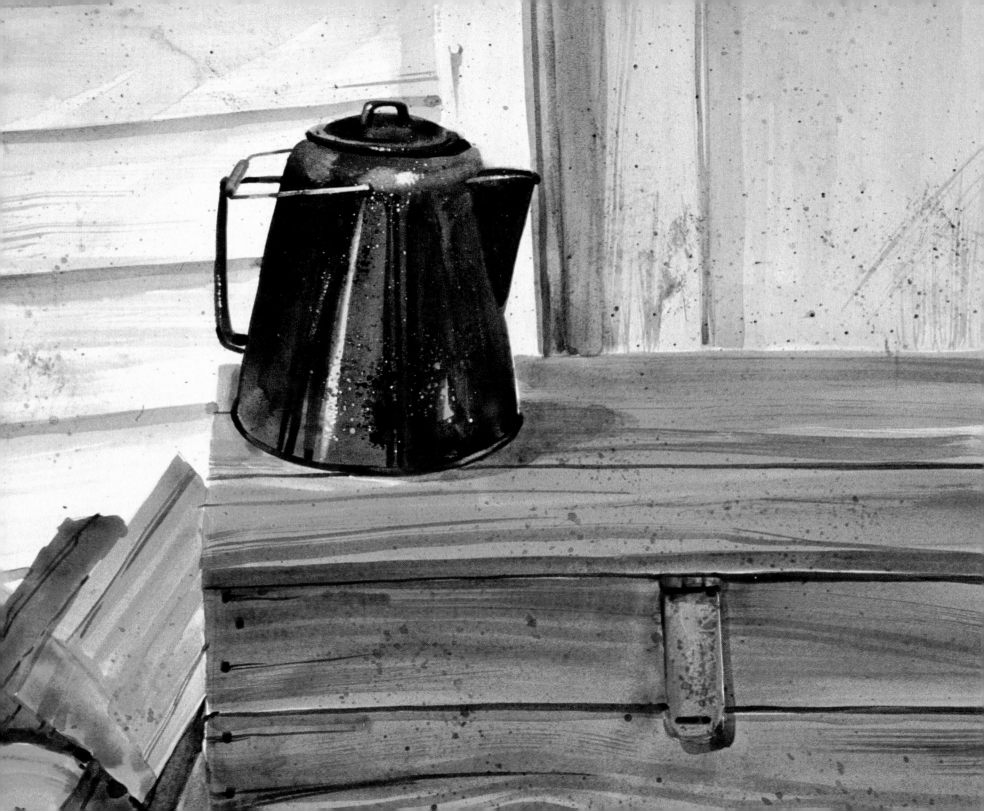

GLASS AND METAL

You may not have thought of these smooth, shiny objects as having textures at all, but they do—smooth, shiny ones. They're a real challenge to capture in most cases, because you're not only concerned with local color but with reflections and, in the case of glass, transparency. What you can see *through* the glass affects the color/texture as much as the local color itself. Highly textured glasses—cut or molded glass—pose an additional challenge, as the facets catch and hold the light, then return it to the eye.

Really, it's a matter of simple observation. Look at what you see and the logic involved. It's not necessary to paint a "portrait" of a specific decanter or teapot (unless you're a photorealist). You can simplify what you see by mapping, as you did for the glossy fur a few chapters back. Notice how the light breaks along a facet and what reflects there. See what it is that is near that silver coffeepot or copper skillet that will affect not only reflections but color.

Glass is a combination of transparency and reflection; shiny metal is all local color and reflection. Both tend to have a broad variance in value patterns. Very, very light tints will be juxtaposed directly beside the darkest darks, and often there's only a mid-value or two between these two extremes. (That's what gives the shiny sparkle: light-lights and dark-darks without a lot of mud in between.)

When you're painting shiny metal, local color becomes extremely important. Copper, bronze and brass all have color of their own, while silver is almost completely reflective and pale in the extreme. Notice the variety of colors that went into the copper pot on page 116, and the white of the paper that says shine. (If I'd been painting silver, only the reflections and a bit of luminous gray would have to tell the story.)

Duller, tarnished or highly textured metals, on the other hand, have a very close value range. Not a lot of deep darks or sparkly whites here. Look for ways (drybrush, spatter, spongework) to express the texture that hard use has given these objects.

Enamel Coffeepot 15" × 22"

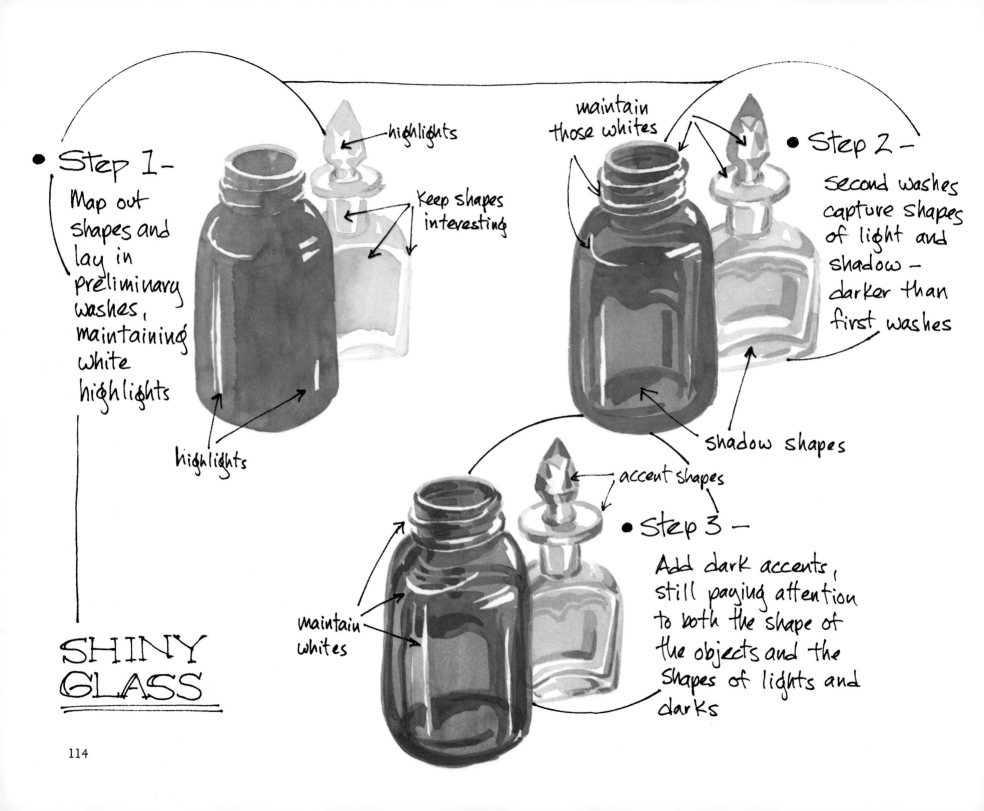

• Step 1 –

Map out shapes and lay in preliminary washes, maintaining white highlights

highlights

highlights

Keep shapes interesting

maintain those whites

• Step 2 –

Second washes capture shapes of light and shadow – darker than first washes

shadow shapes

accent shapes

• Step 3 –

Add dark accents, still paying attention to both the shape of the objects and the shapes of lights and darks

maintain whites

SHINY GLASS

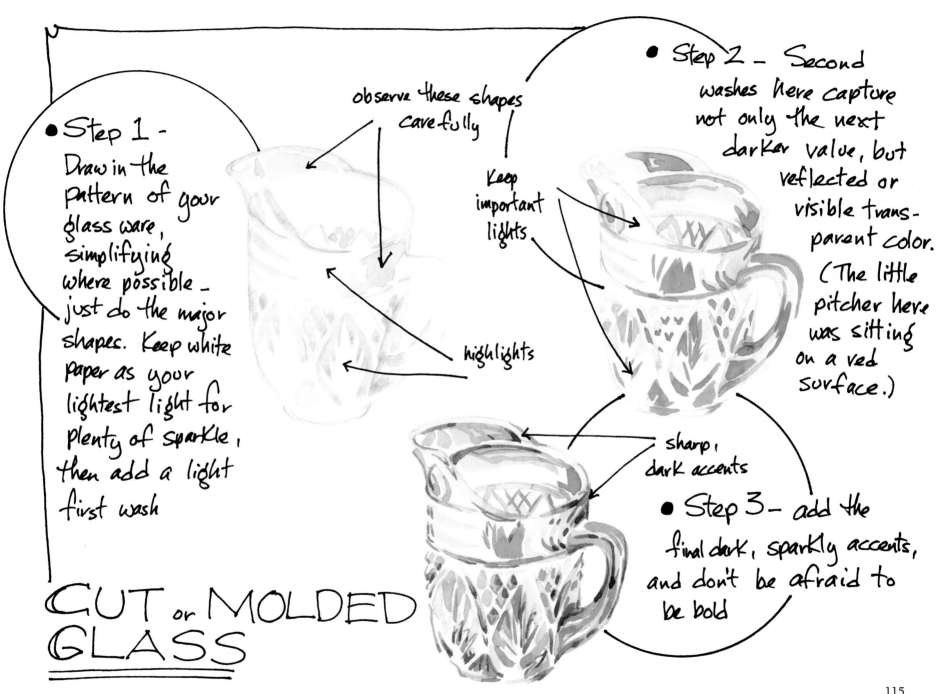

• Step 1 – Draw in the pattern of your glass ware, simplifying where possible – just do the major shapes. Keep white paper as your lightest light for plenty of sparkle, then add a light first wash

observe these shapes carefully

Keep important lights

highlights

• Step 2 – Second washes here capture not only the next darker value, but reflected or visible trans- parent color. (The little pitcher here was sitting on a red surface.)

sharp, dark accents

• Step 3 – add the final dark, sparkly accents, and don't be afraid to be bold

CUT or MOLDED GLASS

All of these colors were used to depict this copper-and-brass Pot.

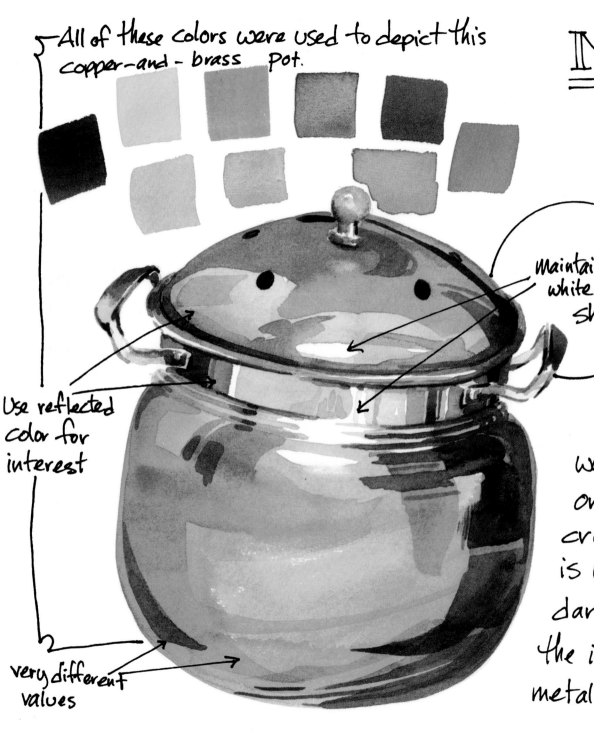

METAL...polished

The local color of the metal you paint is important, and usually goes down as your first (or second) value wash after the white-paper highlights.

In this case, copper-color was created with cadmium orange and yellow, a little alizarin crimson and burnt sienna. Brass is mostly raw sienna. Then, much darker values added next create the illusion of reflective, shiny metal surfaces.

maintain white-paper shine.

Use reflected color for interest

very different values

METAL ...tarnished and textured

Here, local color is the most important element, since the range of values is so tight. Do allow this first wash to blend and vary, with soft transitions from lightest light (still fairly mid-value) to darkest dark. A little sedimentary Manganese Blue suggests the patina of age. A little drybrush work completes textures.

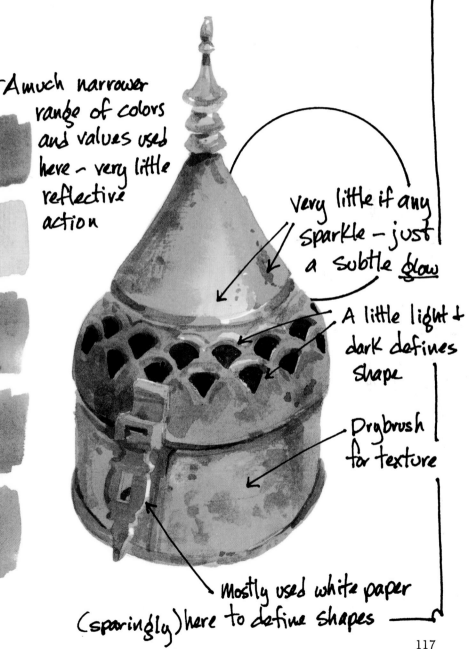

A much narrower range of colors and values used here - very little reflective action

Very little if any sparkle - just a subtle glow

A little light + dark defines shape

Drybrush for texture

Mostly used white paper (sparingly) here to define shapes

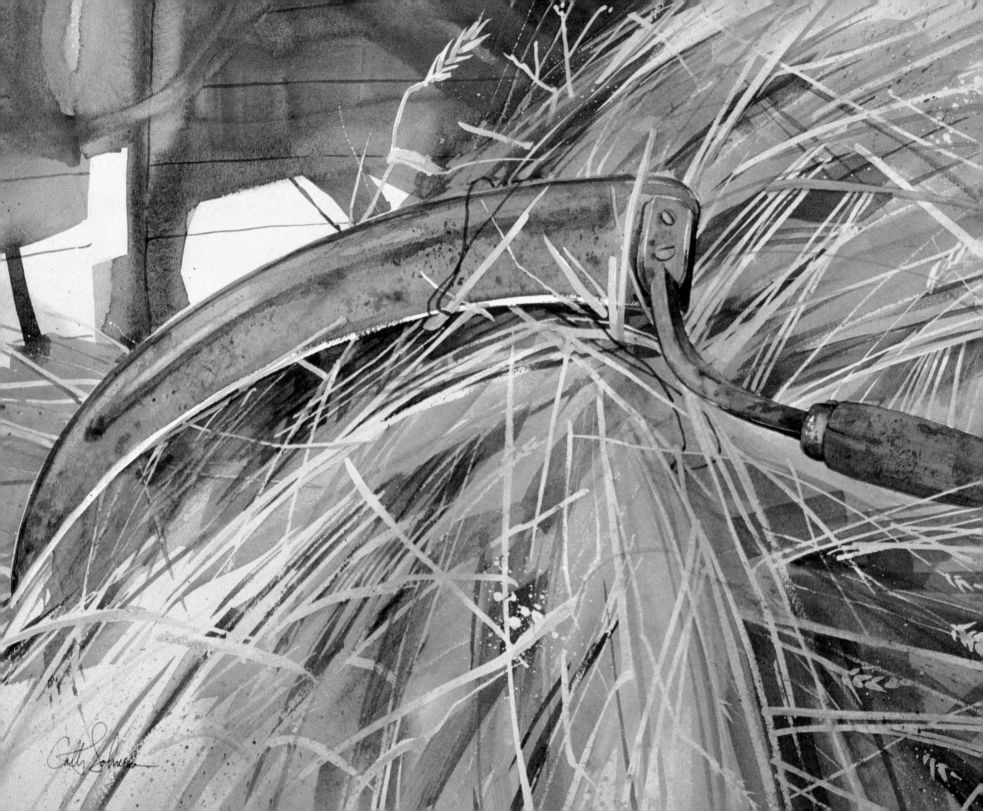

Chapter Seventeen

R U S T

Rust is such a lively, interesting and ubiquitous texture that it deserves a chapter all its own, quite independent from other metal subjects. The colors are warm, evocative. We sense not only age but endurance—and a certain transience in the moldering metals. A rusty old farm tractor abandoned in a corner of a field says something entirely different to us than a brand-new, shiny enameled monster on a vast agribusiness farm. We can relate; we're painting character, not an ad for a tractor company.

It's the same with any old tools that show the effects of time. We know these have been around, have been used—have been useful. A shiny new set of hinges might as well be an illustration in a hardware store's catalog for all the sense of connection with the human they have.

There's beauty in the aging process (now if we can just accept that truth when we look in the mirror!). The corrugated tin roof streaked with rust on the log cabin I used to occupy had it all over the asphalt shingles of my present home for character and durability—and certainly for interest when it comes to painting it!

When you paint rust from a distance, *you* choose how much detail is enough. A little spatter and a variation in color, as in step two of our first demo, may be all you want to say. If you want to carry it further, add a little drybrush work and a bit of detail (our sample might be that corrugated roof, or the single screw that weeps red tears on an old white shed). Close up, you can use every trick in the book: spatter, drybrush, spongework, wet-in-wet, puddling—you name it.

Don't be afraid to play with color, however. You don't need to stick to burnt sienna just because it's rust-colored. A little yellow ochre for an underwash, a bit of blue to reflect the sky, a spark of cadmium orange for warmth, a strong mixure of burnt umber and ultramarine blue to capture the look of handwrought iron just beginning to rust, a little purple or green—whatever it takes to satisfy *you*.

Haying Done 15"×22"

wet-in-wet

scraping

Step 2... Wet-in-wet spatter and a few lines scraped in while the wash is damp add to the illusion — and in fact you could stop here quite happily.

Step 1... Vary your preliminary wash for interest. Here, burnt and raw sienna are mixed with a little ultramarine blue.

nice tonal variation

drybrush

parallel lines suggest corrugation

Step 3... Dry spatter, drybrush work and a little detailing (the corrugation lines) finish the sample.

rust runs down with the effects of weather and water.

RUST...
from a distance

Step 1... the preliminary wash in this case is gray (mixed from burnt sienna and cobalt blue) to suggest the color of galvanized metal.

Step 2... while this wash is still damp (glossy but not shiny) add some splotches of raw and burnt sienna partly mixed with ultramarine blue. Add spatter as it dries.

blob of paint laid in while damp makes nice, evocative hard edges.

wet and dry spatter

Step 3... finish up with more spatter and dry-brush work. Here, a natural sponge was used for additional texture.

sponge dipped in pigment

RUST...

close up

AGING METAL ... tools, hinges, etc.

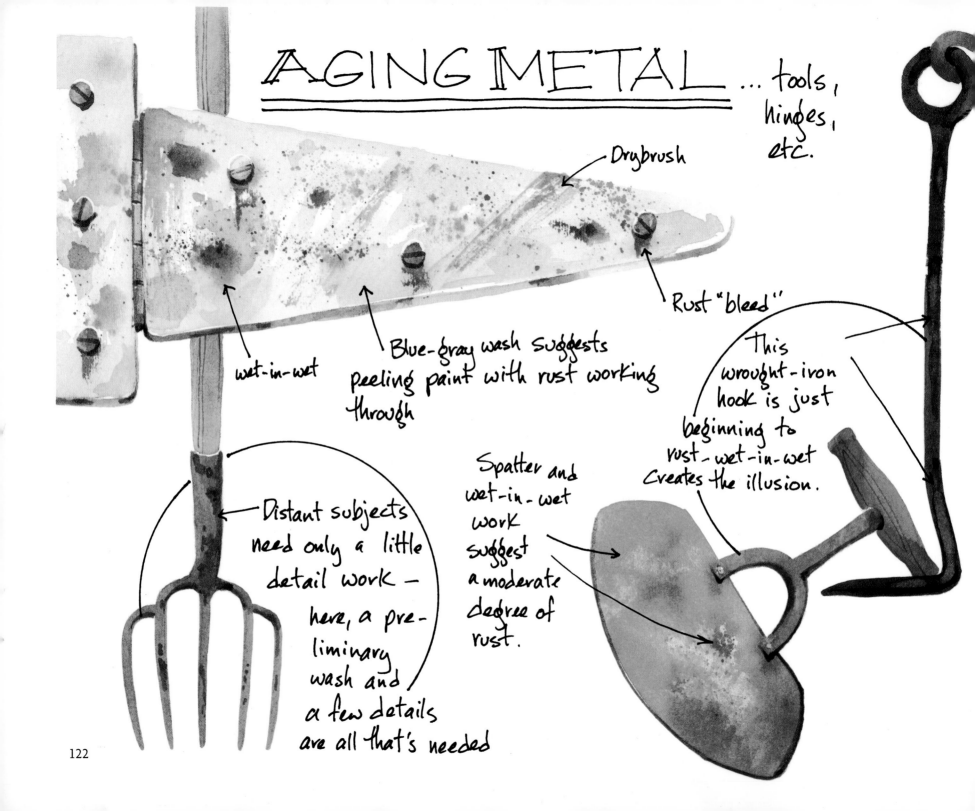

Drybrush

Rust "bleed"

wet-in-wet

Blue-gray wash suggests peeling paint with rust working through

This wrought-iron hook is just beginning to rust-wet-in-wet creates the illusion.

Distant subjects need only a little detail work — here, a preliminary wash and a few details are all that's needed

Spatter and wet-in-wet work suggest a moderate degree of rust.

OLD CARS, TRACTORS, etc.

Subjects like this are too complex to paint in one go and still maintain your timing. It's easiest to do in sections: hood, fenders, front, etc., then add unifying details. The techniques at right are some of the possibilities for successful "rust."

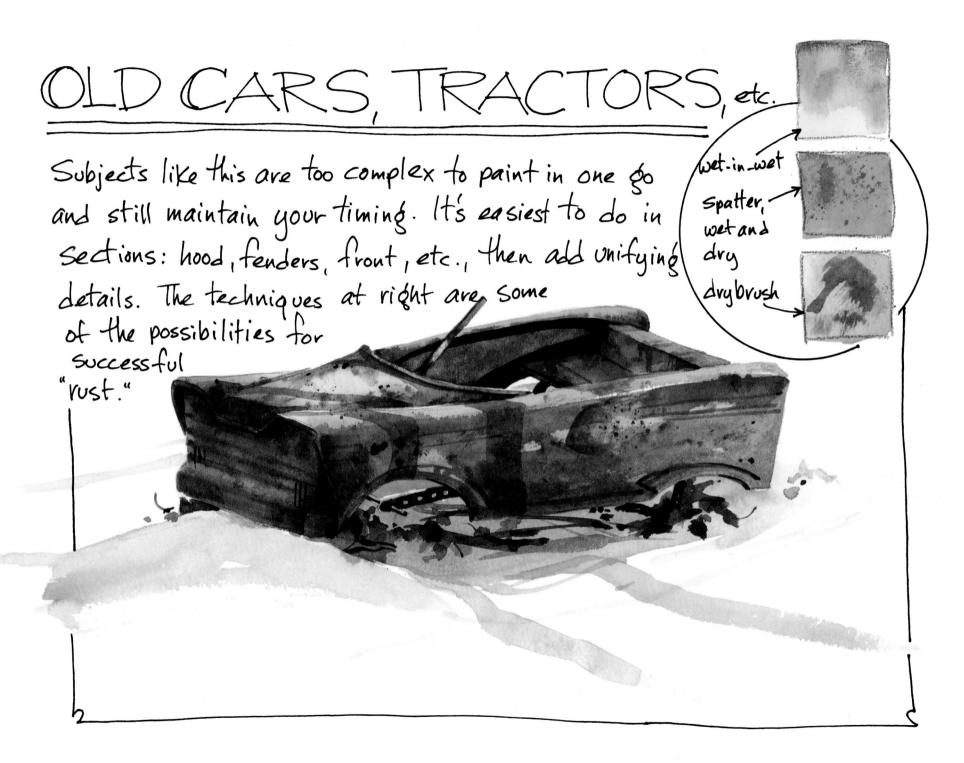

wet-in-wet

spatter, wet and dry

drybrush

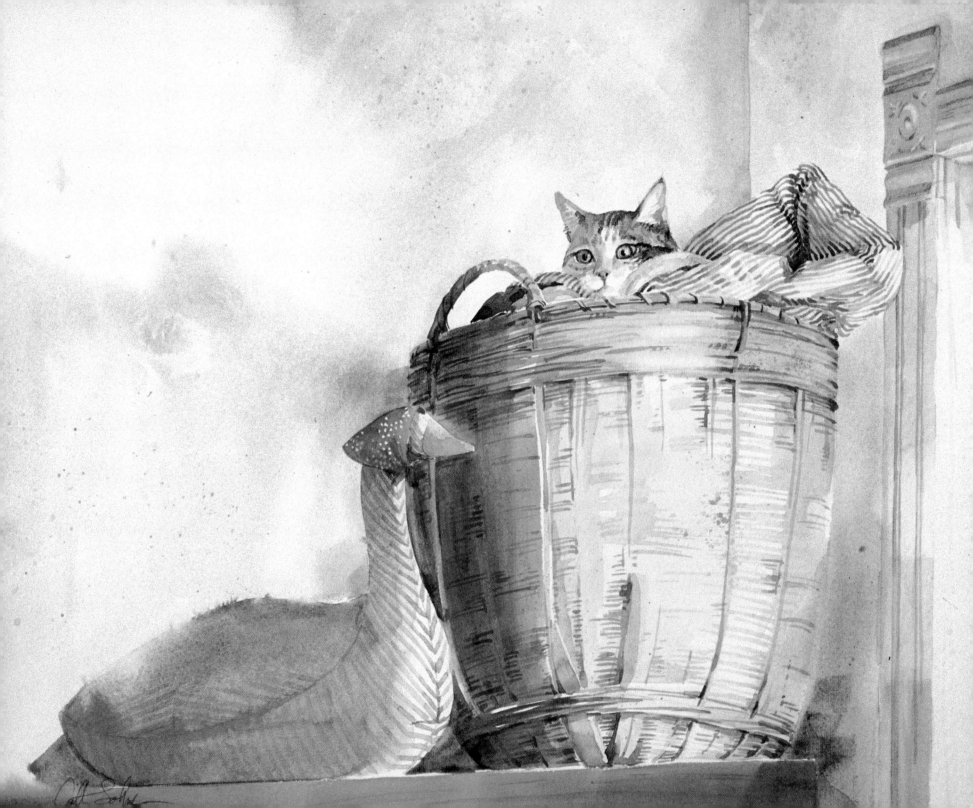

Chapter Eighteen

MISCELLANY

We've only scratched the surface, and we know it. There are so *many* tactile surfaces out there, such a variety of textures. This chapter touches on a few that didn't seem to warrant an entire chapter of their own but still needed to be explored, whether they be the domestic textures of a stucco wall or a polished wooden table, the familiar, personal texture of a favorite pair of corduroy pants, or the natural texture of a forest floor or a single feather.

In most cases, the same three steps will take you from here to there: underwash, secondary wash(es) and details. Think of those corduroy pants: Local color, shadows and folds, and just the suggestion of corduroy's distinctive texture are sufficient. In other cases, two steps may do it. For an open-weave fabric like jute or burlap, a fan brush used to crosshatch the surface and a few detail knots added later are sufficient—though on a larger scale you'd still want to suggest light and shadow. Still other subjects may require *more* steps to catch the effect you're after. When I painted the plaid throw on page 128, I first painted a simple, light wash and added a suggestion of shadows in the fabric's folds with a light, grayed blue. Then I painted in the premapped shapes of the elements of the plaid: red lines first, then blue, then green, then yellow, allowing them to overlap to suggest the complexities of plaid weaving. When that was dry, I added deeper shadows; if need be, I could finish with the kind of woven suggestion in the lower right-hand corner. You can play a bit with laces. Paint them directly, if you like, *or* wet a piece of lace in pigment and print with it—or paint *through* it, like a stencil.

Painting old, shiny wood is much like painting shiny metal, except the shine is more subdued. Still, there's a range between your lightest light and darkest dark, with not too many values in between—if the light source is strong enough. Many domestic textures are fun to paint: I like sheer, light-colored curtains and deeply textured stucco walls, but wallpaper textures are sometimes tedious, like plaid.

My favorite textures, however, are the natural ones: fungi and feathers, scales and seashells. They are so varied and so beautiful, but they're still relatively easy to capture, with care and creative logic.

And yes, there are still a *lot* of textures out there we haven't covered. Most are a matter of taking it slow, analyzing what you see, and being patient about getting from here to there.

Margaret in a Basket 15" × 22"

FABRICS... corduroy, burlap and denim

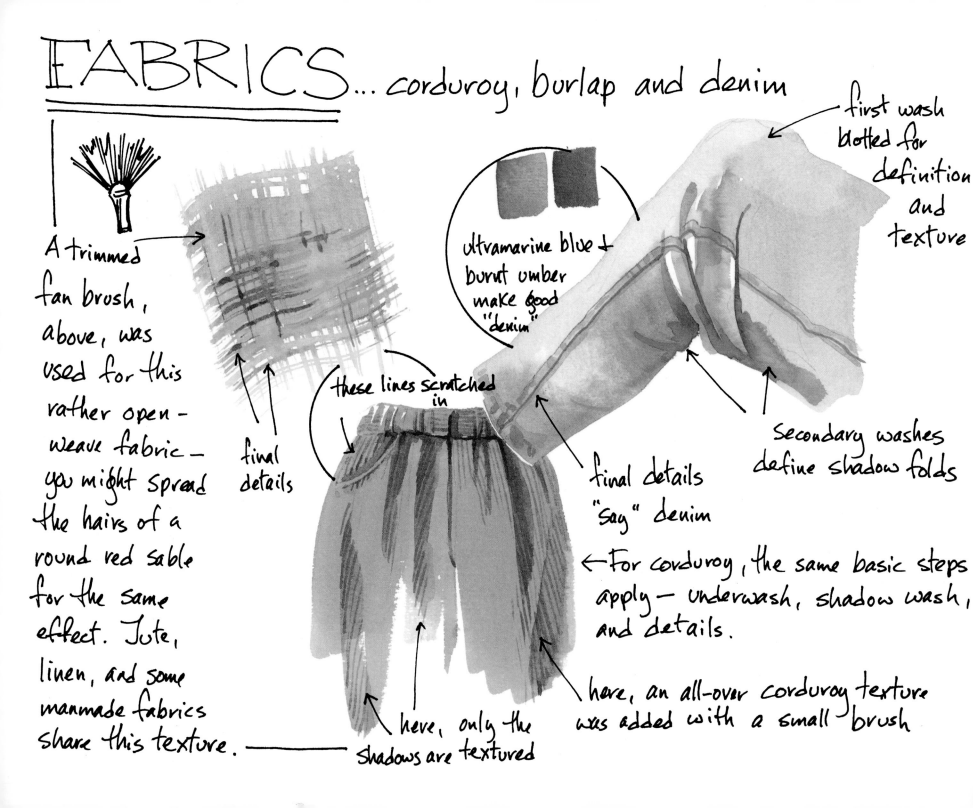

A trimmed fan brush, above, was used for this rather open-weave fabric — you might spread the hairs of a round red sable for the same effect. Jute, linen, and some manmade fabrics share this texture. ——————

final details

these lines scratched in

ultramarine blue + burnt umber make good "denim"

first wash blotted for definition and texture

Secondary washes define shadow folds

final details "sag" denim

←For corduroy, the same basic steps apply — underwash, shadow wash, and details.

here, an all-over corduroy texture was added with a small brush

here, only the shadows are textured

SWEATER KNITS

Whether your subject is simple (like most sweater textures) or more complex (like this Irish fisherman's sweater), the usual sequence of steps will see you through. In the case of cable-knit, you simply need to draw yourself a "map" before beginning to paint.

Final texturing depends on how far you want to take it.

pencil "map"

first wash

second wash

drybrush

first wash

painted last

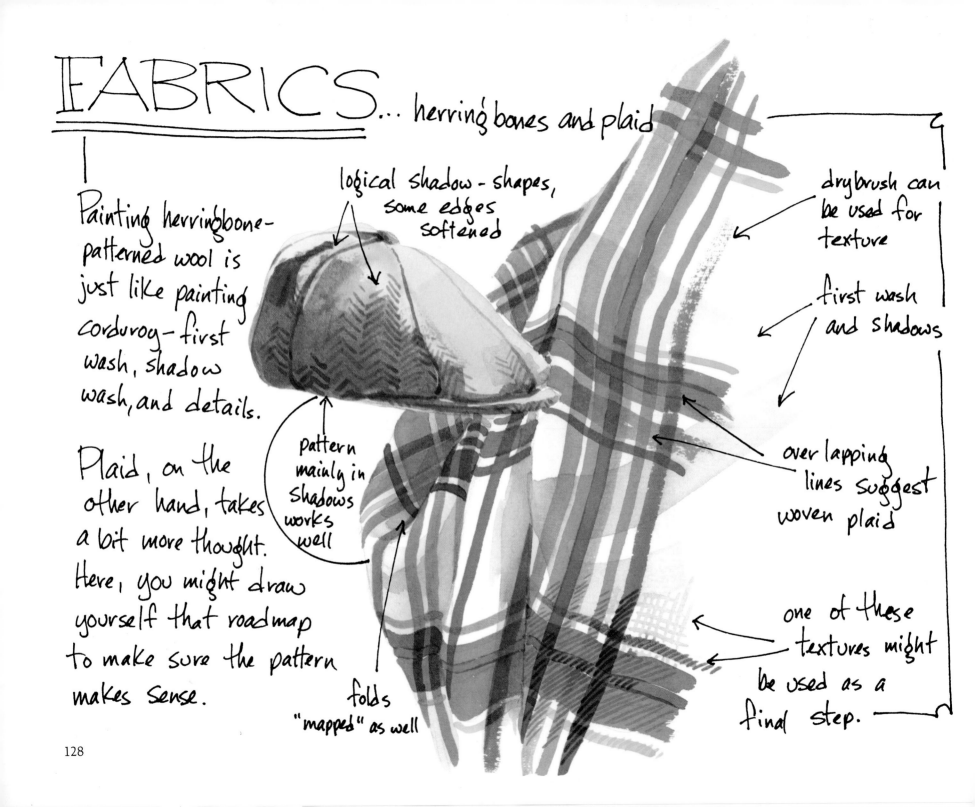

FABRICS... herring bones and plaid

Painting herringbone-patterned wool is just like painting corduroy — first wash, shadow wash, and details.

Plaid, on the other hand, takes a bit more thought. Here, you might draw yourself that roadmap to make sure the pattern makes sense.

logical shadow - shapes, some edges softened

pattern mainly in shadows works well

folds "mapped" as well

drybrush can be used for texture

first wash and shadows

over lapping lines suggest woven plaid

one of these textures might be used as a final step.

FANCY FABRIC

lace, tulle, satin

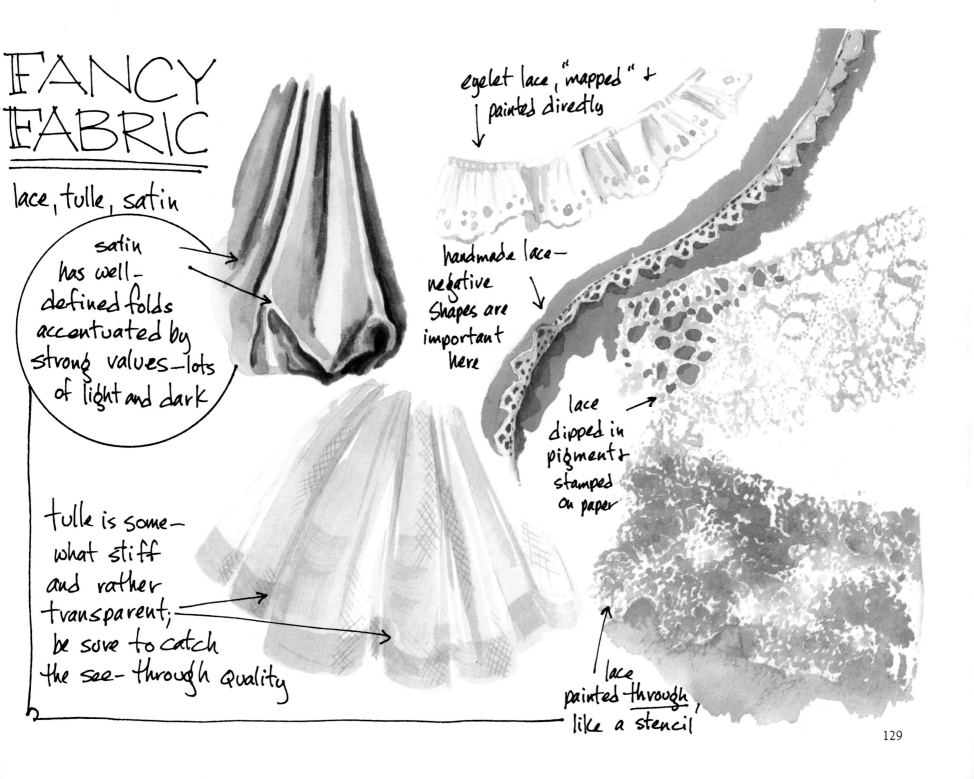

satin has well-defined folds accentuated by strong values—lots of light and dark

tulle is somewhat stiff and rather transparent; be sure to catch the see-through quality

eyelet lace, "mapped" + painted directly

handmade lace—negative shapes are important here

lace dipped in pigment + stamped on paper

lace painted through like a stencil

NATURAL TEXTURES

fungi and feathers....

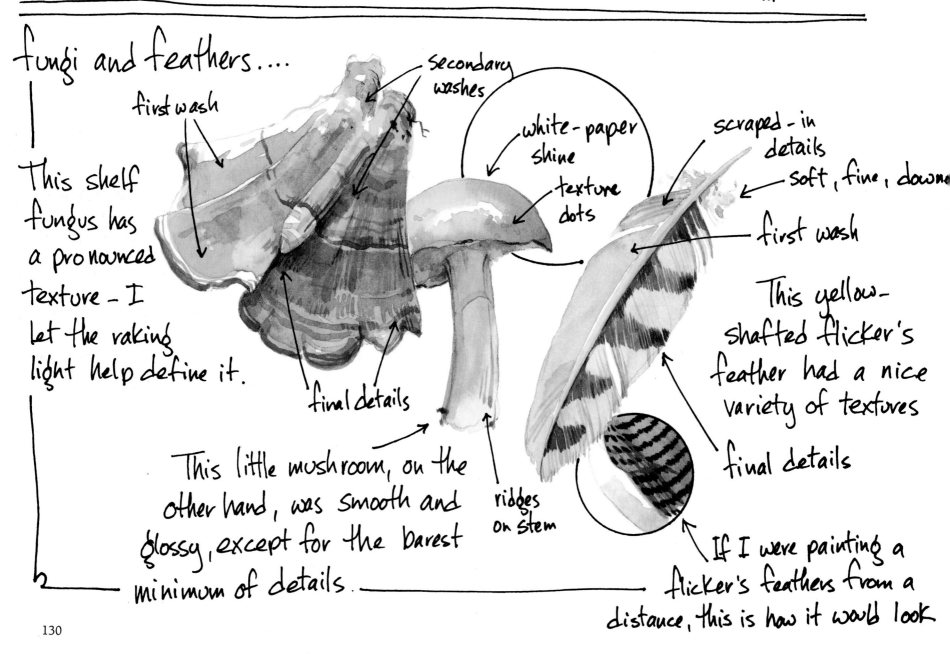

first wash

secondary washes

This shelf fungus has a pronounced texture - I let the raking light help define it.

final details

white-paper shine

texture dots

scraped-in details

soft, fine, downy

first wash

This yellow-shafted flicker's feather had a nice variety of textures

final details

This little mushroom, on the other hand, was smooth and glossy, except for the barest minimum of details.

ridges on stem

If I were painting a flicker's feathers from a distance, this is how it would look

scales and seashells....

first wash

close-up
fish scales

detail
wash

second
wash

This dry shell has a pronounced and rather complex texture, criss-crossing itself while following the over all shape.

from a greater distance, a series of dots is fine

Many creatures have scales - fish, lizards, & snakes among them. Most are somewhat shiny, but some are dry and granular. Leave that white paper to catch the shine!

The little green shell was wet and shiny - I saved white paper with Maskoid.

masked out lights

tines help suggest scales

this colorful snake was like painting a mosaic - the shine, again, was saved with liquid Maskoid.

forest floor....

Step 1... mask any areas you want to remain lighter and lay in a varied first wash.

this Maskoid was applied with a handy stick

Step 2... with masking agent still in place, begin laying in secondary washes to suggest the spaces between leaves. A few blades of dead grass and spatter add to the illusion.

spatter

shadow shapes and leaf veins

Step 3... complete details of leaf litter when preliminary washes are dry, and remove Maskoid. Paint these reserved areas as you choose.

desert cactus....

Step 1... mask out details you want to preserve, like light-struck edges & spines, then add first washes

allow these color washes to dry, or paint wet-in-wet for blended color

secondary wash

Step 2... secondary shadow washes define shapes and suggest depth

watch for color variations

Step 3... remove Maskoid and paint final, sharp details — spines, prickles, details within shadow areas.

2

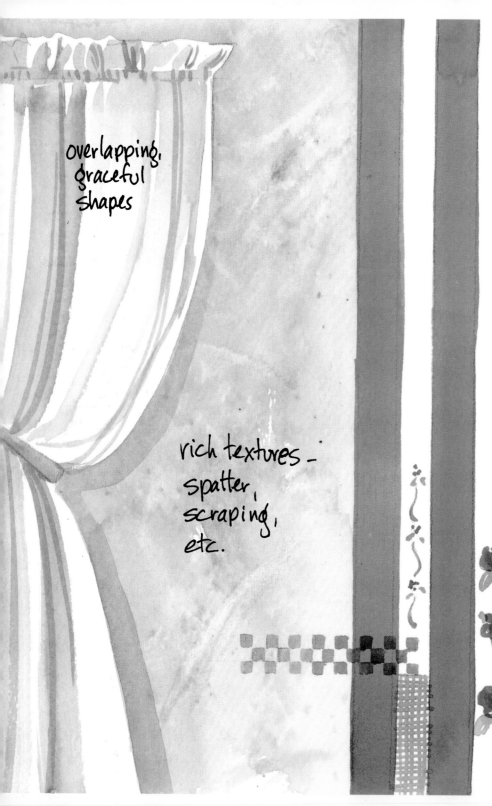

overlapping,
graceful
shapes

rich textures -
spatter,
scraping,
etc.

DOMESTIC TEXTURES

curtains, stucco, wallpaper...

These interior textures
can be fun — lovely, transparent
curtains are just a matter
of overlapping translucent
washes, and stucco or
rough plaster can be almost
like finger-painting.

Wallpapers, on the other hand,
are more like painting
patterned fabrics, requiring
a bit more planning &
care.

...basketweaves and polished wood...

The type of basket you have and what it is woven from determines its texture. An Ozark basket made from split oak splines is very different from a fine Navajo example. Plan ahead — make a map if need be — for best results.

Like glass and metal, polished wood has a lot of lights and darks — a strong value pattern.

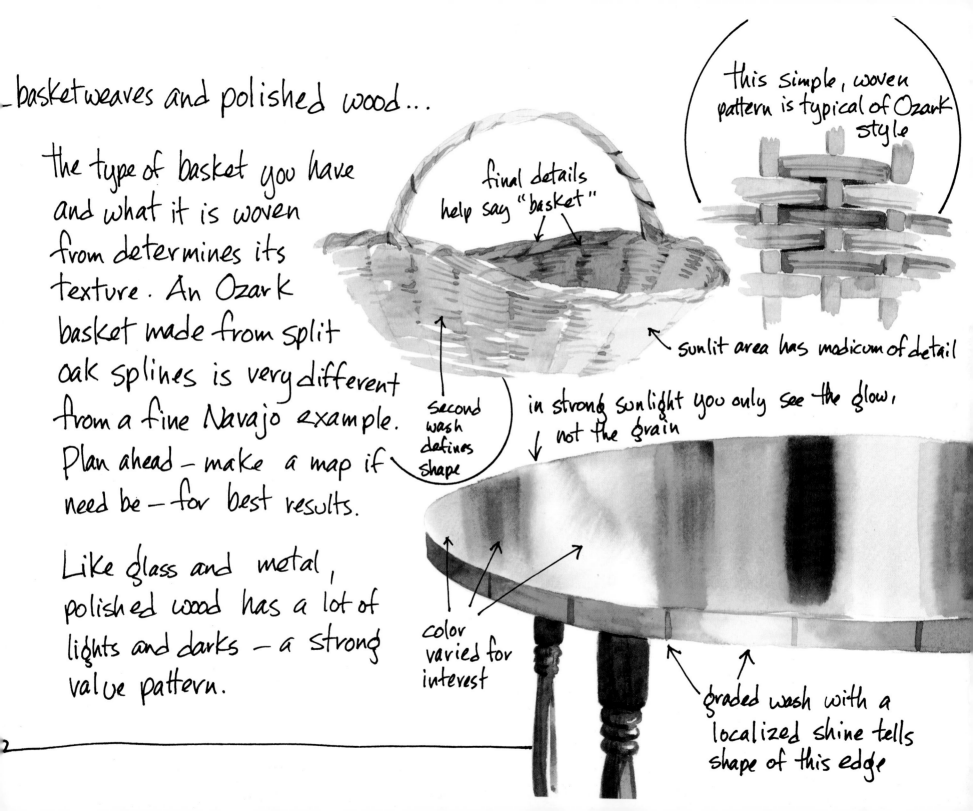

final details help say "basket"

this simple, woven pattern is typical of Ozark style

sunlit area has modicum of detail

second wash defines shape

in strong sunlight you only see the glow, not the grain

color varied for interest

graded wash with a localized shine tells shape of this edge

2

INDEX